the **artful** parent

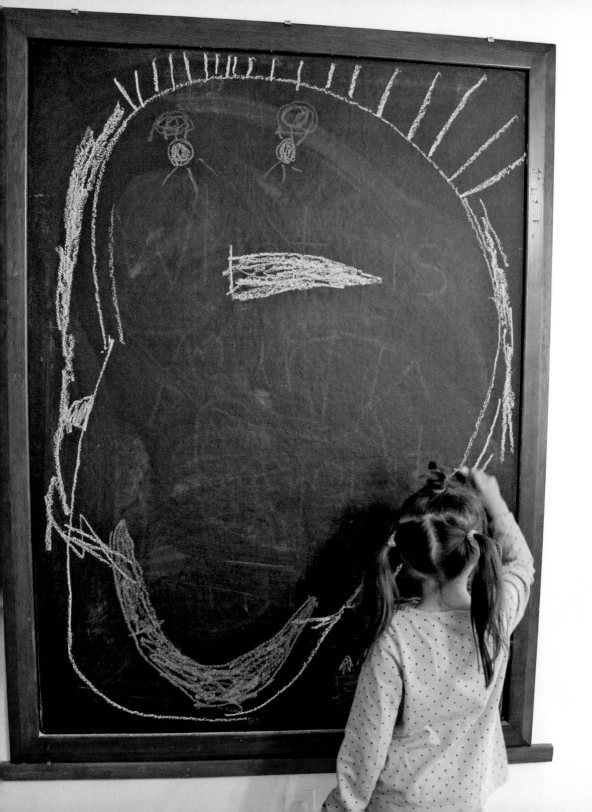

the
artful parent

Simple Ways to Fill Your Family's Life with Art & Creativity

JEAN VAN'T HUL

ROOST
BOOKS

Boston & London | 2013

Safety Note: The activities in this book are intended to be performed under adult supervision. Appropriate and reasonable caution is recommended when activities call for the use of materials such as sharp scissors, hot glue, or small items that could be choking hazards. Although this is a workbook, the recommendations in the activities in this book cannot replace common sense and sound judgment. Observe caution and safety at all times. The author and publisher disclaim liability for any damage, mishap, or injury that may occur from engaging in the activities in this book.

ROOST BOOKS
An imprint of Shambhala Publications, Inc.
Horticultural Hall
300 Massachusetts Avenue
Boston, Massachusetts 02115
roostbooks.com

Text, photography, and illustrations © 2013 by Jean Van't Hul unless otherwise specified

9 8 7 6 5 4 3

Printed in the United States of America

♾ This edition is printed on acid-free paper that meets the American National Standards Institute z39.48 Standard.
♻ Shambhala Publications makes every effort to print on recycled paper. For more information please visit www.shambhala.com.

Distributed in the United States by Penguin Random House LLC
and in Canada by Random House of Canada Ltd

Designed by Daniel Urban-Brown

Library of Congress Cataloging-in-Publication Data

Van't Hul, Jean.
The artful parent: simple ways to fill your family's life with art and creativity / Jean Van't Hul.— 1st ed.
p. cm.
Includes index.
ISBN 978-1-59030-964-3 (pbk.: alk. paper)
1. Handicraft for children. 2. Parent and child.
3. Creative activities and seat work.
4. Child artists. I. Title.
TT157.V285 2013
745.5083—dc23
2012021168

Dedicated to parents everywhere. May you embrace art as a tool for joyful parenting as you help your children reach their true creative potential.

Contents

Foreword by MaryAnn F. Kohl

When my daughters were very young, I was an artful parent like Jean Van't Hul, but I had never heard the term and didn't know that "artful" could be a way of life. My breakfast nook shelves were stocked with shoeboxes overflowing with shells and buttons, cans bursting with markers and brushes, stacks of paper heaped on top of cardboard scraps, and egg cartons nested in a tower. It was natural for one or both of my kids to wake up in the morning and head bleary-eyed and tousle-headed to the little art table—still in jammies—to plop down and draw things like oddly exotic birds with colorful plumes curling from their heads or circles upon colorful circles filled with cotton balls (all this while I browned and flipped funny-face pancakes in a buttered frying pan). The days began and ended with creativity, and it was a joyful time that formed us all in ways we value now but did not plan. I never realized I was artful. I simply said yes to art and creativity, and it seemed natural for us as a family to have art in our lives every day. As I look back, I can say I was most definitely an artful parent.

Before I was the mama of two little girls, I discovered how important art could be when I was a second-grade teacher. I chose to offer real art classes, where my students openly expressed themselves with selected materials each day, rather than crafty, cutesy projects that I made for them to copy. I had some tough cases in those days, kids who couldn't sit still or listen or follow directions or use even the most rudimentary vocabulary to ask for simple things in ways we all take for granted. But when we had art? The entire classroom settled into a productive hum, and everyone—and I mean everyone—was happy and on task. Because art met the needs of so many so easily, I arranged much of my classroom activities around something, anything, that would include art. In this way, I was able to bring otherwise poor students into a world of exciting and successful learning and achieve measurable progress in their

skills. Not only did I hook those kids, I was hooked myself. Art was my answer. I was an artful teacher!

Many, many years later, when I first came across *The Artful Parent* blog (which has evolved into this delightfully inspiring book), I knew I had come home to art that I loved and appreciated! I found a place where I could watch young children explore and discover through their own efforts, where their experiments and explorations were valued, and where the light of creativity was shining night and day, indoors and out. I saw that Jean Van't Hul was an artful parent who could say yes to art, even at times when she might have wanted to say no. Over the years, I have watched her little ones blossom through her loving, art-rich, creative home life, and along the way, I've blossomed a bit myself. Jean has offered me new ideas and a reminder that being artful is a choice.

If you have decided to be an artful parent, even if it's just a tiny bit artful on Wednesday afternoons only, then you are going to delight and revel in *The Artful Parent*, your easy-to-follow guide with enough ideas to last a lifetime or many afternoons, as fits your family and your mind-set. You will be inspired to raise your children in an art-rich environment that will encourage their creativity, their confidence, and their joyful existence on this planet. All the tools are here. All the suggestions for what works and what doesn't. All the hows and whys and whats. Living artfully will be the finest choice you've ever made for your family, next to reading books at bedtime and putting nutritious meals on the table.

Since that time of teaching second grade years ago, my life has advanced artfully to bringing process art to children all over the world through the books I write and the workshops I give. I have grown in my passion and understanding about the importance of art in a child's life and, beyond that, in a family's shared life. The importance of art goes beyond creativity, beyond exploration, and well beyond fun. An artful life trains the brain to work at finding alternatives and choices, solving problems and testing answers, and bypassing the known or accepted way of doing things to find new ways. An artful life will open the mind of a child and pave the way to becoming an adult who can think about and even create options—widely and wonderfully and joyfully! We need people with creative minds to keep society forming and reforming in positive ways. *The Artful Parent* is a tool that encourages thinking and will help you raise creative, productive thinkers and doers.

With this book, we can recognize and launch an artful life with our families. That artful life will be filled with fun and wonder and color and joy and surprises, all wrapped up with a pretty ribbon of commitment and the bright promise of creativity. Join us and become an artful parent, giving your family the gift of a lifetime of creativity.

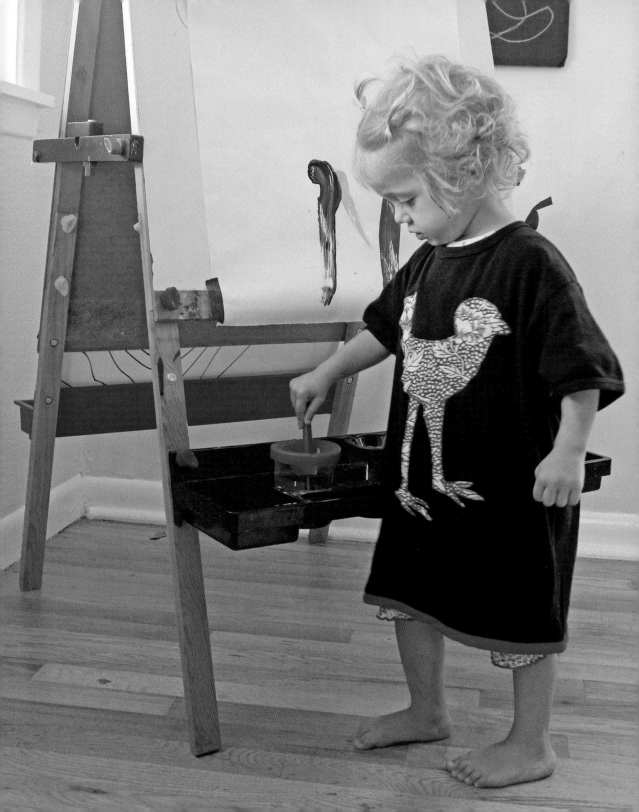

Introduction: Saying Yes to Art

Our task, regarding creativity, is to help children climb their own mountains, as high as possible. No one can do more.

—Loris Malaguzzi

Art has always played an important role in my life. I spent my childhood making it, my college years studying both art history and studio art, and my early adult years working in arts organizations. I am naturally drawn to, and enthused by, the visual arts especially. When I became a parent, I wanted to share my love of art with my children and made it my goal to focus on having a home full of joy and creativity, art and beauty. Having never approached art from the perspective of a parent or teacher, this was new territory for me. To help myself get started, I sought out advice in books and support from other parents who were also interested in introducing art to their little ones.

When my daughter Maia turned one, I started a toddler's art group that was basically a playgroup with a regular art component. Once a week, we met with other families whose children were roughly the same age to play and hang out, always incorporating an art activity. I thought that if my daughter had an art-focused playgroup, she would grow up thinking of art as a fun and valued part of everyday life. And the same would be true for the other families who participated. We continued the art group, on and off, through Maia's preschool years. When my second daughter,

Daphne, turned one, I started another toddler art group, and I imagine we'll meet for a few years as well.

Maia and Daphne (now ages six and two, respectively) couldn't be further apart in terms of temperament and developmental stages, yet they both thrive when given art materials and projects to work with on their own and together. They respond to art in different ways, as all kids do, bringing their own personality, temperament, and experience to the table when faced with a blank page and a pot of paint. Maia, the spirited one, who generally moves nonstop, will sit calmly focused to draw or paint picture after picture. Daphne, the mellow one, gets revved up and excited by creating art. It's fascinating to watch them both approach it so differently.

Out of a desire to share the art we were doing as a family and with our children's art group, I started a blog called *The Artful Parent*. This was also a way for me to stay accountable as a parent to the artful family life I was trying to foster. When I started the blog, these ideas and actions (and parenting in general) were still relatively new to me and not always effortless. As I wrote about what worked and what didn't, I continued to learn and grow. *The Artful Parent* quickly expanded into more than I could have imagined, becoming a supportive group of artful parents and teachers from all over who shared ideas, questions, concerns, and encouragement. It continues to be an amazing community and a place where people come for and give inspiration.

We don't do elaborate art projects every day by any means, but we do manage to make art a priority in our family as a whole. We have a dedicated art space and access to a colorful assortment of art supplies, participate in our children's art group, and often choose to do art together as a family. We also don't stop at painting and sculpture; we try to make the everyday artful through our approach to cooking, playing, and living.

When I look around our house, I see the evidence of our artful family focus all around me. A vase of cheery zinnias picked by my daughter adds splashes of pink, red, fuchsia, and orange from our garden. A shiny red, child-size table stands close by, stocked with sketchbook and markers. My daughters' vibrant paintings hang on the walls. I love the reminders that I have said yes to art emphatically and often—through my surroundings, the way I parent my daughters, and how I interact with the world. You can too.

Artful Parenting

I define an artful activity as any that's full of art, beauty, and creativity. As parents, there are innumerable ways we can make our family life more artful. While painting, drawing, and other traditional art-making methods are obvious choices, many other activities can also be considered artful:

> Enjoy the little things, for one day you may look back and realize they were the big things.
>
> —ROBERT BRAULT

- *Trying out new science experiments.* Creative thinking is encouraged by the act of experimenting.
- *Taking a nature walk.* There is incredible beauty in the natural world; try observing the veins in leaves and the patterns on tree bark.
- *Baking.* Creating food from scratch is nourishing to the hands, heart, and stomach.
- *Planning a teddy bear tea party.* Pretend play encourages imagination.

Just about anything is fair game for becoming artful if you approach it the right way.

You can invite art into your home with your actions, your words, your attitude, and the activities you offer. You can do it by having the space to do art, making art materials available, and introducing new concepts and activities. You can do it slowly over time or start an overnight art revolution. No matter how you introduce art to your family's life, the advantages are profound.

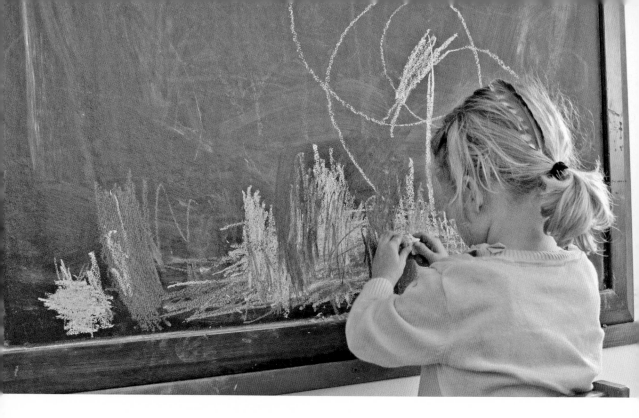

The Benefits of Artful Living

Educators tell us that art encourages fine motor skills, neural development, and problem-solving abilities and that it can be used effectively to teach and understand other key subjects such as reading, writing, math, and science. Therapists tell us that art is valuable because it allows children to process their world, to deal with sometimes scary emotions in a safe way, and because it gives them critical sensory input. Artists tell us that art is important for its own sake—as a source of beauty and expression, as well as simply for the process of creating. Kids tell us that art is *fun*, an activity they enjoy. Parents tell us that art is vital to their families because it keeps everyone engaged and happy and helps with the sometimes difficult transitions of the day. Art is naturally linked to creativity, an attribute that is increasingly being touted as one of the most important factors for the success of individuals, organizations, and cultures.

The truth is that art is vital, if somewhat intangible, and that if children engage

in hands-on art activities, they learn much better in all disciplines. Here are some of the reasons why children thrive when they make art.

Art Promotes Creativity

Creativity is the ability to think outside the proverbial box, to string two unrelated ideas together in a new way. Solutions to major problems and breakthroughs of all kinds are linked to creativity. The ability to be creative is vital to the success of our children and the well-being of our world, now more than ever, as we face incredible challenges such as racial discord, wars, global warming, and mass extinctions. Individuals, organizations, and governments seek innovative solutions every day. According to the International Child Art Foundation, "Research indicates that a child who is exposed to the arts acquires a special ability to think creatively, be original, discover, innovate, and create intellectual property—key attributes for individual success and social prosperity in the twenty-first century." The world needs *more* and *better* creative thinkers.

Art Encourages Neural Connections

Art is an activity that can employ all the senses—sight, sound, touch, smell, and taste—depending on the activity. Children's brain synapses fire away as they experiment and create, squishing paint between their fingers, mixing colors and materials, or drawing from imagination or what they see in front of them.

Art Builds Fine Motor Skills

Gripping a paintbrush, drawing dots and lines, mixing colors, cutting with scissors, controlling a glue stick or squeezing a glue bottle, kneading and rolling playdough, tearing paper—all of these tasks require increasing amounts of dexterity and coordination, yet they are so fun and rewarding that children *want* to do them over and over. As kids engage in art activities over time, their fine motor skills improve.

Scribbling Is a Precursor to Writing

Babies and toddlers begin by scribbling randomly, back and forth. The more they scribble, the more they are able to control the crayon and its movements across the paper. As children learn to control their scribbling, they make a wider variety of shapes, eventually making all the shapes necessary to write the letters of the alphabet— any alphabet.

Art Develops Problem-solving Abilities

Open-ended, process-oriented art is nothing but an endless opportunity for making choices, coming to conclusions, second-guessing decisions, and evaluating results. Children become more comfortable with uncertainty and remain flexible thinkers, which is key for creativity and confidence. And the more experience they have with a variety of materials and techniques, the more likely they are to try new combinations and ideas.

Art Helps Kids Understand Themselves and Their World

Children absorb incredible amounts of new information, and they need to process what they have learned in a safe, reflective way. Art allows them to explore feelings

and deal with both daily and significant events. Art materials provide a safe outlet for emotions. Feelings and ideas can be reduced to a manageable size and manipulated as desired. Movement, image, color, line, and imagination all help children express themselves in a multidimensional way—a way that words may not be able to do, or that may be more comfortable for them than words.

When we encourage our children to explore art, we encourage them to master themselves, their bodies, and a variety of tools and techniques. We give them many ways to express themselves. As parents and teachers, we can offer an environment where it is safe to experiment and create, where questions are encouraged and children have free access to the materials they need and enjoy. We do this not to produce career artists but to raise children who are confident and comfortable with their creativity in whatever form it takes.

Art Helps Kids Connect

Art is an equalizer, helping create a common ground for children who don't know each other and who may or may not be interested in the same things. It can help

people of all ages, races, abilities, and even languages engage in a shared (and generally mutually loved) activity.

The path to an art-filled life involves an open mind, a few simple tools, a bit of preparation, and an exploratory approach. It's a path anyone can take at a pace that suits you and your family. Some of you will read this book and meander down the path, trying out a few new ideas here and there. Others will sprint along, adopting new ideas as quickly as you read about them. Either approach is fine.

It is my sincere wish that you will take the information, ideas, and activities in this book and use them to have fun; explore art as a family; and encourage your children's creativity, self-confidence, and visual literacy. Happy art making!

Commit to Art

Are you ready to embrace art and creativity and to do your best to foster and encourage them? Consider creating a fun family pact that commits everyone to an artful life.

MATERIALS

- · Poster board or paper
- · Drawing tools such as markers, pens, crayons
- · Collage items (optional)

INSTRUCTIONS

1. Write this pact on a piece of poster board or paper, changing the words to suit you and your family. You may want to write each word in a different color, draw pictures that represent your family's creative goals, or glue decorative collage items around the edges. Get everyone involved.

 Our family hereby commits to making art and creativity important parts of our daily life. We will do our best to encourage and honor each other's creativity; to

have fun exploring art supplies; to express ourselves and our ideas freely; and to add more color, joy, and artfulness to our lives.

Signed . . .

2. Have all family members sign the pact. Prewriters can add a handprint or a scribble signature.
3. Hang your pact where everyone in the family can see it every day.

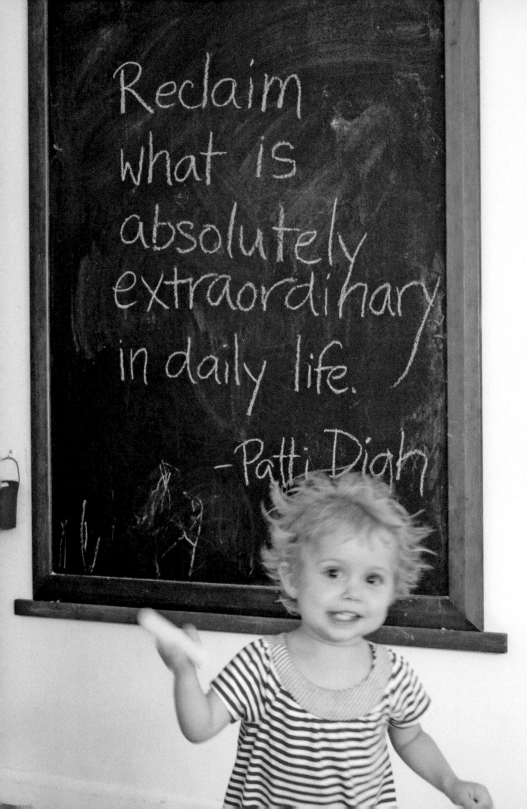

part 1 | preparing for art

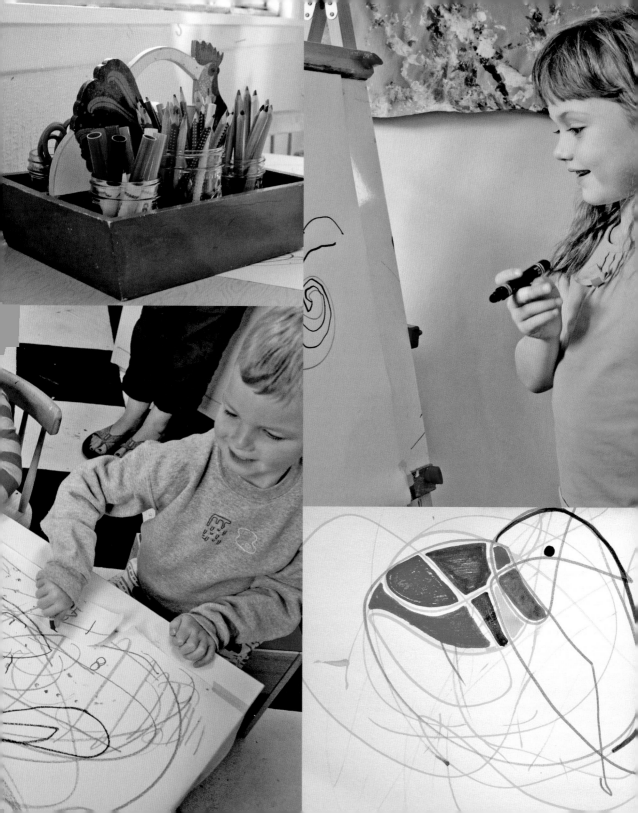

1

An Exploratory Approach to Art

Free the child's potential, and you will transform him into the world.

—Maria Montessori

It is said that all children are born creative. Unburdened by the prejudices and self-doubts of an adult, a child has an open, questioning nature; a willingness to try new things; and a desire to explore the world. Children create by expressing their bodies' movements, their feelings, and the potential of any art materials at their disposal.

The creativity of young children is pure and spontaneous, usually without a lot of internal or external direction. As children grow older, their art making and creativity are influenced by a variety of factors, such as their physical environment and developing understanding of it; the materials they use; their day-to-day experiences and memories; their attitudes, growing interests, feelings, and ideas; and their developing motor skills. This makes the art process more complex and purposeful.

As parents and teachers, we want these external and internal factors to be positive and support creativity in art and life as our children develop and become more deliberate in their thinking and art making. We play a crucial role in helping them hold on to the creative spark they were born with. We can do this by encouraging the open-ended exploration of their world, presenting them with art materials and activities that are developmentally appropriate, and talking to them about their art in a way that engages and inspires them. We will cover these simple steps in the chapters that follow.

Understanding Process Art

The freedom to experiment and the encouragement to do so are especially important to the development of creativity. That's why I believe strongly in process-oriented art, which is about the open-ended exploration of materials and techniques. Because there is no right or wrong way to make art with this approach, it promotes flexible thinking, instills a willingness to take risks, and builds confidence. Children become confident in their creativity and problem-solving abilities, and they learn through experimentation and the observance of cause and effect. If I mix these two colors, what will be the result? If I sprinkle salt on the painting, how will it look? Can I make the sculpture as tall as I am, or will it fall down? What if I try it this way? Repeated investigation of and experimentation with art materials help to develop creative thinkers.

> Creative activity could be described as a type of learning process where teacher and pupil are located in the same individual.
>
> —ARTHUR KOESTLER

Most of the activities in this book are process-oriented. They are about exploring the creative process and your own creativity as well as learning about materials, tools, and techniques. This is opposed to the overused practice of making art with an end result (often teacher imposed) in mind, which cuts off the potential for both creative exploration and whatever the art or craft could have become.

To engage in process art, I usually start children off with a material (watercolors) or a technique (collage) and go from there. There are so many variables at work at the beginning of an art project—the materials, the tools, the surface, and most important, the child. When my oldest daughter begins to do art, she brings a whole set of experiences and expectations as well as her current mood, interests, ideas, and skill level to the process. Add in whatever materials I have made available or she seeks out, and the possible variations of how the project will proceed, let alone look like when it is finished, are endless. This is the way it should be! This is process-oriented art in action. So instead of offering two paper plates, three cotton balls, two googly eyes, and instructions for assembling them the "right" way, give your kids a few art materials (such as tape, paint, and canvas); some encouragement; and possibly a suggestion for

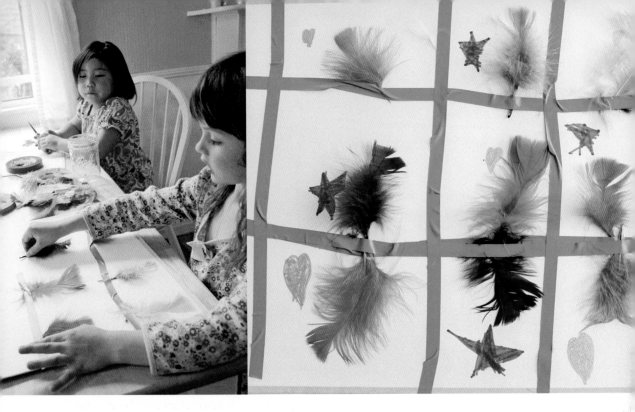

getting started ("Would you like to put some tape on the canvas?" or "Are you going to use big pieces or little pieces of tape?"). Then step back.

Your job, as a parent to these creative beings, is to facilitate their art experiences— to make materials and a space for projects available. Your job is to guide them gently when guidance is called for and to step back and simply watch when it isn't. Your job is to say, "Wow, look at that design! I see zigzag lines and circles," or "Can you tell me about your painting?" or to ask what-if questions ("I wonder what would happen if you painted over your crayon drawing with these watercolors?" or "What if you glued those buttons to the wood?") Your job is to hang the finished painting on the wall with pride or to help your child wrap it up as a gift for Grandma or a teacher.

Your children's job is to create. To use the tools and materials that

The field of creativity that exists within each individual is freed by moving out of ideas of wrong-doing or right-doing.

—ANGELES ARRIEN

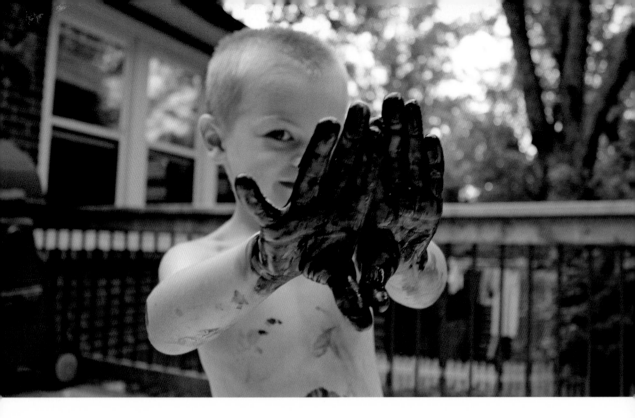

are available in a way that feels right to them. To see what happens when they roll paint-covered marbles around on paper. To scribble and draw and ascribe meaning if they like—or none at all if they don't. Their job is to see what color yellow, red, and green make when mixed together. To squish the paint between their fingers if they need to or to keep the paint from touching their skin if they'd rather. To draw as big or as small as they can. Your children's job is to explore the potential of the art materials and tools and their own bodies. To do it the same way ten times in a row if they need to or to do it a different way each time if that's what they feel like. As they explore the potential of art this way, they will gain important creative skills while, most likely, having lots of fun.

Match the Art to the Child

Process-oriented art is developmentally appropriate for all children, but especially for younger children. Regardless, understanding children's developmental stages

will help you plan art activities that are just right for your little ones. Keep in mind that all children are unique, and even two kids of the same age and gender will approach an activity in distinct ways or prefer different activities.

Maia loves to work big and will generally choose an action painting activity over anything neat, small, or confined. She can and does work small and detailed, but given the choice, she will jump in and splatter the paint, use her whole body, work big, and be bold and expressive. She's the same in everyday life. Her good friend Marlise, who is the same age, makes small and careful drawings, usually preferring to stay neat and clean. She's an enthusiastic artist as well and has been exposed to art activities from toddlerhood just as Maia has (they were in my first toddler art group together), but she has a different temperament and preferences.

One child may prefer to draw detailed scenes; another will paint abstract designs even after mastering realistic images. One child may seem to lose interest in drawing for a while as he masters a new skill, such as writing, whereas another will

work on both side by side, labeling her images and drawing pictures to illustrate her stories. Many children go through phases of being intensely interested in certain materials, tools, or activities and not in others. You can encourage and facilitate whatever the current interest is, while still offering other opportunities. Also, some children may prefer not to get messy or dislike the feel and texture of paint, preferring to use a brush rather than their hands and cleaning paint off of their skin as soon as possible. This is usually a stage they go through, although it can be a preference that remains throughout childhood (very rarely, it can be an indicator of a sensory processing disorder).

You know your own child best and are likely to know his preferences and abilities. If you are new to art, you will explore together and get to know his preferences in time. Even after you know that your child likes to work big, that doesn't mean you should never offer something different for him to try—like occasionally putting out some 3" × 5" index cards and a fine-tip pen. Just because he gets ecstatic at the idea of rolling paint onto a full-size sheet outside, it doesn't mean he won't enjoy or learn from the opportunity to draw small. Children need the opportunity to try different ways of making art, especially as their preferences may change over time.

Ages and Art

As children grow, they go through a series of developmental stages in drawing, painting, and sculpture. Although every child is unique, there are enough similarities across ages that we can generalize and say that a two-year-old can and should scribble, and a three-year-old will begin to master cutting with a pair of child scissors. Some children may begin drawing realistic images before age three, whereas others may continue with abstract art for another couple of years. While children of all ages can work together on the same projects, you may want to offer some projects specifically geared to the younger or older ones. You will likely plan different kinds of art to do with your six-year-old than with your two-year-old. That's not to say there aren't some activities that they can enjoy (free painting, collage, and so on) both at their own level and together. You can offer variations of a project that will fit their respective skill levels and developmental stages. This section offers some suggestions for age-appropriate planning.

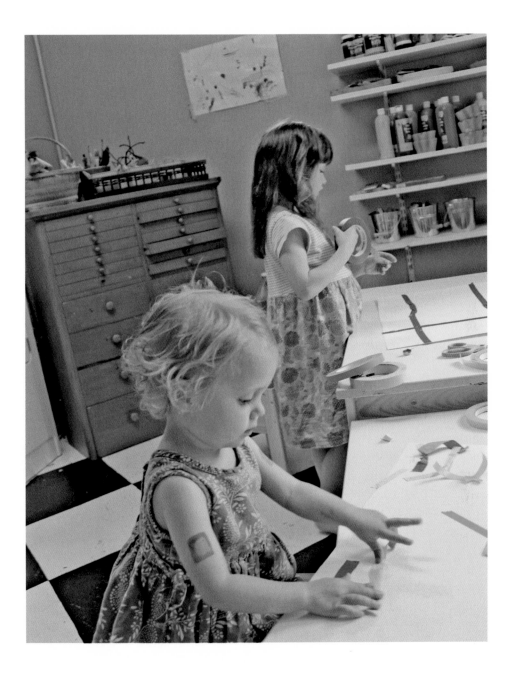

One- to Two-Year-Old Children

You can start offering a crayon and paper to your baby at ten to twelve months while she is sitting in a high chair. Keep an eye on her, because she will taste the crayon. This is normal, as babies and young toddlers explore the world with their mouths, but watch closely so she doesn't eat the crayon or choke on it. Move her crayon hand back to the paper and say, "Draw on the paper. Keep the crayon on the paper." Repeat, repeat, repeat. (Do so in a neutral tone; otherwise, your child may keep putting the item in her mouth just to see your funny reaction.)

One-year-olds can draw with crayons, markers, colored pencils, and chalk. They can paint with liquid watercolors, finger paint, and tempera paint, and they can use their hands or a brush. They can have fun with playdough, although they will just poke and squeeze it at first. Toward age two, they will like stickers and tape. Two-year-olds can begin to make cuts in paper if you show them how to hold and use child scissors (under close supervision, of course). They paint and draw with their

whole bodies. Use only nontoxic, washable art materials, as little ones are likely to put any material in their mouths or get it all over their bodies (our skin is our largest organ and absorbs materials that touch it). You can put your child in a high chair or booster seat to help contain him and the mess during art sessions, but he will do best if allowed to stand while doing art. Set up art materials at a toddler table, coffee table, or easel, or tape a large sheet of paper to the wall or fridge. Children are often enthusiastic at this age, but their attention span can be short—between five and fifteen minutes is normal. The scribble reigns, abstraction is everything, and the process is paramount.

Three-Year-Old Children

Children have more control over their bodies at this age and possess finer motor control. They will continue to scribble and produce abstract art, but they may also begin to draw some realistic images, starting with enclosed circles and moving on to mandalas (circles with lines radiating inward or outward), faces, people, and suns.

Their attention span lengthens somewhat; although they will sometimes just want to work for ten minutes, they may work for half an hour or more at other times. They also understand rules, such as no drawing on the walls, and can help clean up afterward.

Besides the art materials she used at ages one and two, the three-year-old can also begin to master scissors (although she probably started trying them at two) and can better understand the relationship between glue and paper and making things stick (rather than just squeezing out a puddle of glue as she did when she was younger). She will roll balls and snakes from playdough. She also has the patience and understanding to begin working on multistep projects and activities with your guidance. At this age, children may begin to name their drawings or even tell stories about them.

Four-Year-Old Children

Children are really mastering their bodies and sometimes their emotions at this age. They take more initiative and use what they have learned through other projects to create their own, often more complex, projects. Four-year-olds may begin to write letters or words; draw more elaborate and realistic pictures; mold more detailed playdough or clay creations; and expand their use of tools to a stapler, tape, and a hole punch.

At four, children often tell stories with or about their drawings. They use symbols, sometimes over and over, as a first attempt at realism and in place of a real object.

Five- to Seven-Year-Old Children

Children of this age use a particular way of drawing specific things (such as hearts, flowers, trees, and people) and repeat that method over and over. They often draw pictures with a baseline for the ground and grass, with everything lined up along this line. Another line at the top of the paper represents the sky, many times with a stereotypical sun.

As children start school, their social world broadens, and they are exposed to

other kids and other drawing and art styles. This may have the effect of expanding their art repertoire or restricting it to what everyone else is drawing. Peer and gender influences may become stronger. If all the other boys are drawing cars and Superman, your child may start repeating those images over and over. If all the other girls are drawing hearts, flowers, and rainbows, your child may do the same.

With the start of school, or perhaps enrichment classes and camps, this age group can also begin learning specific skills such as pottery or woodworking from experts.

Eight-Year-Old and Older Children

As children grow, they develop a stronger sense of self and their own interests and preferences. While they may have dabbled in a bit of everything when they were younger, they may now begin to have stronger inclinations for specific subject matter and mediums. While likes and dislikes may change over time, kids can delve deeply into their current interest, be it cartooning, sketching horses, making bead jewelry, or building robots.

As your children explore art over time, you will see them master their bodies and materials, discover their own interests, and try out new ideas. The thrill of watching your child draw his first face, tell his first story about a painting, and create his first multistep, self-initiated sculpture is unrivaled. You are raising an artful child! Enjoy the process of watching this creative being unfold artwork by artwork, stage by stage.

What Is Process Art? Why Is It Creative?

MaryAnn F. Kohl

You may have heard it said, "It's the process, not the product." This is delightfully true of young children exploring art materials and how they interact. The value of process art is in the exploration and discovery rather than the resulting product. The latter may be interesting and ultimately even useful or important to a child, but the greatest benefit of her art exploration is in the experimenting and learning that went into the doing. Products are often an adult expectation, and once kids know they can explore and discover on their own, they no longer need to concern themselves with how things *should* look; they can concentrate more on how art materials behave. For example, a child may carefully mix all the paint colors of the rainbow, ultimately making a brown, smooshy painting. That painting may not be much to look at, but the process of creating it was exciting and interesting, opening up possibilities in thinking and decision making. What the child saw and learned while mixing those colors is irreplaceable. She will learn to expect to "make mistakes," which is nothing more than learning through trial and error—and through the enjoyment and excitement of discovery.

Providing the opportunity for children to make process art is as easy as allowing them to draw with crayons on blank paper or press gluey cotton balls on a paper plate. Something as basic as drawing on a blank surface is surprisingly important. Choosing their own drawing materials empowers them and opens their eyes to the world around them.

As children become confident in their exploration of art, they begin to see the product as part of the process. They certainly may wish to celebrate the outcome of their endeavors and find joy in the finished product: "Look what I made"; "This is for you, Mommy"; "I made this for Grandma"; or "This is for the wall!" We can celebrate right along with them. The product is the outcome of the process, an outcome designed and delivered by the individual child's

unique efforts. This is quite different from following step-by-step directions to "make something" that is held up as the preferred result.

Parents who respect children's ideas help them learn to think and solve problems for themselves. Children who feel free to make mistakes and to explore and experiment will also feel free to invent, create, and find new ways to do things. The side benefit is that having art in your home makes parenting more rewarding and fun, and it gives children a zest for imagining and learning that will last a lifetime.

Ways to Encourage Process Art

- Allow children to explore art materials. Crafts with directions to follow and planned projects are fine in moderation, but open-ended art should comprise most of a child's art experience.
- Provide a simple art area where children can create freely with materials that you keep accessible for them. Stock low shelves with tubs of supplies like crayons, glue, staplers, tape, scissors, colored paper, and collage materials. Allow independent access based on the age of your children. Older kids can have more materials and more freedom than younger ones, but younger kids can also work independently.
- Add paints and brushes and a tub of playdough to expand the possibilities.
- Collage invites exploration, discovery, and experimentation. Save odds and ends in plastic tubs or shoeboxes. Provide tape, glue, a stapler, stickers, and cardboard or heavy paper. Watch as children assemble and design their own collages with the materials on hand. Change the buttons to beads and see the collage take on a completely different look. Change the paper to cardboard, and again, it's a new experience.
- Show your appreciation of your children's creativity by displaying the art *they* choose to display. Many of their works will be experiments, and the final outcome may not be important to them. Accept their evaluations of their own work. Celebrate what they want to save, and let go of what they are through with.

2

Planning for Art

It is in rhythm that design and life meet.
—Philip Rawson

Having a sense of the art-making process goes a long way toward making the planning process easier, but introducing art into your everyday life can still feel overwhelming. Where do you start? This chapter offers a general overview of the planning process, from identifying where art may fit into your family's lifestyle to selecting and setting up art activities your kids will love.

Making Time for Art

Do you want to do more creative activities with your kids but aren't sure how to fit them in? We're all busy, but with a bit of planning, we can find ways to incorporate art into our day-to-day lives.

Take this scenario of a hypothetical mom. As usual, Marie scrambles to wake the kids and make sure they are dressed, fed, and out the door to get her six-year-old son, Jack, to kindergarten on time. By the time he's at school, Marie is already frazzled and just wants to sink into her chair with a cup of coffee and a bite to eat, but her two-year-old, Amy, who has been overlooked in the morning rush to get Jack to school, wants some of Mommy's attention and playtime. Marie responds

halfheartedly, then puts her in front of a PBS kids show on the computer while she cleans up the kitchen and does the breakfast dishes. Afterward, she and Amy run a couple of errands, going to the grocery store and storytime at the library. Back home, Marie puts away the groceries then slaps together a simple lunch before putting Amy down for her nap. Naptime is Marie's time to relax, catch up on e-mail and Facebook, tidy up the house a bit, and think about what she'll cook for dinner.

Too soon, Amy is up from her nap, and Jack is home from school. The kids are running around, and the house is noisy and chaotic. Marie starts to cook dinner and counts the minutes until her husband comes home from work. Dinner is followed by bedtime routines and stories until—bliss!—the kids are finally in bed. As Marie reviews her day, she realizes that once again she was not able to slip any art into her family's day. It just seems too hard to find the time.

Sound familiar? It actually describes plenty of my own days. If I don't plan for art, it often doesn't happen. But if I do, however simply or casually, it can fit seamlessly into our busy day. Here's the same scenario with a bit of planning.

Marie wakes up at her normal time, starts the coffee, and takes a quick glance at the to-do list she scribbled the night before. Among her other activities, such as buying groceries and going to the library, she was written:

- Drawing time with Amy after breakfast
- Set out paints for when Jack gets home
- Remember playdough
- Contact paper

So after the usual chaos of getting Jack to school, Marie sets out some paper and markers for Amy at the kitchen table and sits beside her with her cup of coffee and slice of toast. Amy scribbles away enthusiastically on sheet after sheet of paper. Marie doodles on her own paper while sipping coffee and talking with Amy. It doesn't last more than fifteen minutes, but it's enough for the two of them to reconnect after the morning rush and for Marie (and Amy) to relax a bit together.

Marie then sets out playdough on the toddler table for Amy to work with while she cleans up the kitchen and dishes.

When they head out to run errands later, mother and daughter are both in a good mood because their needs have been met. Marie chooses a book of art activities while at the library and picks up some transparent contact paper at the grocery store (for a suncatcher activity she wants to try soon with the kids).

After lunch, Amy goes down for a nap, and Marie uses the time to catch up on e-mail and tidy the house as usual. This time, though, after picking up toys, she sets up an art activity on the kitchen table for the kids to do when Jack gets home from school. She puts out paper, pours paint in small bowls, and adds Q-tips for a simple pointillism activity (see page 156).

The kids are excited to see the art materials and gravitate toward them immediately. They both work on their own versions. Amy jabs dots all over her paper, then paints with the Q-tips as though they are brushes. Jack makes a dragon, spells his name in dots, and tries making patterns out of the different colors. Amy moves on to the toddler table after ten minutes and picks up where she left off with the play-dough, bringing pretend food to Jack and Marie. Jack stays with his pointillism for almost an hour and is excited to show his father the paintings when he gets home.

When he finally segues to playing with Amy and they move into the other room, Marie cleans up the art materials and sets the table for dinner (which she has been working on as the kids painted).

That night, after the kids are in bed, Amy feels great that the day went so smoothly and she was able to fit creative activities into the day. Instead of being crazier and *more* chaotic, art seemed to help make the day easier. Everyone was happier. She glances through her new library book of art activities and jots down a few she'd like to try. She has the materials on hand for potato printing and thinks she'll set that up tomorrow afternoon.

With just a little planning, Marie was able to add the creative activities she believes are important to her family's routine. The course of the day was not significantly altered, but the feel of it was.

It's not hard to add art. Your plan can be as loose or as structured as you like—whatever suits your family and personality. Families, of course, vary tremendously. You may be a single parent; you and your spouse may both work outside the home; you may both work at home; you may homeschool your children; you may have one child or five; you may have a special needs kid. If there's one thing we know about

modern families, it's that they are a diverse lot. But with intention and just a bit of preparation, you *can* add art into your family's life.

Identify Where to Add Art

When you first decide to add more art to your family's life, you may want to identify when or where it will fit best. Here are some ideas.

Squeeze It In

Are there any gaps in your day where it would be possible to incorporate some art? Even five to fifteen minutes here or there may be a good starting point. Perhaps when your child gets home from school or before or after a family meal. Transition points between one activity and another (lunch to nap) or between one location and another (school and home) are often good times for incorporating some art. Not only can art time smooth the way for changes during the day, but it can often fit in relatively seamlessly.

Put It on the Calendar

Consider making art time a regular part of your routine, whether you have a daily drawing session after breakfast, a weekly family art fest, or a recurring art-based playgroup. If you put it on the calendar, you are more likely to find a way to make it happen, and family members have a chance to look forward to and plan for it.

Occupy the Kids

When you are busy with housework, meal prep, or work-at-home tasks, it may be a good time to set up a low-key art activity for your child that doesn't require your involvement, such as playdough play, drawing, stickers, collage, or sculpture (the materials used depend on your child's age, especially since this would be a less-supervised art time).

Let Your Child Decide

Art time doesn't always have to be planned. By creating a simple, dedicated art space (discussed in the next chapter) stocked with basic materials, you create the opportunity for your child to add art to her own day whenever the mood strikes.

Be Spontaneous

Be open to unplanned art opportunities. Whether you or your child initiate it, spontaneously responding to an interest or some available time can result in memorable art experiences.

Find Ideas and Art Activities

Once you have an idea of how and where you will fit art into your life, you'll want to seek out activities and projects that suit your family. The resources section at the back of this book provides detailed listings. Here are a few highlights.

Books

You can find many ideas for art activities in books, including this one. Other great resources include any book by MaryAnn F. Kohl, such as *Scribble Art, First Art,* and *Preschool Art;* Susan Striker's *Young at Art;* and other art activity books. Browse the bookstore shelves or ask your librarian to help you find some appropriate resources.

Magazines

FamilyFun magazine is full of crafty ideas to do with children; although it is geared more toward crafts than art, it does include both. Other parenting magazines sometimes have ideas as well. Digital magazines are another option. *Action Pack* is an e-magazine full of creative activities for kids to do themselves or with your help.

Blogs

There are so many ideas online. As I surf the Web and read other blogs, I often see activities I would like to try with my daughters or projects that inspire new ideas. Many blogs besides mine are full of arts and crafts activities for children: *The Crafty Crow, Inner Child Fun, Childhood 101,* and *TinkerLab,* to name just a few. Use one or more of these as a jumping-off point to find others.

Other Websites

Disney's FamilyFun website (www.familyfun.com) has many craft ideas for children. Pinterest (www.pinterest.com) is a social bookmarking site that allows people to share images, ideas, and links that they find on the Internet; it is a treasure trove of arts and crafts ideas.

Art Materials

Use the art supplies themselves as inspiration for an activity. Sometimes I'll brainstorm activities I can do with a particular material, either a new one or one we already have in the studio, and come up with new (to me) ideas, concepts, and combinations. Some work out well and some don't, but the experimenting is fun.

Gather Materials

Once you have a project in mind, start preparing mentally and physically by setting aside the time for it and making sure you have everything you need. Gather materials together from around the house; add those you don't have to your shopping list and pick them up when you're out doing errands.

Set Up the Activity

Finally, set up the art activity, whether you quickly pull the playdough and tools out of the drawer for some modeling play after a meal or put out a more elaborate painting activity for when your child comes home from school.

You may also want to consider strewing as a way to plan for art. Have you heard the term? *Strewing* is a great way to encourage creativity in a low-key way and entice your children to create with new materials in different areas of the house. To strew, simply set out things—library books, art materials, musical instruments, whatever—around your house where your kids are likely to come across them. (Note: This is more about strategic placement than adding to existing clutter. It works best if the surrounding area is at least somewhat neat.) You can't guarantee that your

children will be interested in what you put out, but chances are they will be inspired to try something new. Here are some ideas to get you started:

· Lay black poster board on the art table with a white crayon or cup of white paint.
· Leave playdough and some kitchen tools (such as a rolling pin, potato masher, or garlic press) on the kitchen table.
· Set a challenge drawing paper (see page 226) on the coffee table alongside a cup of markers.
· Leave window crayons or window markers in a cup on the windowsill.
· Add a sheet of blank address labels and some markers to your child's art table or desk.

- Tape a series of 2" × 2" pieces of watercolor paper to the art table next to some watercolor paint, a brush, and a cup of water.
- Sort a variety of dried beans, rice, and pasta into muffin tin sections; leave the tin on the table next to some glue and a piece of card stock.
- Leave a sketchbook and some colored pencils in a basket on the front porch.
- Tape a large sheet of butcher paper to the living room floor and leave a basket of crayon rocks in the middle.

After strewing, stand back and watch what happens. Chances are your children will be drawn to the art supplies naturally. Even if they don't notice them or seem

to ignore them, you don't necessarily need to say anything. It may take some time before they give the materials a try. If they come to you looking for direction, you can always say, "Hey, there's some paper and colored pencils on the back porch," or "I left you something to try on the coffee table," and leave it at that. There's no need to push it if they're not interested; be casual about it.

How I Plan for Our Art Activities

I'm a planner sometimes, a spur-of-the-moment gal other times, and usually somewhere in between the rest of the time. I can be overly ambitious in my planning and I don't like to be tied down to a schedule. So ultimately any planning I do is more for inspiration, ideas, and a gentle kick in the butt rather than for a plan with a capital *P* that I follow through to the letter.

Sometimes I sit down with a stack of books (perhaps *Scribble Art; The Preschooler's Busy Book; Roots, Shoots, Buckets & Boots;* and my childhood copy of *Making Things*) and thumb through them, making a list of activities I'd like to try with my girls or with the art group. I also find a wealth of ideas online, whether on other blogs or on Pinterest.

This list can get really long! I may find myself jotting down almost every activity I come across because I want to try it all. But then I go back and put a star next to the ones that (1) I *really* want to try, (2) I think my daughters will especially like and are developmentally ready for, and (3) I have all the materials for. Generally, I try to narrow down the list to activities that fit at least two out of these three criteria.

Next, I'll put the list up on the fridge where I can see it every day. I'll use it as inspiration and a reminder of the activities I'd like to try. I might decide to do one of them in the afternoon and begin gathering materials. Sometimes I'll plan an activity a day for a week. Here's an example:

- Monday: Make our own postcards
- Tuesday: Tissue paper suncatchers
- Wednesday: Salt painting
- Thursday: Collage
- Friday: Observational drawing

- SATURDAY: Make teddy bear bread
- SUNDAY: Shaving cream marbling

That's usually enough to get us started. We may do only four of the seven activities and probably some that I didn't think of, but it still helps to have the list. If I'm not feeling this organized, I may just add an idea or two to my regular to-do list.

My motto is "Don't let planning get in the way of the art." Which is more important? That everything is well and properly planned? Or that art gets made? (Yes!) So, sometimes it's good to *just do*. The art will take care of itself. And if the project is flubbed, as sometimes happens, or it just doesn't work out as planned, we learned from the experience, right? We'll probably be able to try it again more successfully. Every failure is a learning experience, so it's not really a failure. And we can always talk about what we learned from the project with our children.

Your planning may look different from mine. But I hope that one or more of the methods in this chapter resonate with you.

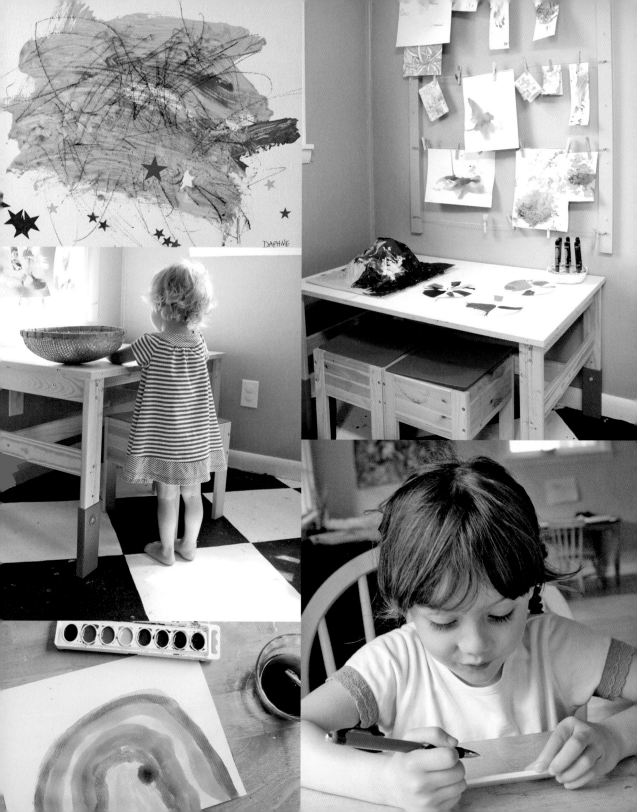

3

Making Space for Art

A person's a person, no matter how small.
—Horton the elephant

We give our children many gifts by making art and creativity a priority. When we do parent-directed art projects with our kids, we give them our time and attention. In those hours, we can introduce new materials and methods and just share the joy of the process. But perhaps even more precious is the gift of space and freedom. We can make a place in our home where our children can explore art materials and techniques guided only by their own imaginations.

To make such child-led art possible on a regular basis, you need to carve out some space in your home that's dedicated to art making—a place your children can come back to again and again, a place that is stocked with the tools and materials they need for creating. A dedicated art space is great for kids, because it gives them permission to create art whenever the mood strikes. It invites them to make art and confers a sense of ownership. The space is there for them, and they can use it as they like (within family boundaries, such as no drawing on the walls). Also, when children approach the art space of their own volition and create something on their own, they're artists. They own their art, their artistic mojo, their space. What confidence that engenders!

Elements of an Art Space

When creating your art space, you will want to consider how to make it accessible, appealing, and ultimately usable. You'll need a table or an easel, art materials, storage and organization solutions, a place to dry art projects, task lighting, and ways to protect surfaces (table, floor, and clothing) if necessary.

A Work Space

Your first step in creating an art space is to decide on a location. You don't need a separate room or even a lot of space. A child's art space can be carved out of an existing room or even a closet. All you really need is a work surface somewhere.

If you will be using a multipurpose table, such as the kitchen table, then you should ideally make a dedicated space close by for your art materials, whether a cupboard, shelf, or a rolling storage caddy. Keep a waterproof tablecloth or drop cloth handy to spread over the table anytime you want to work on messy projects. Plastic art trays work as well.

If you will be dedicating a special table to art, you can leave out materials and projects in progress and hang a wire or corkboard above the table to display finished pieces. Consider the age of your child when choosing a table. Toddlers and preschoolers often stand and use the whole upper body when drawing and painting, so it's especially important to have a table that's the right size for them. If you don't have a child's table, a coffee table is the right height for a toddler or preschooler to work at standing up. A child-size chair will allow him to sit and work when desired. We use and love the SANSAD children's tables from IKEA for our studio. They have a wipeable laminate surface and adjust to three different heights so they can be raised as kids grow. A school-age child can work at either an adult table or a desk as well as a smaller one.

Although the flat surface of a table is more versatile and allows you to keep more materials at hand, easels are also a good choice for young artists. I like to provide both. Our easel, by Melissa & Doug, is adjustable so it grows with our children. (See the sidebar on page 32 for tips on picking the perfect easel.)

If you plan to dedicate a closet to art, you'll need to find a table that fits inside. If the closet is shallow, then consider a narrow one, such as a hall table, with the legs

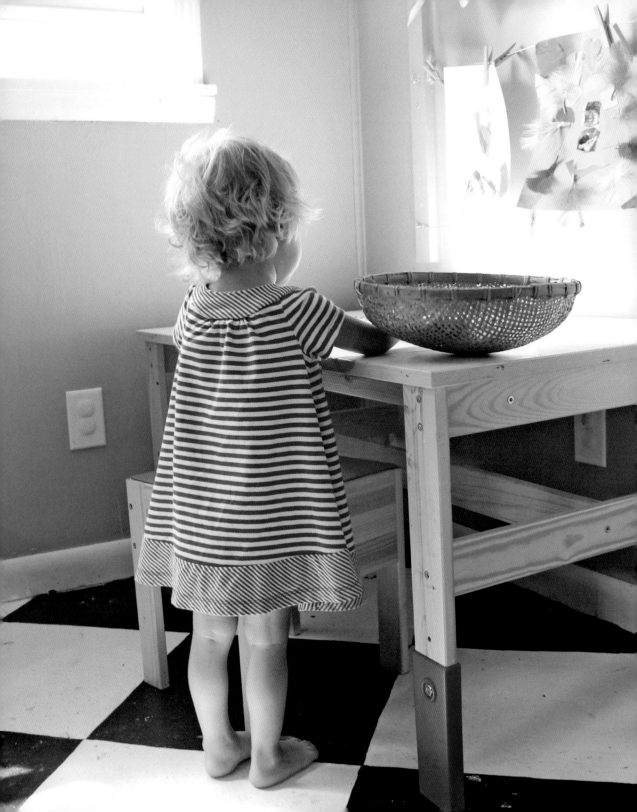

cut down; you may be able to find one at a yard sale or thrift store. Put a splat mat on the floor, and add a chair and adequate lighting. Take the doors down, if desired. You can put a wall-mounted easel on one closet wall and a chalkboard on the other. Hang a mirror on the third wall, possibly above the table, to increase the sense of space and light in the closet and to provide an additional "canvas" for painting or drawing (it's easy to clean).

If you have a corner of a room to dedicate to art, you can use many of the ideas for the closet studio, but you may have more space for spreading out. Are there shelves or a hutch you can use to hold art materials? Room for an easel? Wall space for a chalkboard? You can curtain off the art space if you like, either to hide the mess when desired or to create the feeling of a separate art room.

If you have an entire room, garage, attic, or basement you can turn into your family's art studio, you can do whatever projects you like and not worry about paint or glitter in the rest of the house. You can also close the door to shut out any disorder and keep out toddlers when you're not using it together.

When outfitting an entire room, you can use many of the ideas already mentioned but with the added luxury of space. What kind of floor does the room have? Tile or cement floors are the easiest to clean; carpet is the hardest. Will you allow paint-splattered floors and walls in your studio, or will you attempt to keep them clean? (We went for the low-maintenance, "paint-splattered studio" look.) If you are going to paint the studio walls, consider a high-gloss or semigloss paint finish rather

Choosing and Using an Art Easel

An easel is a wonderful, multipurpose art tool. It allows the artist to work standing up, using the whole arm and upper body when drawing and painting. An easel is easily moved to different rooms or even to the porch or backyard. Its small footprint doesn't take up a lot of space; a wall-mounted or table-top easel takes even less.

WHAT TO LOOK FOR

- It's durable and well made. Ideally, it will get a lot of use over several years.

- It's adjustable, so it can grow as your children do.
- It's double-sided, so two children can work on it at the same time or two different kinds of artwork can be done on the different sides (for example, chalk drawings on one side and paintings on the other).
- It has sturdy trays to hold paint cups and drawing materials.

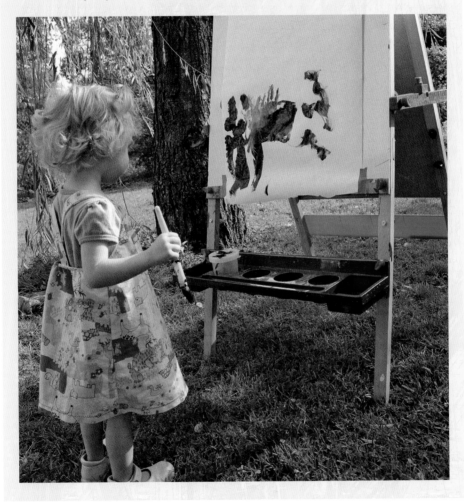

Ways to Make Your Own Easel

Making your own easel can be simple and inexpensive.

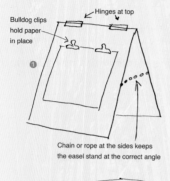

Hinges at top

Bulldog clips hold paper in place

Chain or rope at the sides keeps the easel stand at the correct angle

1. Plywood Easel

Connect two pieces of plywood with hinges along the top to make your own rudimentary easel. A length of chain or rope at the sides keeps it standing at the correct angle.

Cut along dotted line with X-Acto knife

Tape paper to side of cardboard box easel

2. Cardboard Box Easel

Cut a cardboard box in half diagonally to make an easy tabletop easel.

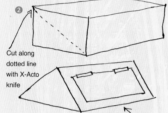

3. Pizza Box Easel

Use a pizza box for an even easier version of a tabletop easel.

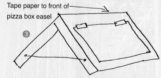

Tape paper to front of pizza box easel

Punch holes in cardboard with knife then string yarn between both ends

4. Clip or Tape Paper

Attach clips to the wall to hold a sheet or pad of paper or tape a large sheet of paper to the fridge indoors or a fence outdoors.

than matte for easier cleanup. Depending on the size of the room, you can have any number of the following items: one or more tables (one just for long-term projects might be nice or one for each child), an easel, plenty of storage for art supplies, a

display wall, a drying rack, a large unbreakable mirror, and perhaps a wall or door that you have converted to a chalkboard (chalkboard paint is readily available at hardware stores and some art supply stores).

Art Materials

Specific art materials are discussed in the next chapter. When setting up your art space, it's important to include supplies that are appropriate for your child based on her age, interests, and developmental stage. Stock the table with a few materials she can use without supervision or assistance. For a two-year-old, this may mean a sketch pad and some washable markers. For a five-year-old, it may include an art caddy with a variety of drawing, stamping, and cutting tools. The rest of the supplies can be stored nearby to switch out periodically with those currently in use. They can also be used on request or brought out when you are prepared to supervise an activity.

Storage to Hold and Organize Art Materials

You need some way to hold and organize your art materials so they're handy when you want them. An art or silverware caddy with a handle is useful, as is an art organizer on wheels, a collection of cups to hold pencils and markers, a lazy Susan (revolving tray), wall pockets, or a nearby shelf. You probably already have something around the house that you can use, or you can shop for a solution that works in your particular situation.

While it's important to keep art materials accessible, you also want a relatively uncluttered work space that encourages use. Extra materials can be stored in rolling storage drawers or a cupboard. (See the sidebar on page 37 for creative storage ideas.)

Drying Space

Children need a place to leave paintings and collages to dry where they won't be in the way. Install a drying wire by stringing wire or twine between two hook-eye screws or nails in the wall. Hang your artwork with clothespins. (Keep the wire flush against the wall rather than crossing the room to avoid safety issues.)

You can also purchase drying racks from some art supply stores, or simply use shelves as flat drying surfaces. We've even used stackable wire cupboard dividers to

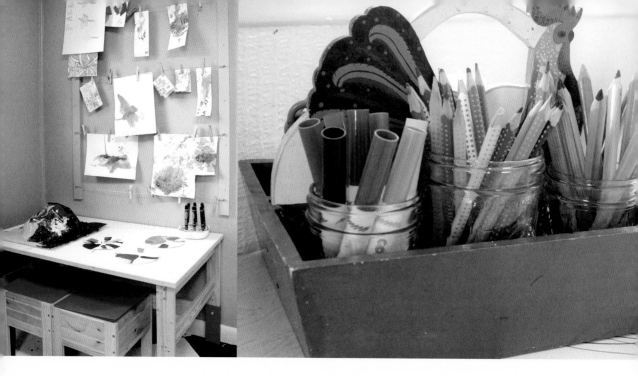

create extra drying space. The simplest option is to leave the paintings to dry on the table or the floor along a wall or in an unused corner.

Good Lighting

Every artist needs good light to work by. A swing-arm lamp or other task light is great if there isn't enough natural light. Even if your art space is near a window, you may want another light source for evenings or cloudy days.

Easy Cleanup

Whether setting up an art space or just an activity, plan with an eye toward cleaning up afterward. Consider putting down a vinyl splat mat, old waterproof tablecloth, or newspapers. Oil cloth or vinyl can be stapled to the top of the art table to make long-term cleanup easy. Keep an art smock or old T-shirt on hand, and have a wet towel or sponge close by during art activities for washing paint- or glue-covered fingers and for spot cleaning the table and floor.

This is probably the most important element of all. There's something to be said for a completely separate space, such as an art studio in its own room, garage, or basement, but that separateness needs to be balanced with the needs of the child and parent. If your child is older, both of you may revel in the independence and space, but a preschooler may need to be close and supervised (a toddler, definitely so). So if your young child is in the garage studio, you may need to be there as well. This can sometimes limit its use, so you may also want to set up a table or an easel in the main part of the house where your child can do less messy art activities—such as drawing, cutting, and using playdough—while you're close by.

Organizing Your Art Supplies

Here are some clever ways to organize your art materials. Some are from our family, and others were shared by artful parents on my blog.

Canvas Paper Holder

A wall-hung canvas magazine rack is a great way to store a variety of different papers. Buy a wall pocket, or sew your own, and hang it near your child's art table.

Kayte's Tape Holder

Artful parent Kayte came up with an innovative solution for her family's supply of colored masking tape. She slides each of them onto the rod of a paper towel dispenser, keeping them visible yet organized and easy to use.

Over-the-Door Shoe Holder

A clear plastic, over-the-door shoe organizer can hold a cornucopia of art supplies, from beads and pipe cleaners to ribbons and yarn. It can be kept in view, perhaps hung on a wall, or hidden behind a closed door.

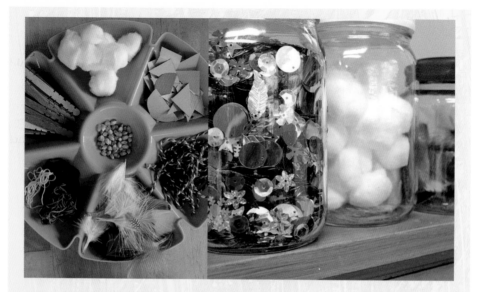

Candy or Mason Jars

You can also keep your art supplies organized and visible in clear mason or candy jars. We use mason jars to store ribbons, feathers, cotton balls, pom-poms, and beads.

Shawn's Chalkboard-Painted Stacking Boxes

Repurpose an outgrown set of wooden stacking boxes as art supply bins by giving them a coat of chalkboard paint. Artful mother Shawn writes catchy mantras on hers, such as "Life's fun. Get messy." Chalkboard paint (or chalkboard contact paper) is also an appealing way to label your materials or customize your storage boxes.

Compartmentalized Collage Materials

Keep an assortment of small collage materials ready to use by storing them in a divided container such as an hors d'oeuvres tray or an old muffin tin (both can be picked up inexpensively at thrift shops).

Accessibility with Siblings

So you've set up an art table for your four-year-old and want to stock it with paints, scissors, glue, and collage materials, but you're worried about her eighteen-month-old brother getting into it all when your back is turned. You don't want him to interfere with the four-year-old's artwork or space, and you're also concerned about safety and the mess factor. What do you do? Here are some ideas to give your independent preschooler or school-age child access to the art materials and tools she needs and wants right now, while keeping your toddler and your home safe:

- Put the washable crayons, markers, and paper on the art table, but keep the paints, glitter, and scissors higher up (on a shelf, perhaps), where the older sibling can reach them but the toddler can't.
- Have a regular art time for the older child while the younger one naps.
- Put together a box of materials just for the older child that the toddler can't open (possibly a storage box with a latching lid) or that is out of his reach.
- Keep the door to the room with the art materials closed. The older child can open the door, but the toddler cannot. Or use a childproof gate across the doorway.
- Encourage the older child to take responsibility for putting her materials away safely.
- Remember to do art with the toddler as well! He can use many of the same materials as his older sister but will have to be supervised.

Making Space for Messy Art

Messy art, such as finger painting or creating with papier-mâché, can be so much fun. Some early childhood development experts even believe that kids need the tactile experience of squishing paint and playdough. If you don't think your house has appropriate space for messy art, here are some ideas to try:

- Put a toddler in a high chair to confine the mess. Let her finger paint, draw, or paint with a brush. She won't be able to touch the sofa with paint-covered hands if she's strapped in.

Make and Decorate a Sign for Your Art Space

For ages 3 and up

MATERIALS

- Plain wooden plaque (available at big-chain art supply stores)
- Liquid watercolor paint in one or more colors
- Paintbrushes
- Magazines
- Scissors
- Glue or Mod Podge
- Picture hanger hardware
- Small collage items, such as buttons or action figures (optional)

INSTRUCTIONS

1. Paint the background of the wooden plaque with the watercolor paints.
2. Decide on a name for your space, such as Lara's Art Space, The Smiths' Studio, or Sadie and Justin's Drawing Table. Or you can put a mantra—like "Make Art Every Day"—on your sign.
3. While the paint is drying, look through magazines to find the letters for your sign. An older child can do this on his own, but a preschooler might need help finding the letters.
4. Cut out the letters and arrange them in the proper order. When you're satisfied with how the sign looks, glue them down. Use a paintbrush to spread the glue or Mod Podge evenly.
5. If you are using decorative collage items, glue them on now.
6. Paint a layer of Mod Podge or watered-down glue over the entire sign for protection. Let dry.
7. Hang your sign, using picture hanger hardware (or a glue gun and ribbon).
8. Stand back and admire. Take a photo of your young artist(s) next to the sign!

I like the unfinished wooden plaques available at big-chain art supply stores, but you may prefer a small stretched canvas, a piece of poster board, or just a piece of natural wood, such as driftwood. If you're using canvas, paint with tempera or acrylic paints rather than watercolors.

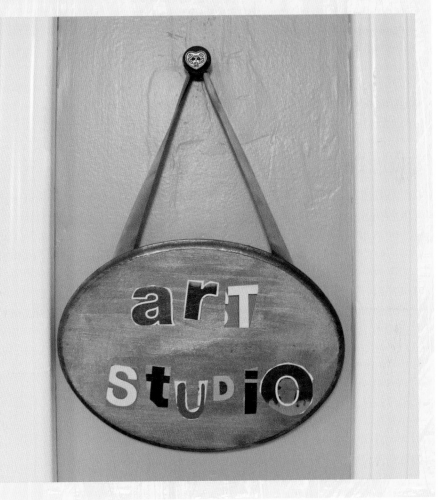

- The kitchen is generally easier to clean up than the rest of the house. Depending on the space available, you can put a child-size table in a corner or set up an easel for painting projects.
- If the weather permits, take your art materials out to the backyard, sidewalk, or playground. MaryAnn F. Kohl's *Big Messy Art Book* is filled with great art projects, many of which can be done outdoors.
- Give your child finger paint, bathtub crayons, or tempera paint, and let him paint or draw in the tub before he takes a bath. Afterward, wash the child and the tub as he bathes. Note: Paint can make the tub slippery. If you don't have a nonslip tub bottom, spread an old towel over the bottom first.
- Shaving cream feels like the messiest art project to a child, yet it is easy to clean up. Consider letting your child "draw" in shaving cream on a mirror or window (see page 200).

Farther Afield: Ideas for an Outdoor Art Space

Even with the best indoor art space, a change of venue can motivate you and your child. Nature provides new subject matter and is stimulating to the senses. If the weather is nice, you can let your backyard, balcony, or a nearby park be your art studio. Take advantage of the outdoors to work big, be messy, and shed inhibitions. Let your children paint with shaving cream and tempera paint on a cardboard box, drip and splatter paint on poster board, paint the house or driveway with a bucket of water and a large paintbrush, paint rocks, draw body outlines on the sidewalk with chalk, paint *on* their bodies, and use flowers or pine boughs as paintbrushes. Remember you can always let the kids wash off under the hose or in the wading pool before they come back inside.

For your outdoor art space, consider one or more of the following:

- A TABLE. Set up a table outdoors and take out a portable caddy with your art supplies. When you are finished creating or when rain threatens, it's easy to bring the art caddy back inside.
- AN EASEL. Bring your easel outdoors and paint en plein air. You can also set up a makeshift easel by taping a large sheet of paper to an outdoor wall or a fence.

- AN OUTDOOR CHALKBOARD. Whether you paint a large sheet of plywood with chalkboard paint or just use the sidewalk or driveway, drawing with chalk outside is a classic.
- A PORCH, BALCONY, OR DECK STUDIO. If the porch or balcony is covered, you can outfit it much like an indoor art space, at least during the warmer months.

Keeping It Real

It always sounds easier on paper than it is in real life. When doing art with children, as with much of parenting, there will forever be messes to clean up and accessibility

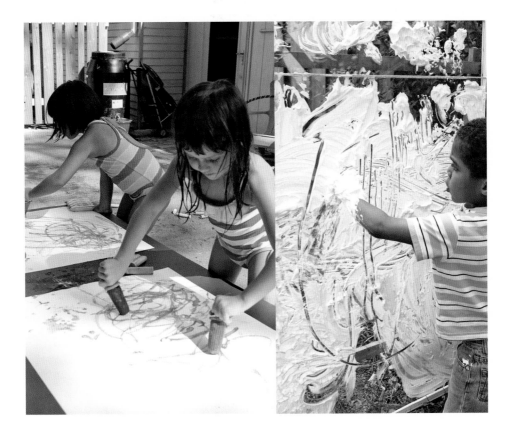

challenges to consider, especially when you're balancing the needs of older and younger siblings. The use of the space will likely ebb and flow, depending on your children's interests. Keep an open mind, stay flexible with expectations, and remember why art is important.

Your children's art space will likely get varied use over time; don't be surprised or disappointed if it's ignored for long stretches or used for science experiments or tea parties instead of art. Other times, it may be used day in and day out. If the art space is not being used, there are a few things you can do:

- Stand back and understand that it will probably be used again. Don't pressure your kids.
- Clean and organize it (especially if your children are young). An inviting space may be all that's needed.
- Casually add an interesting new art material or two, then stand back and watch as your children are drawn to the table.
- Take your art elsewhere (perhaps try a project outside or at the playground).

If a child doesn't seem excited about making art right now, think about what he *is* excited about and how he can enhance that interest creatively. Cars? Maybe create an activity mat together for car play using butcher paper and markers or paint. You can even add buildings made of boxes or make stick houses and "towns" outside.

Is your child more interested in dressing up? Cut out a mask or crown from card stock and leave it on the art table next to feathers, sequins, and a squeeze bottle of glitter glue. Do a fabric-scrap collage, or use the fabric scraps to "dress" a paper doll. It usually doesn't take a lot of brainstorming to find ways to explore your child's current interests in a creative way.

You can also just take a break from art for a while. Abstaining from art projects doesn't mean you can't be artful in your daily life. Cook pretzel shapes together. Talk about the patterns and colors of leaves, flowers, and rocks during your nature walks. Check out illustrated children's poetry books from the library or thick tomes of underwater photography. Take excursions, whether to the zoo or the art museum. Sign up for a class to try something new, such as music, pottery, dance, or gymnastics. But above all, follow and encourage your kids' interests.

Take Your Time

Creating and stocking an art space for your children and family may take some time. There's no rush. Add elements as you have the time, inspiration, and resources. Regular access to simple art materials and creative opportunities are more important for children than an expensive art studio. Create a space that suits your family, your home, and your budget; and stay flexible as your needs and the space change over time.

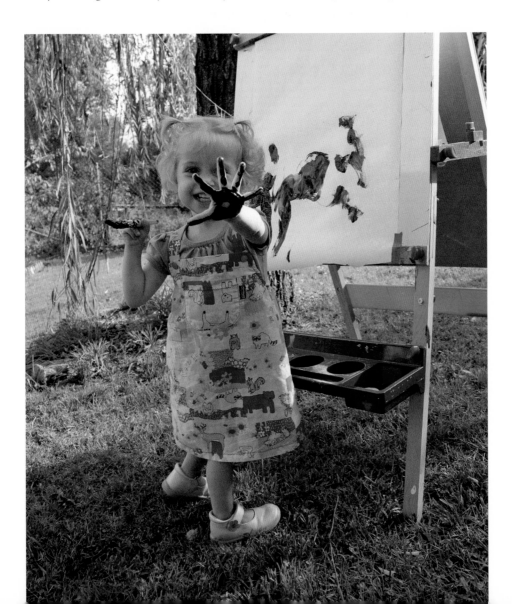

Sew an Easy Art Smock from a T-Shirt

An art smock will protect your child's clothes from paints and other messy art materials. An open back makes this smock especially easy to put on and take off, and the T-shirt material is soft and comfortable.

MATERIALS

- T-shirt (Choose one that will be large on your child but not overwhelmingly so. A women's small or extra-small may work well for a toddler. As a guideline, choose one that will reach at least midway down the thigh.)
- Scissors
- Pins
- Extrawide, double-fold bias tape
- Sewing machine
- Thread to match bias tape
- Fabric for decorative appliqué (optional)
- Fusible webbing (such as Pellon Wonder Under) for decorative appliqué (optional)

INSTRUCTIONS

1. Cut off the bottom hem of the T-shirt, then cut straight up through the middle of the back. Trim the two bottom corners into curves.
2. Pin the bias tape along the entire unhemmed edge of the shirt with the narrow side of the tape facing out. Leave several extra inches at both sides of the top (this will be used to tie the smock on).

3. Sew along the entire length of the tape, keeping your seam along the edge of the narrow side. Fold the raw edges in before sewing the two ends of the tape.

4. If desired, add a decorative appliqué. Following the manufacturer's directions, iron the fusible webbing onto your chosen fabric. Draw or trace your image on the reverse side of the fabric and cut it out. Pull off the paper backing, then iron the fabric appliqué onto the front of the art smock. Use a zigzag stitch to sew along the edges of the appliqué.

VARIATION

If you don't sew, you can still make an open-backed smock from a T-shirt. Simply cut the back of the shirt as in step 1 and put adhesive-backed Velcro on for the closure. The knit material will not unravel if left unhemmed.

4

Gathering Art Materials

The artist is not a special kind of person; rather,
each person is a special kind of artist.
—Ananda Coomaraswamy

I feel privileged to live now, when there is such a wonderful variety of art supplies to choose from for children. There are crayons of all shapes, sizes, colors, and ingredients: soy-based crayons, wax crayons, good old Crayolas, newfangled crayon rocks, triangular crayons, thin crayons, stubby crayons, multicolored crayons, even crayons shaped like stars and cars. And the selection isn't limited to the humble crayon. There's a vast array of papers, paints, collage materials, modeling materials, markers, and pencils. The number of options is astounding. It can overwhelm anyone who is just beginning to buy art supplies for their family.

I will help you select some good, basic materials that every child should have access to, such as markers, paper, and paints. When we have the basics under control, we'll go over some of the fun-but-optional extras, such as googly eyes, multicolored feathers, and glitter. Finally, we'll talk about affording it all and building your stash slowly over time. See my specific art supply picks in the resources.

Paints
Tempera Paint

If I could offer just one art material to children, it would have to be tempera paint. Nothing says *art* as much as painting, and no material is as universally loved as paint. Tempera, also sometimes called poster paint, is the classic childhood paint. It's thick, and the color is rich and opaque. It is widely available, but quality varies as much as the selection. Make sure to look for labels that say nontoxic and washable.

Watercolor Paint

All the things you can do with watercolor paints! There is watercolor resist, wet-on-wet and wet-on-dry painting, droppers and paint, marbling, shaving cream marbling, Easter egg dyeing, and more.

Watercolor paint is a translucent, water-based paint. It is usually used on heavier paper that can absorb and hold up to the extra liquid without buckling (watercolor paper works best of course, but card stock and poster board are okay as well). You can buy watercolor paint in several forms: cakes, tubes, and liquid. While each is used in different ways and for different purposes, you really need only one kind to start—all watercolors are inherently liquid, whether they start out that way or you add the water yourself.

Watercolor Cakes

This is the form that is familiar to most families—a row of colorful cakes lined up in a shallow case with a skinny brush. You dip the paintbrush in water first, brush the water over the cake to moisten it, then transfer the watery paint to your paper. Cakes are convenient and low mess, and they travel easily. They are best for ages four and up, as most toddlers don't understand the steps involved with the brush and water and will just mix all the colors into a muddy mess. Also, depending on the quality of the paints and the amount of water used, cakes can result in pale paintings that may not be satisfying to a young child. They come in a wide range of brands, prices, and levels of quality.

Watercolor Tubes

With tubes, you squeeze the thick pigment into a dish, add water, and mix. It's very easy and satisfying to paint with these "liquid" watercolors. I've used them with one-year-olds on up. Kids just dip their brushes into the watery but colorful paint and then apply it to the paper. You can dedicate a different brush to each color, so there is no need to wash out brushes between colors. Tubes are inexpensive—you can buy a box of them for as little as $7 or $8, and they'll last a long time.

Liquid Watercolors

I *love* liquid watercolors and have written plenty of odes to them on my blog over the years. They are liquid when purchased; you squirt some of the paint into a cup and use it as is (for intense color) or watered down. For ease of use and vibrancy,

they can't be beat, and the selection of colors is great. The biggest drawback is that they are not as washable as other watercolors, so you need to take more care with your furniture and clothes. At $3.39 per bottle, they can also be more expensive than other options, but they last a long time, especially if you dilute them. We sometimes use liquid watercolors in place of food coloring for homemade art materials, including playdough, and in science experiments.

Finger Paints

Finger paints are smooth and slippery—lovely for painting with your hands. They are generally used with specially coated finger painting paper, but you can also use them directly on a tray or tabletop or on regular paper. We sometimes use tempera paint for finger painting projects, but true finger paints have more of a gel-like consistency,

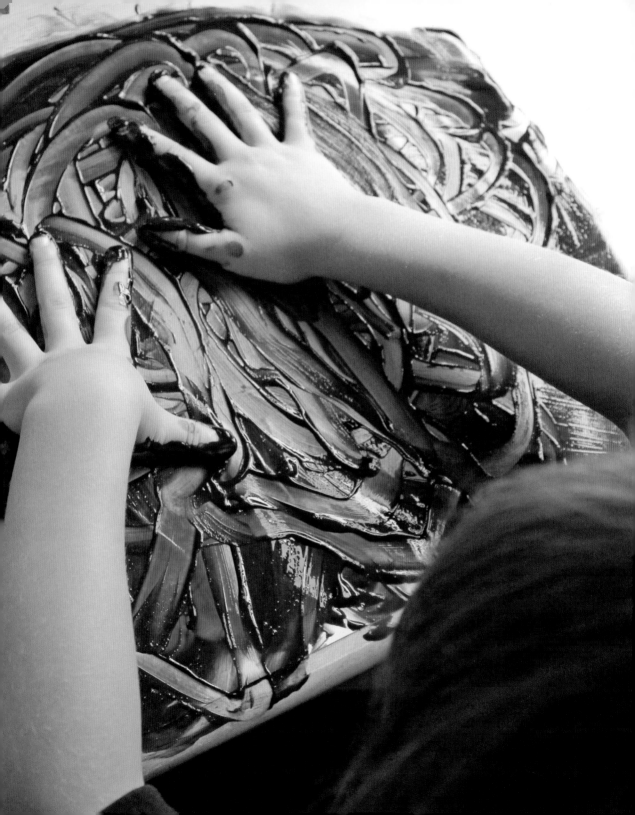

making them smoother to work with. They also take longer to dry, which lets your child manipulate the paint longer. See my recipe for homemade finger paints on page 288.

Drawing Implements
Crayons

I seldom buy the pricey art materials, but I love Stockmar crayons. They are decidedly more expensive than the crayons you can pick up at the drugstore, but their quality is excellent. They are made of beeswax and natural pigments, and the colors are vibrant. Available in sticks or blocks, they're chubbier than normal crayons, so they're easier for young children to manipulate and less likely to break. They last for years. The only downside (besides the price) is that they are not washable.

Remember the appeal of a large box of sharp-tipped crayons in many colors? Who could resist? So you're probably going to buy a box of Crayolas even if you spring for the Stockmars. You can enjoy them during their relatively short life span, then use the broken remains for other art projects, such as melted-crayon drawings, melted-crayon rocks, crayon-shaving suncatchers, crayon-shaving watercolor resists, and multicolored crayon cakes (see pages 174 and 234).

Oil Pastels

My family loves oil pastels. They slide over the paper so smoothly and easily, the color is rich, and they are inexpensive. We use them for drawing, multimedia artworks, and crayon-resist projects. They also show up very well on darker paper, such as colored construction paper, brown kraft paper, or contractor's paper.

For toddlers, I especially like Crayola Twistables Slick Stix (an oil pastel in a hard plastic case). You twist up only as much of the pastel part as you need, so the rest doesn't get smashed or broken. The plastic case provides a firm base to grip, and there is no paper to peel back.

Chalk

Every family should have some chalk for indoor and outdoor use. It is easy to use and ultrawashable, and it encourages spontaneous drawing. Note: If you don't have a chalkboard, you can use chalkboard paint to make one out of a wall or door. Alternatively, you can buy removable chalkboard wall decals.

Colored Pencils

Some families swear by colored pencils and say their young children prefer them to other drawing tools. Others (including ours) say their kids prefer markers and crayons, and colored pencils get second string. I think colored pencils are better for children ages five and up, because you have to learn some specific techniques to make them work effectively (shading, using the side as well as the tip, pressing hard, sharpening them, and so on) and that is more easily accomplished by a child who has developed fine motor control. That said, some young children do just fine with them and enjoy using them.

Quality varies a lot, so try to get a decent set if you're going to buy them. Chunky or triangular colored pencils can be easier for younger children to use.

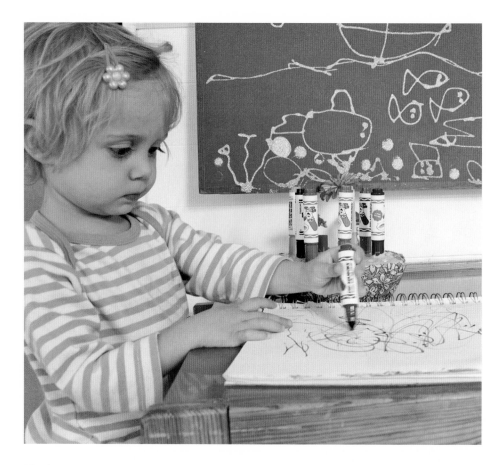

Markers

Markers are inexpensive and easy to use, suited to everything from drawing and coloring to writing and designing. They are more vibrant than crayons and colored pencils, making them the preferred drawing tool of many children, including my own. Washable and permanent markers come in many colors and thicknesses. The biggest drawback is that they can dry out if the caps are not put back on properly. To avoid this and to make it easy for toddlers to cap their markers, we use an easy-to-make plaster marker holder that I found in MaryAnn F. Kohl's *First Art* (see page 71 for my gussied-up version).

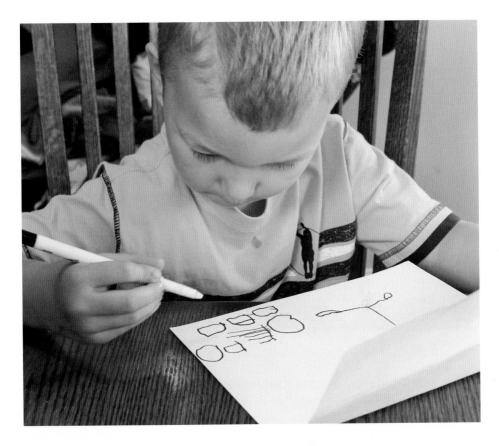

Pens and Pencils

Regular pens and pencils (you know, the kind in your desk) are fun too and are often the tool of choice for professional artists and most adults. We write our grocery lists, to-do lists, journal entries, and crossword puzzles with pencils and pens, and any child worth his salt naturally wants to use what Mom and Dad are using. However, chances are that those grown-up pens are not washable, so keep an eye on their use around clothes and furniture.

I suggest using whatever pen or pencil is handy at the time. As children get older and interested in certain kinds of artwork, such as cartooning, they may have specific demands.

Paper

We use a variety of papers for our art making and crafts, depending on the project. Paper varies in color, size, weight (20 lb. for copy paper, 90 lb. or more for watercolor paper), and tooth (how rough or smooth the surface is).

Paper for Drawing, Painting, and Collage

We buy heavyweight (80 lb.) white sulphite paper for a lot of our drawing, painting, and collage projects. It's our general, all-purpose paper. I keep a stack of it in the studio and a basket of it near the dining table.

I also often purchase large sheets of poster board (Target carries them for $0.39 each). You can cut them down into several smaller pieces or keep them whole. I love letting my children work large, and this is an inexpensive way to provide this size (2' × 3').

I also pick up free mat board remnants at a neighborhood frame shop. They are sturdy and provide a good base for paintings and collages.

For Watercolor Painting

Watercolor paper is thicker than other kinds so it can hold up to all the moisture without tearing or buckling. A wide variety is available; many watercolor papers are more suitable for professional artists than for preschoolers. This is one situation where price makes a big difference in quality. I buy basic, student-quality paper, but if your family is really into watercolor painting, you might like to try some of the better-quality materials. We paint on poster board and mat board as well.

For the Easel

Of all the easel papers I've tried, I like the rolled paper offered by Discount School Supply the best. It's inexpensive yet sturdy enough to paint on. Besides using it on the easel, I sometimes pull off sheets for working big at the table or on the floor. You can also purchase large pads of paper to use on the easel.

For Working Big

I buy brown contractor's paper at Lowe's for about $10 a roll. It's supereconomical compared to $30 or $40 for craft butcher paper. We use this for big projects such as body tracing or when we want to cover the table with paper and have a family draw fest.

For the Writing Table

Besides the basket of white sulphite paper that was mentioned earlier and travels all over the house, I also keep inexpensive, spiral-bound sketchbooks at Maia's desk, at the little red table, and in the car. I know some people buy fancy Moleskine sketchbooks for their children, but at the rate we go through paper, it's hard for me to justify the price. I get inexpensive spiral-bound sketchbooks and then don't worry when they get used for all sorts of drawing, writing, cutting, and taping projects.

Paper for Recycling and Upcycling

Keep a collage box of bits and pieces of interesting papers. Susan Kapuscinski Gaylord, the author of *Handmade Books for a Healthy Planet* (makingbooks.com), recommends keeping a box of appealing types of paper and cardboard destined for the recycle bin. They can be used for any arts and crafts projects, including collage,

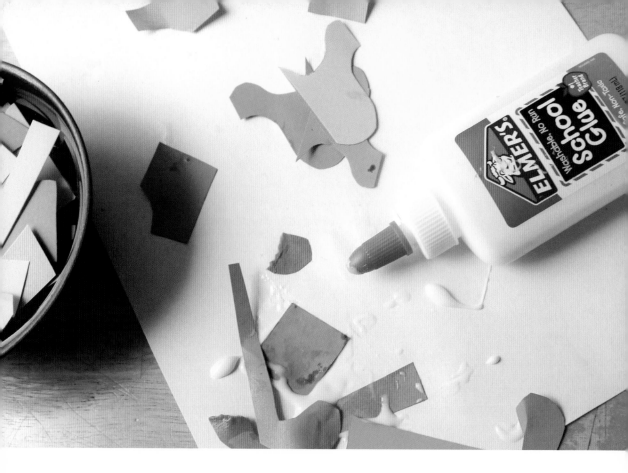

multimedia artworks, or bookmaking. Collect wrapping paper, cards, magazines, cereal boxes, and old calendars.

Construction Paper

Colored construction paper is a childhood staple. We don't like the kind you can buy in the drugstore—the quality leaves a lot to be desired. Instead, I buy colored sulfite paper from Discount School Supply and colored construction paper from IKEA.

Other Fun Papers

Paper plates are useful; we work with them for drawings, paintings, spin art, marble rolling, and frames for suncatchers. We also use transparent contact paper (shelf pa-

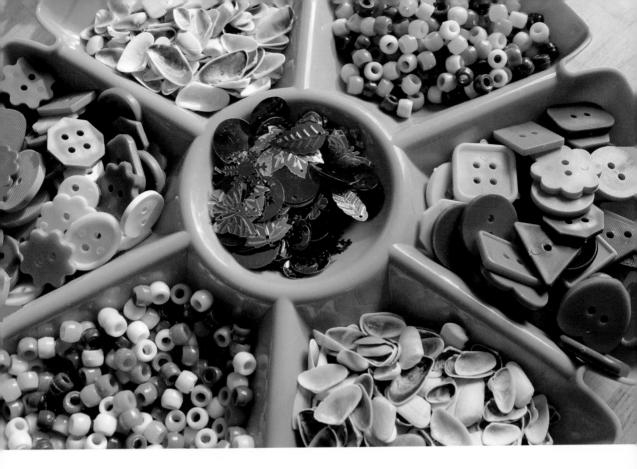

per that is sticky on one side) and colored tissue paper quite a bit, often for various stained-glass projects.

Paper to Avoid

One paper we don't use is newsprint, which is too flimsy. Its irregular brownish color and acidic content make it a poor choice for any pictures that you might want to save.

Collage Materials

Collage materials can be just about anything and often include paper, cardboard, cotton balls, feathers, beads, beans, pom-poms, pasta, fabric scraps, things in your

recycle bins, buttons, and wooden craft sticks. Search your house and recycle bin for collage materials.

Glue

Glue is a staple for many childhood arts and crafts projects, and there aren't many things little kids like more than to squeeze a bottle of glue until puddles form on the paper! I've always let my kids do this, since glue is inexpensive and I knew this stage of life wouldn't last long. Some parents and teachers prefer to offer a small amount of glue in a dish with a brush or Q-tip for applying it. Glue sticks are also a good way to limit glue overuse, but they work best for paper projects. Glue guns are a favorite in our household because of how quickly and easily they attach items that are not normally easy or quick to attach. (See the sidebar on glue guns and children on page 181.)

Modeling and Sculpture Materials

These materials include clay, playdough, air-dry modeling materials, marshmallows and toothpicks, pipe cleaners, straws, cardboard boxes, foil, and many homemade options (salt dough, bread dough, and cornstarch dough). See my recipes in Chapter 14, "Homemade Art Materials to Make and Enjoy."

Tools

The tools children use affect both the success of the art activity as well as how easily art fits into your family's home life.

Paintbrushes

As with any other art material and tool, there is a seemingly limitless variety of paintbrushes available: chunky, thin, wooden handles, plastic handles, expensive, cheap,

sable bristles, synthetic bristles, and even funky brushes specifically designed for creating interesting textures. I prefer plastic handles because I often dunk brushes into a bowl of water to soak until I have time to clean them (unfortunately, this ruins wooden handles over time).

Paint and Water Cups

You can buy no-spill paint cups that have special lids to let the brushes in but keep paint from spilling if they tilt over. They fit into most easel trays and are also good for working on tables. If you prefer, you can use old bowls and cups (the thrift store is a good source) or mason jars to hold paint and water.

Art Smock

Smocks help protect children's clothes from paint and other art materials and can make you feel better about encouraging messy projects. I've always made my own from large T-shirts (see page 46), but you can just use a T-shirt as is or purchase an art smock. If you're going to buy one, I suggest getting a breathable, flexible material rather than stiff plastic.

Art trays help keep messes contained and are easy to clean off. You can use them for playdough, clay, beads, collage materials, and finger paints.

Splat Mat

A splat mat is a waterproof mat that will protect the floor when your kids are doing messy art projects. You can bring one out once in a while or leave one under the easel.

Other Tools

Scissors, tape, and a stapler are the go-to tools in our home for many creative projects. We keep both transparent tape and masking tape (including special colored masking tape available from Discount School Supply) handy and make child-size scissors, a hole punch, and a sturdy stapler accessible.

Fun but Optional Materials

Once your family is familiar with the basics, you may have fun exploring some of the more optional art materials listed here.

Glitter

Glitter definitely falls into the fun-but-optional category of art supplies (although my daughters would question the optional part). It is much loved in our house and is used for decorating drawings and paintings as well as three-dimensional items. We often get it out when making holiday art or decorations, but we use it all year long as well. In addition to regular glitter, you can buy glitter glue and glitter paint, both of which are also popular at our house. We've used and enjoyed a variety of glitters and don't have any preference as to brand, but that's not the case with glitter glue. Most that we've tried have been hard to use, and I gave up on them until someone suggested we try the Colorations brand, which is easy to squeeze and doesn't clog up.

Fun Paints

You will be fine if you stick with basic watercolors and tempera, but if you have the desire and budget to experiment with different paints, there are several different kinds out there. Besides the glitter paint already mentioned, there are puffy paints, chalk paint, fabric paints, and window paints. We use acrylic paints for some art projects such as glue batik, glass painting, and rock painting—basically, anytime we want a paint that won't wash out.

Window Crayons and Markers

If you want to let your child explore drawing on a transparent surface, you can purchase window markers or window crayons. Both wash off with soap and water and also work well on mirrors.

Fabric Crayons, Markers, and Paint

It can be fun to decorate plain T-shirts, flags, bags, and other fabric items. We use fabric crayons quite a bit, and the color is easy to set with an iron.

Fun Collage Items

Googly eyes, sequins, stickers, and feathers are four optional but superfun (and inexpensive) collage items that we like to keep stocked.

Make a Marker Holder

A marker holder helps toddlers put markers back in their caps and doubles as an effective and attractive storage stand. This holder is inspired by one in MaryAnn F. Kohl's book *First Art.*

MATERIALS

- Melamine or plastic bowl
- Petroleum jelly
- Piece of attractive fabric, slightly bigger than inside of bowl
- Plaster of Paris
- Milk carton, bucket, or old bowl (for mixing plaster)
- Old spoon or wooden paint stirrer (for mixing plaster)
- Food coloring (optional)
- Set of markers
- Beads for decoration (optional)
- Mod Podge

INSTRUCTIONS

1. Gather all the materials in one spot, as you will need to work quickly once the plaster is mixed.
2. Grease the inside of the melamine bowl with petroleum jelly.
3. Wet the fabric, wringing out the extra water

until it is barely damp. Lay the fabric, right side down, in the bowl and smooth it out as much as possible. The fabric should stick out the top of the bowl by an inch or two.

4. Mix the plaster of Paris in the milk carton or old bowl according to the directions on the package. Add food coloring to tint the mixture, as desired.

5. Fill the fabric-lined melamine bowl with the plaster.

6. Remove the caps from the markers and set each cap halfway into the plaster with the open side up. Try not to shift them once they are in place; you want the plaster to form a tight bond around the caps.

7. If desired, add beads to the plaster while it is still wet, pushing them in slightly.

8. Let the plaster set, then put the markers back in their caps. (Just set them in loosely for now to prevent them from drying out. You can push them all the way in tomorrow.) Leave the plaster to harden overnight.

9. Tip the bowl upside down and gently pull the marker holder out.

10. Add one or two coats of Mod Podge to protect the surface, making sure to cover the fabric as well.

11. Use!

NOTES

- Pour leftover plaster of Paris in the trash, *not* down the sink. It will clog your drains.
- Purchase a brand of markers that you will be able to find again easily. The holder will last for years, but you will need to replace the markers periodically.

- Food coloring may tint your fabric somewhat as well as the plaster, so keep that in mind when choosing colors.
- Use caution when working with the dry plaster dust, because it is not good to breathe.

Keeping It Affordable

I know I've told you about lots of different art supplies, many of which I say are my favorites, but the list of indispensable art materials for children is really quite short. Essentials are a readily available supply of paper; some sort of paint (ideally in red, yellow, blue, white, and black); something to draw with (such as crayons or markers); scissors; tape; playdough; and a glue bottle. Everything else is extra. Fun, yes, but extra. Also, there is no need to have a fully stocked art cupboard all at once. I built mine slowly over time, and you can too. When you add just one or two new materials at a time, you can fully explore and enjoy them on their own first and then combined with supplies you already have. Even when I get a new box of materials, I'll bring out only one new thing at a time to share with my daughters. It's more relaxed and less like Christmas morning.

Art Materials You Already Have

You don't need to go out and buy a ton of art materials. You can make some (see Chapter 14), and you probably already have more than you think around the house. Time to explore and get creative.

KITCHEN

- Toothpicks and marshmallows (for sculptures)
- Flour, salt, cornstarch, and cream of tartar (for modeling dough, playdough, homemade paints, and homemade paste)
- Food coloring (for homemade paints, cookie decorating, color mixing, and science experiments)
- Potato masher, whisk, mesh strainer, meat mallet, sponges, and Scrubbies (as painting and printing tools)

- Potatoes, fruits, and vegetables (for printing)
- Garlic press, rolling pin, potato masher, cookie cutters, and utensils (as playdough tools)
- Coffee filters (for snowflakes and dropper art)
- Rubber bands (for geoboards and stretch art)
- String (for installation art)
- Wax paper (for melted-crayon-shaving suncatchers)
- Freezer paper (for stencils and stabilizing fabric art)
- Foil (for sculpture and collage)
- Freezer (for ice wreaths and ice sculptures)
- Mason jars (for homemade paint or playdough storage)
- Beans, rice, and pasta (for collage)
- Pasta (dyed for necklaces and collage)

BATHROOM

- Q-tips (for pointillism painting)
- Cotton balls (for pointillism painting and collage)
- Rubbing alcohol (for watercolor special effects)

TOOLBOX

- Wing nuts, washers, and bolts (for collage and sculpture)
- Wood scraps, wood glue, nails, and hammer (for collage and sculpture)
- Wire (for sculpture)
- Duct tape (for collage and sculpture)

OFFICE

- Address labels (for mini sticker art)
- Sticky notes (for miniart, sticker art, and installation art)
- Rubber bands (for stretch art and sculpture)
- Masking tape and transparent tape (for tape art and tape resist)
- Scissors (for paper cutting)
- Copy/printer paper (for drawing)
- Index cards (for drawing and painting)

- Blank dot stickers and hole reinforcement stickers (for collage)
- Pens, pencils, and highlighters (for drawing)

My Top Ten Art Materials for Toddlers

1. Crayola Pip-Squeaks Markers
2. Crayola Twistables Slick Stix
3. Washable tempera paint
4. Finger paint
5. Chubby paintbrushes
6. Playdough
7. Chalk and chalkboard
8. Squeezable glue bottle
9. No-spill paint cups
10. Contact paper

RECYCLE AND TRASH BINS

- Papers and cardboard (for drawing, painting, and collage)
- Boxes, egg cartons, and milk cartons (for crafts and sculpture)
- Newspaper (for papier-mâché and sculpture, and as splat mat)
- Bottle caps, broken toys, and found objects (for collage and sculpture)

SEWING BASKET

- Fabric scraps (for collage, sewing, embroidery, and weaving)
- Ribbon (for suncatchers, collage, and weaving)
- Yarn (for weaving, string painting, jewelry)

You Don't Need to Buy the Best

Adding to your collection over time helps to keep it all affordable, but it's also fine to buy inexpensive art supplies. There are times when it's worth spending a little

more for better-quality materials, but for the most part, you can stick to the basic brands.

I'd rather have all children making as much art as their hearts desire than be forced to limit their experience because of cost. Therefore, while more expensive art materials may be more satisfying to the discerning eye, I don't necessarily recommend them. The inexpensive ones are *good enough* and will let your children create happily and copiously. There's no reason to restrict their artwork because you bought the most expensive watercolor paper and now have to dole it out like a miser. Just buy what you're comfortable with so you can make plenty of basic art materials available.

My Top Ten Art Materials for Preschoolers

1. Oil pastels
2. Collage materials
3. Mini paint rollers
4. Colored masking tape
5. Glitter glue
6. Scissors
7. Colored construction paper
8. Liquid watercolor paint
9. Washable markers
10. Shaving cream

My Top Ten Art Materials for School-Age Kids

1. Colored pencils
2. Skinny markers
3. Paints
4. Clay
5. Watercolor crayons
6. Glue gun
7. Cardboard and recycle bin materials
8. Sharpies
9. Printmaking tools
10. Pipe cleaners

5

Encouraging Your Budding Artist

Creativity is inventing, experimenting, growing, taking risks, breaking rules, making mistakes, and having fun.
—Mary Lou Cook

Encouraging young artists takes more than just setting up a space and supplying materials. How we interact with our children and talk about their art is just as important. Actions, attitudes, and words all hold immense power between adults and children. If we strive to use that power consciously and thoughtfully, we can enhance our children's inherent creativity.

While it's certainly important to present developmentally appropriate art to your children and encourage them to explore, it's just as important to consider the ways you talk to them about their art. A picture is worth a thousand words, but words are significant too. The way parents talk to children about their art can foster self-confidence, help build their vocabulary for understanding art experiences, and keep them interested in and excited about art.

Many parents offer an automatic "That's pretty," when their child shows them a new drawing or painting. They'll ask "What is it?" or guess—"That looks like a train," or "Is that a dinosaur?" These comments are well meaning but not helpful. What does *pretty* really mean, especially if it's applied to every artwork you create?

And what if you didn't mean it to be pretty? What if you were angry when you slashed that red paint across the page? What if you were painting something spooky? *Pretty* and *cool* and *beautiful* are meaningless adjectives that parents and teachers pull out too often, usually because we don't know what else to say. We need to learn how to talk about our children's artwork in a constructive way.

Asking what the subject matter is shows that you can't see what is depicted in the artwork. To your child, it's usually perfectly clear, and she may be disappointed and frustrated that you can't see it too. She may even lose confidence in her drawing ability. Or it may not be *about* anything, and asking what it is shows your child that you assume it is or *should be* about something.

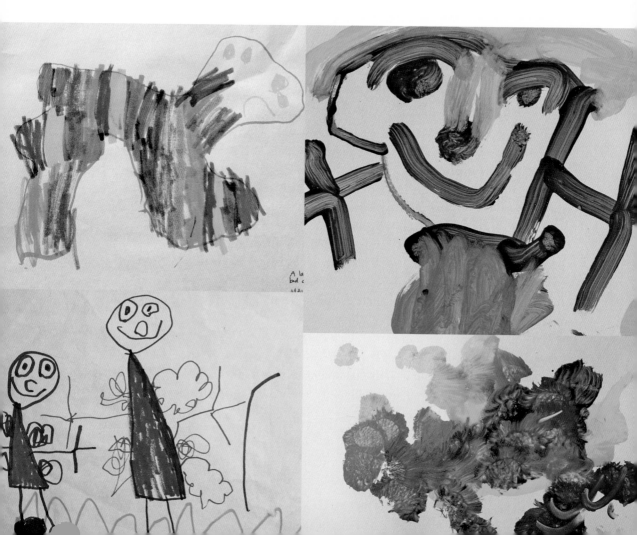

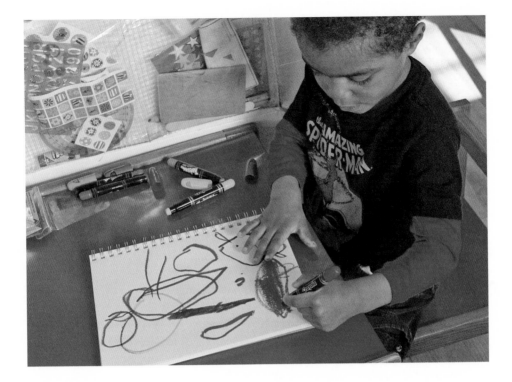

The truth is that much of early childhood art is abstract. It is made for the pure joy of making marks on the paper. It is inspired by the materials, the tools, and the surface. Young children often enjoy the process of transferring paint to paper without much (if any) thought to "what it is." They scribble wildly or draw tiny because it feels good, and that's what they want to do at the moment. But now you're asking what it is, and by doing so, you devalue the process, the fun they had scribbling across the page, the joyful colors they chose, and the way they drew or painted them on their paper.

Guessing is also a frequent fallback. You ask, "Is that a chick?" But no, she had something else entirely in mind. It's not a fluffy chick but a friendly monster (a mistake I made once). Now she's disappointed you couldn't see that, and her belief in her artistic ability drops a notch.

MAIA
MAY

Giving "compliments," asking what something is, and guessing the subject matter are completely normal and widespread. Most of us do it. It's not bad. *We are not bad.* We just need to train ourselves to talk about children's art in a more constructive, open-ended way that reflects and guides how small children think about their art.

This chapter discusses how to talk about artwork to build art vocabulary and self-confidence. By describing what you see on paper and what your children are doing, you give them the words to explain the process for themselves.

Talk about What You See Your Child Doing

Is your little one making big, bold marks on the paper or tiny, careful marks? Comment on it: "I see you're drawing big today." Is he using his whole arm? You can say, "You're really using your whole arm (or whole body) to paint." Is he using a thin brush or a thick brush? Is he drawing dots or big circles? What colors is he painting with?

Are they separate or mixing on the page? Your comment might be, "I see you're painting yellow on top of red. The colors are mixing together to make orange, aren't they?"

Besides talking about what he's doing, talk about the colors, images, and patterns on the paper. What do you see on the artwork your child is showing you? Lots of red with some blue dots and green swirls? You can say, "You sure used a lot of red on this drawing," or "Those dots and swirls look like they were fun to draw." You don't have to talk like this all the time or keep up a running commentary during all art sessions, but if you are looking for something to say, consider commenting on the process and what you see.

This is the response I use with toddlers. It's all about the process for them, and they don't yet have the vocabulary to talk about their art or have an idea of a story to go with it. For kids preschool age and up, I might ask them to tell me about their artwork.

> Imagination is more important than knowledge.
>
> —ALBERT EINSTEIN

Ask Your Child to Tell You about the Artwork

Perhaps the most used phrase in our family, and the one that I rely on over and over, is, "Will you tell me about your painting (drawing, sculpture, collage, and so on)?" Maia has been known to go into great detail about what is depicted, usually with a story to go along with the picture. Sometimes I try to write it down as fast as I can so I'll remember it later. Sometimes I just listen closely and add a "Hm," "Oh," "Wow," or "What about this?" as I point to some aspect of the painting she hasn't mentioned yet. I love this process! I love learning what she's thinking about, her burgeoning storytelling ability, and the intention she's putting into it.

Something to keep in mind is that meaning is often not set in stone for young children. What is a mama bird with her babies today may be a grandmother hedgehog tomorrow. What is a dark cave with a scary bear today may be a house for a pet dog tomorrow. So don't be surprised if your child talks about the mountain she drew when you clearly remember her saying that it was a roller coaster yesterday. Go with the flow.

My other default response to a child's artwork, especially for preschoolers and older kids, is, "You really worked hard on that!" This acknowledges the effort the child put into the piece, especially if she spent a fair amount of time on it.

Dos and Don'ts for Talking about Children's Art

Here's a quick reference for how to talk to children about their artwork.

Don't Say This	*Do* Say This
That's pretty!	Wow, look at all the colors you used!
What is it?	Will you tell me about your drawing?
That looks like a truck.	That looks like it was fun to paint.
Color inside the lines (or any sort of criticism).	I see thin lines over here and thick lines over there.
Draw me a pretty picture.	What would you like to draw today?
	Nothing. (When in doubt, zip your lips.)

What Color Are You Feeling? A Color Journal

Explore feelings and the interaction and symbolism between color and feeling by keeping a color journal.

For ages 3 and up

Yellow makes me feel inside like the sun.

—MAIA

MATERIALS

- Blank journal with plain, unlined pages
- Crayons or markers in a variety of colors

INSTRUCTIONS

1. Talk about the concept of color and mood. Besides including stereotypical color connections such as blue means sad (or contemplative), red means anger (or excitement or hunger), and yellow means happy, also talk about the possibility that everyone can have their own unique color and mood connections. Robin's egg blue may make you feel euphoric, whereas red may make you feel grumpy. You can bring up the concept of color and mood connections throughout the day by making comments such as, "This yellow room makes me feel cheerful"; "I'm feeling spunky today, like this orange shirt I'm wearing"; "Look at that gray weather outside; how cold (or peaceful) it looks."

2. Now introduce your child to the journal and the concept of thinking about and recording how you feel about colors. You can each have your own color journal and work on them side by side, if you like.

3. Each day, perhaps before bed, get out your color journal and say, "What color are you feeling?" or "What color was your day?" Then draw with that color. You can fill in the entire page, scribble, draw something, or draw scenes from your day—all with the chosen color or colors. This can be elaborate or simple to suit your child's age, skill level, and personality.

4. Write the date and your child's mood, if desired. If your child is a prewriter, he may dictate something about the day for you to write. If he can write, he may wish to write something himself. Or he can keep strictly to colors.

- Before bed, fill in the day's square on the calendar with the color for that day. Or create a grid for the week with seven boxes and hang it on the wall. Each day fill in the day's square with the appropriate color.
- Make a collage for the color you are feeling that day. Use magazines, construction paper, or drawing and painting materials to create a multimedia exploration of the color and your feelings.
- At the end of the week, month, or year, review and discuss the past colors, feelings, and moods.
- If a child is having a hard time or you would normally give a time-out, consider asking, "What color are you feeling?" and encouraging him to make a color drawing. Or just ask if he wants to draw *how* he is feeling (without the emphasis on color).

Connecting with Children through Talking about Their Art

Judith Rubin

Having art materials available for spontaneous expression is important for enabling children to say things in art that they cannot put into words. Art making helps them express their feelings, especially those that might not be acceptable (like anger at an adult), as well as sort out their impressions of the world. Thus, it is a vital activity for healthy emotional and cognitive growth.

Helping children to talk about their art can be a challenge that depends on many variables, such as the age and verbal ability of the child. Yet talking about what has been created adds another level to the experience, enhancing its value for growth and development.

A great deal of children's communication is nonverbal, from facial expressions to body language that tell adults how they are feeling. Indeed, a great deal of spontaneous dramatic play is virtually silent, perhaps with added sound effects but no words, whether the child is using miniature figures, dolls, puppets, or enactment.

Art is a natural language for children, and, as with speech, there is a normal developmental process. Youngsters generally move from disorganized to organized scribbles to pre-representational and then naturalistic drawing and modeling. There are predictable stages of development in children's art, from early schemas (repeated symbols) to realistic representation.

When children are very young they are comfortable with drawings that look strange to adult eyes, such as "X-ray" drawings or clearly unrealistic sizes (such as when a human being is much larger than a house). Young children also use colors that are different from reality with equal freedom.

It is natural for adults to see things in a child's art, but these are usually the grown-ups' projections and, while valid for them, are less valid for the child.

Here are some tips for talking with children about their art.

Accept What Has Been Created

Talking to young children about their art requires, first and foremost, that you accept what the child has created (be it a scribble or a representation), whether or not it is understandable or makes sense to your eyes.

Don't Ask What It Is

A question like "What is it?" about a scribble makes no sense to a child, though she might decide to accommodate you and say it "is" something, even if she has not yet reached the natural stage of naming her scribbles. Similarly, if the child did intend the drawing or sculpture to be something and assumes you can figure it out, the question can be deflating if not depressing.

Don't Try to Guess

You naturally want to be responsive, and it is normal to want to figure things out, but guessing what the child has represented—whether general ("Oh, it's a house") or specific ("Oh, it's Grandma's house")—is not the best way to begin. It is not unusual for an adult to be unable to "read" a picture.

Be Receptive and Supportive

If you want to reinforce your child's desire to show something and enhance his self-esteem, it is always good to be pleased that he is doing so and—if you're sincere—to say how much you like it. If you say you love everything a child creates, he won't feel that your approval is genuine or worth very much. I'm not suggesting that you be critical; simply that you be sincere.

Talk about Art during the Creative Process

If your child wants to describe or talk about the process or product while working, listen but try not to intrude or to unwittingly influence what is happening. Only in this way can the artwork truly be your child's own creation.

Ask Open-ended Questions about the Product

This is the ideal way to inquire about children's art, because it is respectful and will give you the most valid information. It also encourages your child to think

about what she has made and to extend the experience imaginatively. By *open-ended,* I mean questions that don't suggest or imply an answer (which can be a hazard because of your own projected ideas about the artwork). For example, ask, "Can you tell me about your picture?"

Such questions can initiate a whole new creative process. If a child responds to the first one by saying something like, "Oh, it's just a person," the next step is to offer logical options to help her clarify and extend the idea, like asking whether it is a child or a grown-up, a boy or a girl, and what age the person might be. What might the person be thinking? What happened before this picture? What will happen next? And so on. In this way, you open new doors to your child's imagination, and she is your guide.

6

Sustaining Inspiration

Creative isn't the way I think, it's the way I like to live.
—Paul Sandip

Whether you are new to the artful life or are well along on your artful journey and just looking for ways to sustain inspiration, this chapter is for you. You will find many ideas here that encourage you and your family to live, explore, and create in new and different ways. Anyone can make everyday family life more artful. Food, play, and science are some of our favorite areas of exploration. There is also inspiration to be found all around us—in other people, places, and things. Learn from books, websites, and artists, or get out of the house for artful excursions and adventures. You will broaden your horizons and feed the well, while also getting out of any rut you might be in. I hope you find this chapter useful and have as much fun with the ideas as my family has.

Making Every Day Artful

Doing art activities isn't the only way to be an artful family. Remember my definition of *artful*? It means full of art, beauty, and creativity (with a handful of whimsy thrown in). If you are mindful about the choices you make and how you focus your attention, you can infuse your family life with artfulness and creativity through your approach to everyday activities. I think of it as celebrating life through the joy of living and

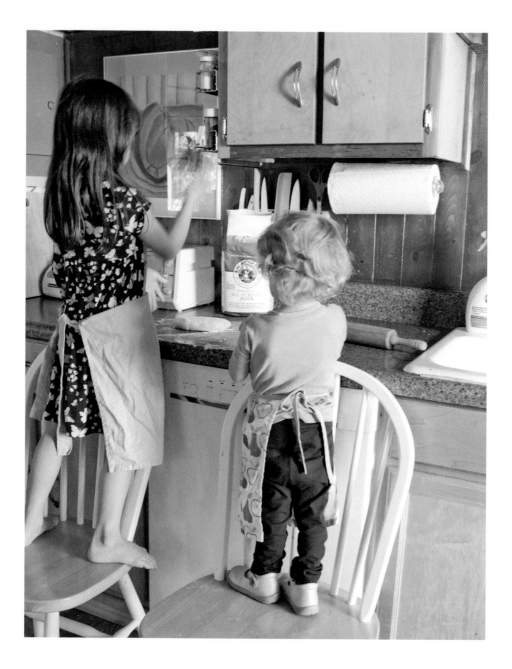

creating together. Adding a sense of artfulness to everyday activities is also a great way to start shifting your family toward art and art making, and it can have the added benefit of inspiring future projects.

For example, cooking with children is an area in which we can inject some artfulness into our lives. We have to eat every day, so making the cooking and preparation of meals, snacks, and desserts a fun, child-friendly activity is an easy way to create an artful environment. I grew up making teddy bear bread, and I especially love continuing that tradition with my daughters (see page 280). Besides forming the dough into bears and other animals, we also shape it into suns, faces, monsters, and flowers. We like to eat our bread shapes plain or turn them into extraspecial sandwiches. How fun is it to have a teddy bear PB&J for lunch?

Other areas that are ripe for exploring in a more artful way include music, play, children's literature, storytelling, science, outdoor activities, and excursions.

Cooking Fun

Cooking and eating together satisfies the soul and truly helps make the house a home. As parents, we can share this important bit of grown-up life with our kids, teaching skills, making memories, and above all, having fun together.

Maia is always asking to cook something with me. We'll ignore for now the fact that she inherited her mama's sweet tooth and that we often bake when we cook, and just focus on the fun we have. She's been helping since she was a toddler and first dumped flour into a bowl and stirred it around. Daphne, now two, grabs her apron and pushes a chair up to the counter at the first hint that we might be cooking. Of course the flour can end up all over the kids and the counter, but we make simple things like bread and cookies, soups and playdough, smoothies and popovers, and they always turn out fine.

The joy my daughters get from helping in the kitchen far outweighs the additional mess and time it takes to cook with them. Don't get me wrong—I've been known to shoo them both out when I just want to get dinner on the table as quickly and cleanly as possible. But the times when we're faced with an afternoon and a craving, cooking together is as fun as any activity I know. And the fun doesn't end when the muffins are in the oven. Then there's the anticipation of watching them

rise through the oven window, setting the table, and finally, eating our yummy baked goods. Even when I cook something on my own, I'll usually save a bit of the bread dough or piecrust for the girls to work with and make their own creations. Daphne is at the age where she enjoys just exploring it, but Maia crafts minipies or rolls biscuit dough into thirty tiny balls to bake "for the fairies."

To make working in the kitchen even more fun for your kids, consider outfitting your young chefs with their own cooking gear.

- Make or buy a cooking apron for each child. As everyone knows, when playing dress-up, the outfit is key. Of course, an apron is also practical and will help protect clothes from flour and other messes.
- Child-size cooking tools and dishes are fun. Maia gets the most use out of her small, oven-safe baking tins. She bakes tiny loaves of bread and little pies in them. Cookie cutters of various shapes get used for everything from cookies to sandwiches and playdough. Small teddy bear and star-shaped molds are used for baking banana bread or making jello.
- The Montessori website For Small Hands (www.forsmallhands.com) sells special child-safe knives that make cutting fruit and vegetables easy and safe for children.
- All children should have their own cookbook. For young children, I especially like *Pretend Soup* and *Salad People* by Mollie Katzen (Tricycle Press), because they show as well as tell. The step-by-step illustrations make them perfect for beginning and prereaders. With these cookbooks, children can flip through and choose something to make themselves, giving them a feeling of control and ownership. School-age children will enjoy the *Kids' Kitchen* recipe cards by Fiona Bird and Roberta Arenson (Barefoot Books, 2009).

Consider giving your child a daily dinner task or chore, such as setting the table, making the salad, filling a vase with flowers, or creating a centerpiece. Her involvement will give her more ownership of the meal and make her feel needed (good for any member of the family, regardless of age).

Ideas for Foods to Make Together

- Pizza faces
- Fruit kabobs
- Sandwich shapes or tiny tea party sandwiches
- A cake (Make sure to decorate it!)
- Watermelon flowers
- Doughnuts
- Pretzels
- Fruit juice or smoothie popsicles
- Popovers
- Muffins
- Smoothies
- Soups

Tea Party Time!

Bake cookies, assemble tiny sandwiches, and cut up fruit in preparation for a tea party. Invite friends or your child's stuffed animals. And don't forget to dress up in your fancy clothes and hat. Set a little table or spread a picnic blanket indoors or out. My girls especially like to have a tea party under an indoor fort of sheets draped over the chairs or table. Pick a bouquet of flowers. If you have edible flowers, such as violets or nasturtiums, you can even use them to decorate the food. Brew a pot of herbal tea (or make sun tea if it's summer) and sit down with your real or imaginary guests.

Some fun picture books about tea parties include:

- *Let's Have a Tea Party: Special Celebrations for Little Girls* by Emilie Barnes and Sue Christian Parsons (Harvest House Publishers, 1997)
- *Miss Spider's Tea Party* by David Kirk (Scholastic Inc., 2007)

- *Fancy Nancy: Tea Parties* by Jane O'Connor (HarperCollins, 2009)
- *My Very First Tea Party* by Michal Sparks (Harvest House Publishers, 2000)

Celebrating Nature

Nature is a rainbow of colors, a collage of textures, a cacophony of sounds. It's living, breathing, and constantly changing—day by day, season by season, and year by year. The natural world provides endless artful inspiration for our family. Besides simply enjoying the beauty in our garden and in the wider environment, we are fascinated by the miracle of life in all the different ways it is present in nature, from the

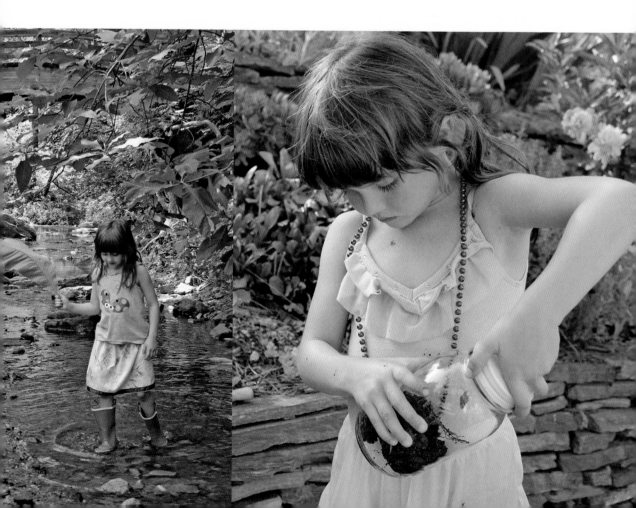

regal praying mantis to the chattering assortment of birds at our bird feeders and the perfect symmetry of zinnias and other flowers. We incorporate nature items into many of our creative activities, including leaf prints, nature keepers, and sand casts. Here are some ideas for incorporating more natural inspiration into your artful life:

> Creativity is piercing the mundane to find the marvelous.
>
> — DANIEL PATRICK MOYNIHAN

Get outside every day with your children, if you can. Go for walks and observe the life all around, bringing a magnifying glass or binoculars if you want to observe close up or far away. Gather rocks, leaves, and other natural items as you explore. You can create a seasonal nature table with these treasures, pile them in the center of your dining or art table as drawing subjects, or use them for nature collages. You can even draw *on* them. Sharpies work well on rocks and leaves.

Pick flowers. Maia picks daily bouquets for us when we have flowers in the garden. We float the blossoms in bowls of water; arrange the stemmed flowers in vases; and use the petals in an endless succession of flower art, including suncatchers, collages, pressed-flower art, and flower crowns.

Garden together, whether in the backyard or just a windowsill pot. Little kids love to plant seeds, check on progress, pick vegetables and flowers, and water. Sure, you might need to provide much of the plant care if your children are young, but that's no reason not to grow something. Kids especially love sunflowers, pumpkins, flowers of all kinds, tiny carrots, strawberries, sugar snap peas, and cherry tomatoes. Read *Roots, Shoots, Buckets & Boots* by Sharon Lovejoy (Workman Publishing Company, 1999) for ideas and inspiration on gardening with children.

Artful Activities to Do with Natural Items

- Paint rocks
- Print with flowers and leaves
- Do leaf rubbings
- Observe and draw from nature

- Make nature collages and flower suncatchers
- Build, assemble, and design with rocks, leaves, and sticks

Play and the Imagination

As parents, we can do a lot to make everyday play more artful by how we arrange play spaces, the toys we provide, and the activities we do (and don't do). I try to purchase toys that are attractive and multiuse and that invite imagination. (For me, this means avoiding many of the noisy, plastic, battery-operated toys.) Just as I prefer open-ended art to coloring books, I also like open-ended toys such as blocks, play silks, dress-up clothes, dolls, puppets, balls, swings, a sandbox, and cars. These are toys that can be used in many different ways over time, making full use of a child's creativity during play. One of the most important things we can do as parents is to allow plenty of free time for play (which may mean limiting scheduled activities as well as television and computer time).

Artful Activities for Encouraging Imagination during Play

- Both boys and girls enjoy dressing up and role-playing. Consider keeping a dress-up box or corner stocked with an assortment of fun costumes, thrift-store clothes, accessories, play silks, and hats.
- Games can provide wonderful opportunities to learn and have fun together. Card games, word games, board games, and social games are all engaging in different ways. We enjoy some of the classics, such as Go Fish and Chutes and Ladders, as well as new, imagination-inspiring options, such as eeBoo's beautifully illustrated Tell Me a Story cards and Fairytale game.
- Don't always try to keep your child entertained. Let him entertain himself, even if it means he complains of boredom sometimes. Often creativity and the use of imagination are just on the other side of boredom.

Artful Science

Simple science experiments celebrate children's curiosity about how our amazing world works. From the way molecules act to how bodies function and nature interacts, it's all science. We know that science is educational, but it can be beautiful and artful as well. Whether they make glow-in-the-dark slime, mix colors, experiment with optical illusions, play with prisms and kaleidoscopes, or run their hands through a bowl of cornstarch and water, children learn that science can be engaging and fun. And the more fun they have, the more likely they are to remember what they learn.

Science isn't just for school! We can make simple science a part of our days as easily as we do drawing and painting.

Easy Science Experiments

Some of our favorite simple and artful science experiments include milky fireworks, painted daisies, dyed ice sculptures, and baking soda volcanoes.

- Set white daisies in glasses of water tinted with food coloring and watch how the flowers change as they soak up the dye (talk about capillary action and how flowers, and even trees, drink water from the soil).
- Make milky fireworks by pouring a shallow layer of whole milk on a plate. Add drops of food coloring or liquid watercolors. Dip a Q-tip in liquid dish soap, then dab it in the center of one or more of the colors in the plate of milk. Watch as the color shoots away from the Q-tip in all directions like fireworks. Kids love this, so be prepared to repeat this experiment over and over. (Why does this happen? One end of the dish soap molecule attaches to the fat in the milk and one end attaches to the water in the milk. This results in the boiling action and the food coloring erupting across the surface of the milk.)
- Create a dyed ice sculpture while learning how salt melts ice. Freeze water in a milk carton, then sprinkle salt over the block of ice. Add drops of food coloring or liquid watercolors. The food coloring helps children see the tunnels and chasms the salt creates in the ice. Plus, it's beautiful.
- Make a baking soda volcano, and ooh and aah over the reaction between baking soda and vinegar when it erupts (while also delving into how volcanoes work). Fill a bottle three-quarters full with warm water tinted with red food coloring. Add six drops of dish soap and two tablespoons of baking soda, then pour in some white vinegar. While you can do this in any jar or bottle, consider jazzing it up by mounding colorful, no-cook playdough (see page 274) around the jar for the mountain and sticking leaves, twigs, and other natural items into it to create a forest. Round out the ecosystem with play animal figurines before setting off the volcano.

Storytelling, Poetry, and Children's Literature

Children's literature is a window into a wonderful world that often combines words and art in amazing ways. These stories and images can feed the imagination and the soul. The range of children's books is tremendous. There are silly books and serious books. Stories that inspire or educate. Books with morals. Books of jokes. Picture books that can inspire you to try new art techniques, such as collage—Eric Carle's *The Very Hungry Caterpillar* (Hamilton Hamish Children's Books, 1994)—or scratch art—Beth Krommes in Susan Marie Swanson's *The House in the Night* (Houghton Mifflin Books for Children, 2008). There are pop-up books, such as *Yellow Square* by David A. Carter (Little Simon, 2008), that make you feel like you're entering a modern

> The creation of art is not the fulfillment of a need but the creation of a need. The world never needed Beethoven's Fifth Symphony until he created it. Now we could not live without it.
>
> —LOUIS KAHN

sculpture museum. There are poetry books that play on language and mental imagery such as *Meow Ruff* by Joyce Sidman (Houghton Mifflin Books for Children, 2006). There are also beautifully illustrated collections of classic fairytales and stories from around the world, such as *The Barefoot Book of Princesses* by Caitlin Matthews and Olwyn Whelan (Barefoot Books, 2008).

Besides reading books with your children, you can explore the world of words by telling stories, making up poems, and writing your own books. Storytelling frees you from prescribed scripts, engages the imagination, and encourages creativity. You can tell your children stories (start with a story about your childhood, if you like, or tell your version of a classic such as *Goldilocks and the Three Bears*); tell stories *with* them (take turns adding plot twists); or provide a listening ear as your children practice storytelling themselves.

Music

Music is art for the ears, and some of the world's greatest artists are musicians. You can add music to your life simply by turning it on, whether at home or in the car. Go to live concerts or listen to friends who are musicians. Have an impromptu dance party in the living room to upbeat music—one of the best ways I know for turning a bad day around. Sing to and with your kids (even if you "can't sing"). Make music too, and encourage your children to join in. Clap your hands, tap your feet, whistle, drum on pots and pans, or play a real musical instrument. And if you feel musically challenged (as I do), then consider taking your children to parent-child music classes, such as those offered by Music Together or KinderMusik. These classes expose children to music making while teaching you ways to encourage them musically at home.

Many of our favorite picture books are songs in book format. Try *The Wheels on the Bus* by Paul O. Zelinsky (Dutton Juvenile, 1990) and *The Animal Boogie* by Debbie Harter (Barefoot Books, 2000). Singing and looking at pictures together work well for our family. We also enjoy books about making music, such as *Hand, Hand, Fingers, Thumb* by Al Perkins and Eric Gurney (Random House Books for Young Readers, 1969) and *My Family Plays Music* by Judy Cox and Elbrite Brown (Holiday House, 2003).

Artful Adventures

While making our everyday activities more artful is a fun way to enjoy family life and fuel creativity, it can be easy to get stuck in a rut if all we see are our own routines and family, day in and day out. When we are hurting for inspiration, sometimes we just need to shake things up a bit and try something new. So get out of the house and explore together. Go on an artful adventure: visit an art museum, take a trip to the zoo or aquarium, check out a craft fair, watch street performers, take home stacks of books from the library, or sign up for a pottery or dance class.

While not all of the ideas in this section relate specifically to art and creativity, they work to fill the well, as many artists and writers say. New experiences broaden our horizons, keep us actively learning, and introduce material and ideas that may very well inspire our art.

Art making is a way to process what we learn in the world around us. And, conversely, all of life can be material that fuels art and creativity. The more children learn about their world in an appropriate, fun way, the more they can apply what they learn to their lives and art.

Sometimes we don't know what will resonate with us until we see it. When something really clicks with us or our kids, we should pursue it. If it is the ocean, then we can find out as much as possible about sea life, visit the aquarium, take a boat ride, and check out books on coral reefs. We never know ahead of time if it will be a weeklong fancy or the interest of a lifetime. Even short-lived interests feed into who we are and who we become. We model resourcefulness and show our children that we believe in them as we help them follow their interests. As children get older, they will be able to take more control in exploring their interests on their own, especially if we have laid the groundwork. They may explore a new interest in many ways through their art, stories, and play.

> If a child is to keep alive his inborn sense of wonder, he needs the companionship of at least one adult who can share it, rediscovering with him the joy, excitement and mystery of the world we live in.
>
> —RACHEL CARSON

Prepare for your trip by checking out your destination's (such as an art museum's or a zoo's) website to get a general feel for the collection/sights and layout ahead of time. Scout out any kid-friendly activities or areas offered. Is there anything you know your kids will be interested in? If they are older, they can help you get ready and point out what they would like to see. If your kids are young, you'll do it yourself based on your knowledge of their interests and your own.

> Allow children to be happy in their own way, for what better way will they find?
> —SAMUEL JOHNSON

Pack appropriately. Do you have what you need to make the trip successful? Essentials may include water, snacks, a map, changes of clothes, a cell phone, weather-appropriate clothing, sketchbooks and pencils, activity bags for the car (see the sidebar for the portable art box on pages 107–8), a camera, music or audio books for the car, sunblock, towels, wet wipes, and a diaper bag.

Help prepare your children for what to expect by talking about where you are going over breakfast and in the car. Ask questions to encourage their interest and get them talking about and predicting what you'll see.

Once at your destination, stay flexible. Be willing to wander and let your family's

interests lead you. Be open to surprises. Share in the mysteries and fun of exploring something new together.

Take frequent breaks for snacks, meals, drinks, and restrooms—especially important for younger children.

Stay engaged during the excursion. Ask questions and encourage your children to do the same. Learn as much as you can but also be willing to skim. As an inspiration and world-broadening mission, you don't have to absorb it all in one trip. You can come back, if you like.

Record your excursion. Make sketches, write notes, doodle, take videos or photographs, buy postcards and books. These serve as mementos, helping you recall the excursion later, but they also help with idea gathering and processing.

When you get home, encourage your children to process what they have learned in a fun way, such as by drawing pictures ("This is a picture of jellyfish. They're the kind that sting you. That's why all the fish are over here away from it."); making books ("I'm cutting out these pictures for my boat book."); or talking about it ("Wow, did you know that the sperm whale is bigger than our house?").

Review mementos together. Sit down and look at photos, postcards, sketches, notes, or brochures. What were your favorite moments? What were your favorite images? Can you paint them or write about them? Make a book? Write a letter to Grandma about them?

What did everyone like (or not like) about the excursion? Would you go back? Did the trip make you want to learn more about anything? Did visiting the aquarium make you want to see the ocean or go on a boat trip? Can you go to the library or bookstore for a book about stingrays? Look up some information online? Ask someone you know about them or take another related excursion?

Preparing and Using a Portable Art Box

A portable art box, basket, or bag can be used around the house and backyard, in the car, or in a waiting room. Keep the box within reach so your child can grab it and work anywhere, or keep it just for car trips and doctor visits.

WHAT TO PUT IN YOUR PORTABLE ART BOX

- Spiral-bound sketchbook
- Blank index cards
- Washable markers
- Crayons or crayon rocks
- Pencil or colored pencils
- Stickers
- Blank address labels
- Bag of beads and a shoelace to string them on
- Small felt board
- Pack of travel activity cards such as Usborne's *100 Things for Children to Do on a Trip* or *Animal Doodles*
- Magna Doodle or Etch A Sketch

Seeking Inspiration from Books and Artists

A trip to the zoo or museum is not the only way to find inspiration outside of every-day life. We can also take ourselves into the world of books, onto the vast Internet, or to local artists' studios. If we simply remain open and accepting, we can see the inspiration all around us.

Books

There is a wealth of creative information in books, and I encourage you to lead your family in using them as a resource to broaden horizons and find ideas. Books can provide an incredible breadth of wisdom, information, and visual stimulation. You can learn about other countries and cultures; how to cook, fold origami, and be polite; how to speak different languages and tie knots; and how people lived in medieval England.

While books cannot replace actual experiences (a book about France will never be the same as a trip to Paris), they can inspire the imagination and encourage creativity as well as help prepare you for real-life events. They are especially good when you don't have the resources for, say, an actual trip to China, and they help prepare you for when you can go. Books are also invaluable if the experience you are interested in is one that you can't have *without* books or imagination (such as Viking ships from a thousand years ago, space travel, unicorns). And they are great friends on rainy days or in the winter when actual trips outdoors may not be as much fun or as practical.

It's all there for free—fodder for the intellect and the imagination—if you use the resources of a library. It's even relatively cheap when you buy the books (especially compared with trips to foreign countries or weekly classes on a subject).

The Internet

Another gold mine for ideas is the Internet. There's an almost endless amount of information online, not to mention images, music, and videos. From websites on specific subjects to news organizations, social bookmarking sites, and blogs, there is so much to educate, inspire, and motivate.

Start with a blog tour to find new activities to try with your family. Begin with one blog (see the resources section at the back of the book for suggestions), follow

interesting links within the text, and see where they take you. Or browse through the blogroll (which includes a blogger's favorite, or similar, blogs and is sometimes found in the sidebar) and visit related sites. Keep going, following links, and exploring. Take note of interesting activities or ideas you find along the way—write them down, print them, or "pin" them on Pinterest. You can also explore YouTube for music, dance videos, and demonstrations of art activities. Enjoy! Whenever I explore online, I'm amazed and gratified that there are so many creative, resourceful people out there sharing countless wonderful ideas for free.

If you're looking up a specific topic such as Native American history, your librarian may be able to recommend sites that have reliable information.

Artists

Learning about artists, both old masters and contemporary ones, can be fun, motivating, and educational. Since there are countless ways to do art, learning about different artists' work can motivate your children to try a variety of techniques, materials, and formats. And exploring the life and times of artists can be a fun way to learn about all kinds of other subjects such as history, religion, social studies, and science.

One way to learn about an artist is, again, through books. Look up an artist with your child at the library or bookstore, online, or in a museum, and learn together. Go with what you know of your personality and that of your child. Would you rather start out with a children's picture book that has a simple introduction to the artist and a few reproductions? Some are even fictional and provide an engaging introduction to the artist's world. Or would a coffee table book, with hundreds of photos of the artist's work, be inspiring?

Seek out working artists in your community by participating in an open studio stroll. Most studio districts open their doors to the public once or twice a year. You can see the artists' spaces and their art, talk to them face-to-face, and sometimes even see them at work.

Art Museum Scavenger Hunt

A scavenger hunt can make it fun for young children to explore art museums with their family.

For ages 2 and up

MATERIALS

- Paper
- Pencil or other writing tool
- Digital camera or camera phone (optional)

INSTRUCTIONS

1. Before visiting the museum, talk with your children about the artwork they will see there—how there will be lots of different sizes, subjects, mediums, artists, and types of artwork.
2. Ask what they think they will see and what they would like to see.
3. Based on your conversation, come up with a list of items you will look for as you explore the museum, such as robots, pictures of children, seashells, birds, castles, or red circles.
4. Write down the scavenger hunt list on a piece of paper (or let your children do it).
5. Take the list with you and keep an eye out for the items during your visit. Talk about each item you find and the artworks in which they appear. If you wish (and if the museum allows it), take photographs of the items you find for a visual memento of your scavenger hunt and for later review.

Hummingbirds, Pebbles, and Maps: Writing Poems with Children

Susan Marie Swanson

Poems are art made of words. Perhaps more than other art forms we explore with the children in our lives, the writing of poems overlaps academic and skill work. But poems can be as free and playful as finger paintings. Here are three ways of thinking about writing poetry with young children:

- Poems can appear by surprise, like hummingbirds in the garden.
- You can look for poems the way you search for just-right pebbles on the beach.
- Poems can be written through observation and thoughtful effort, as when you read a map and start hiking.

Hummingbirds

The poet William Stafford once said, "Talk with a little luck in it, that's what poetry is." Maybe you and your child will begin writing a poem by jotting down an intriguing thing that somebody says at the kitchen table: "The sky is like a giant jar," or "What if I lost my bed?" You write the words down and enjoy them together. Look, it's a poem!

Pebbles

If you want to undertake a more deliberate search for poems, a notebook will help. Another poet, Naomi Shihab Nye, has said that if you keep a notebook, "your thinking will befriend you. Words will befriend you." What happens if you and your child make a list of things you like about spring? How about if you blow some bubbles and jot down some of the words that float through your heads? Maybe you'll even find a pebble that sparks a poem: "This rock is smooth like water," or "That rock makes me think of a bear's tooth."

Maps

When you set out to write a poem, other poems can show you the way.

> Twinkle, twinkle, little star,
> How I wonder what you are!
> Up above the world so high,
> Like a diamond in the sky.

This little poem by Jane Taylor is full of friendly suggestions for young poets and their helpers: repeating words, talking about things we wonder about, writing about something up in the sky. Most intriguing of all, what about writing a poem that talks to a star—or the moon or a pickup truck or a hamster?

Maybe your poem can include comparisons:

> Star, you are as bright
> as the key
> that unlocks the door to my house.

It may also include observations:

> Star, sometimes you disappear.
> The clouds rush across the sky
> and get in your way!

And questions:

> Where do you go in the morning?
> Star, where do you go?

You can find more maps—that is, poems—at your local library. It often takes a bit of effort to find the selection of children's poetry (in the nonfiction section), but they're there, right near the jokes and riddles. Look for two big,

bright anthologies compiled by Jane Yolen and Andrew Fusek Peters: *Here's a Little Poem* and *Switching on the Moon* (Candlewick Books). Lee Bennett Hopkins has edited some welcoming small collections published in an easy-reader format, including *Surprises* and *Weather* (both available in paperback from HarperCollins).

Another thing to remember as you explore children's poetry is that many picture book texts are poems. A famous example is *Goodnight Moon.* Two recent books by Deborah Underwood are poems-in-picture-books: *The Quiet Book* and *The Loud Book* (Houghton Mifflin).

Explore different ways of playing with words together. Try writing things down for children or trading the pencil (or marker or computer) back and forth. Invite them to write, inventing their own spellings for words. It may be more fun to write on long strips of paper, in small booklets, or on paper plates. You can make a list of words, cut them out, mix them up, and glue them back down.

Writing poems for particular readers can be fun. A small person may need her very own goodnight book, or a special friend or relative might enjoy learning some new verses for "Skip to My Lou." You can even add a little bit of poetry about dandelions or robots to a birthday card.

In poetry, we can celebrate language and the small moments and observations in our lives. A child's pencil can be a magic wand or a fishing pole or a flashlight or. . . .

7

Storing, Displaying, and Sharing the Art

A work of art is a world in itself reflecting senses and emotions of the artist's world.
—Hans Hofmann

Children can be prolific, and most parents are inundated with an overflow of paintings and drawings they're not sure what to do with. Even families who don't do a lot of art at home need to find a way to manage the large quantity of artwork their children bring home from day care or school. Some parents chuck much of it in the trash because they just don't know what to do with it, or they don't understand or value it. Others may start saving some of the art when their children get into realism, but they don't pause to consider that their little ones' scribbles and other abstract works might have merit. What should you do?

Storing Art: The Big Conundrum

I started out keeping every piece of paper my first daughter made a mark on, but I soon realized this wasn't practical or even desirable. The number of pieces was incredible, and many of her drawings were quick scribbles—she could go through pages and pages of paper in the course of a few minutes. Now I put each child's art (what doesn't go up on the wall or get shared with friends and family) in clear plastic boxes with lids, labeled by name and age, with two to three years' worth of art in

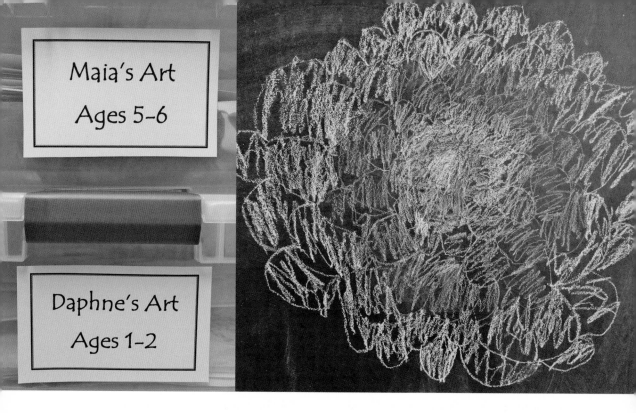

each box. Sometimes I sort as I go, and sometimes I put all the artwork in the box and sort for what to keep and what to toss at the end of six months or a year. *Tip:* Write your child's name and the date on each piece of art as soon as it's finished; for example, Desmond, June 2013. You probably won't remember later.

You can store everything your children create, and some parents do. Most, however, choose to keep what they feel are the best and most interesting pieces. I add in any that show developmental changes—the first circles, mandalas, or faces. If you choose to do this, you'll want to do the sorting yourself and do any tossing or recycling on the sly. As your child gets older, you can involve him in deciding what to keep, what to share or recycle into other artwork, and what to throw out.

Besides using plastic boxes, as I do, there are many other options for storing art. You can use large, flat portfolios (we use one of these for oversized artworks) or make your own with poster board, ribbon, and packing tape. The L'il Davinci Art Cabinets are display frames that double as storage and hold up to a hundred pieces of paper

each. You can also use dresser drawers or file cabinets. Some people use paper grocery bags or cardboard boxes, but they are acidic and will make the artwork yellow and deteriorate at a faster rate, so they're not a good long-term storage solution.

You may want to take digital photographs of your children's artwork and save them on a computer or flash drive. Photographs work especially well with ephemeral art (such as snow sculptures and land art); sculptures (like papier-mâché volcanoes or toothpick-and-marshmallow sculptures); and anything else that can't be saved (including window drawings, bathtub paintings, chalkboard masterpieces, and string installation art). Take a photograph of the artwork, with or without the child, as a way to remember it later.

Use the photos you take to create a photo book of your child's artwork. This both saves the artwork in an easily accessible, visual format and allows the artist and family members to flip back through his past creations.

There are many websites you can use to make books, calendars, or other products with the art (see the resources section at the back of the book for suggestions). Upload photos or scans of artwork to your chosen site and use the company's software to create anything from mouse pads to mugs. You can include photos of three-dimensional and ephemeral artwork alongside drawings, paintings, and collages. Mural-size works can appear next to the smallest two-inch drawing. And you can include photos of your child actually making the art. If you don't want to do the work yourself, you can even send a box of your child's art off to a company such as SouvenarteBooks, which will scan the artwork and assemble a book for you.

Display the Art

Of course, you will want to display the wonderful drawings and paintings your child creates, whether you frame them for the wall or hang them on the fridge. I cycle our family's art in and out of our collection of frames. They hang around the house intermingled with photos and other art we have on display. We also tape some pictures directly to the walls without frames—especially if they're large, such as those on 2' × 3' poster board or butcher paper. This temporary display solution works well for us—after a while, we take them down and tape up something new. Paintings on stretched canvases also go up as is, without frames.

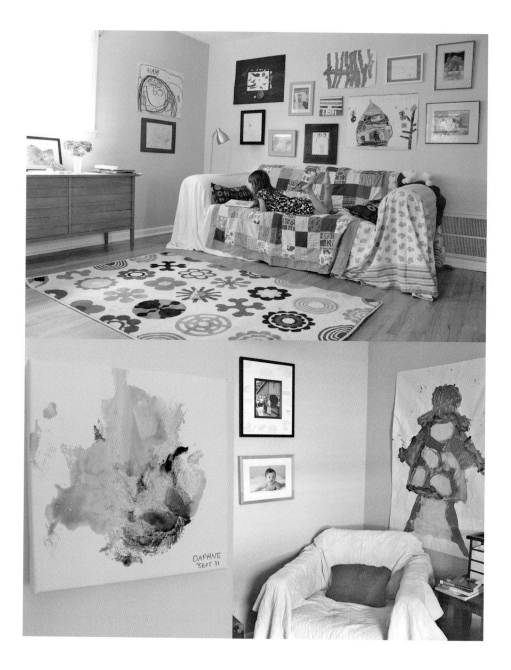

Our frames are a motley collection; some were picked up on sale at the art supply store, some are from the thrift shop, and some were passed down. We also use a lot of acrylic box frames. They're inexpensive, we like how they look (quite modern), and it's super-easy to change the art in and out of them. Old wooden frames are easy to find at thrift shops and can be painted to look like new. You can also buy unfinished wooden frames at the art supply store and decorate them yourself with paint or collage.

You were born an original. Don't die a copy.
—JOHN MASON

Art display wires allow you to create an easy, ever-changing art gallery. You can rig your own with a couple of hook-eye screws and a length of flexible wire. Some stores, such as IKEA or Pottery Barn Kids, even sell special display wire kits. The benefit is that it's easy to hang the latest and greatest masterpiece right away. You can also add other items to your display, including photos, newspaper or magazine clippings, letters, birthday cards, pretty leaves, and trinkets.

The refrigerator is a popular children's art showcase. It's usually in a central location, and it's quick and easy for all ages to hang art with magnets.

If your artist in residence has been especially prolific lately and is proud of her artwork, then consider inviting friends over for a home art show. In preparation, hang her recent artworks together around the house or living room, with or without frames, and add museum-worthy descriptive tags with the title, artist's name, and materials used. An invitation created with a photocopy of a favorite artwork and the details of the event can be sent or handed out to friends.

Hang plenty of artwork at children's eye level rather than everything at adult height. Offer sparkling grape juice and snacks to munch on, play music, and let the guests mingle and admire the art. The young guests can make art as well. A group art activity such as Jackson Pollock splatter painting (see page 202), Simon Says drawing (see page 252), or musical chairs painting (see page 262) will add an interactive element to the event.

Sharing Art

One of the best ways to work with an abundance of art is to share the wealth! Sending art to family and friends is a wonderful way to reduce the pile. Maia often has a

recipient in mind when working on a new drawing or painting. It may be someone in our household, but just as often it's Aunt Jenny or Grandma, a friend, or a neighbor. We jot a quick note to accompany the artwork and then pop it in the mail. Just because we are experiencing art overflow, it doesn't mean relatives or friends are too. They may appreciate hearing from the children and pinning up a few of their creations. I try to keep a stack of envelopes handy for mailing (both letter-size and 9" × 12" manila envelopes). I also recently stocked Maia's writing desk with her own

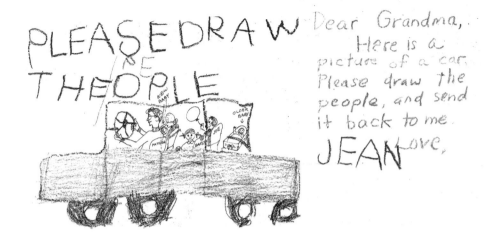

return address labels, as well as a series of mailing labels preaddressed to the people she writes to most often—grandmas, aunt and uncle, pen pal, and friends. This way she can affix the correct label to the envelope herself as she prepares to send her art.

Your child might like to receive art (and mail, of course) as much as send it. Try encouraging grandparents to send their own drawings to your child, if they don't do so spontaneously. When I was little, I would draw part of a picture, send it to my grandmother, and ask her to complete it. One time I sent her a drawing of a car; she added a large family, complete with pets, and sent it back—a wonderful cross-generational drawing! My grandma is an experienced artist, a big plus for me, but if you've read this far, you know that this isn't a prerequisite.

You might also initiate a round-robin picture. Your child can start a picture with an image, pattern, or collage and send it to a family member or friend, instructing him to add to the picture then pass it along to one or more other family members before returning the completed drawing.

You might find a pen pal your child's age who would like to write notes and send artworks back and forth. Sharing art is a great way for prewriters to communicate and send and receive mail. Children can dictate letters to be included or just mail

the art. As they master writing, they begin sending simple notes to accompany the art. Does your child have a cousin of similar age who might be interested? Or do you have any friends in different states who have kids? There are also official pen pal programs, although not specifically about art, that can arrange pen pals for your children (usually for a fee). A couple include www.penpalkidsclub.com and www .amazing-kids.org.

Art postcards and art envelopes are two more ways to share art with friends. Pictures can be created specifically with this use in mind, or you can repurpose existing artworks into postcards and envelopes. Find a stack of paintings or drawings on heavier paper, such as watercolor paper or poster board, and using an existing postcard as a template, cut out cards from the artwork. You can also create new art postcards from scratch by painting or drawing on postcard-size card stock. To use the less-expensive postcard-rate stamp, U.S. postal regulations state that postcards must be at least 3½" × 5" and no more than 4¼" × 6"; other sizes or dimensions

require letter stamps. On the back of the postcard, draw a line down the middle to separate the note side from the address-and-stamp side. Once you have a stack of postcards ready, send them off with brief notes. Alternatively, tie a stack of several together with a ribbon and give them as a gift to a relative or friend.

Okay, so now your children's works of art are buzzing off to all corners of the country and world to friends and family and pen pals, right? Your family's art has wings!

Give Old Art New Uses

There are countless ways to repurpose art. You can turn it into wrapping paper, seasonal decorations, handmade books, or collages as you introduce the idea that art can be used for more than just hanging on the wall or fridge.

Involve your child in the reuse of her artwork and be respectful when giving it a new purpose—ask permission or inquire if she'd like to make a book with some of her paintings and then let her help select the ones to use. If you're headed for a birthday party, your child can help choose a painting to wrap the gift in. Or simply say, "The colors in this painting are so beautiful. Would you like to wrap your gift to Susie in it?" or "Do you want to draw a card for Henry or find one of your paintings

to use for a card?" That way you involve your child in the idea, selection, and process. You give her veto power and respect her creations and feelings.

Here are some ways to reuse artwork:

• *Wrapping paper.* Paintings and drawings created on larger paper, such as easel paper, are well suited for use as gift wrap.
• *Decorations.* Paintings and drawings, especially abstract ones, can be repurposed into seasonal decorations to use around the home. Cut out the artwork into shapes, such as hearts or stars; punch holes in the top with a hole punch; and string them up as garlands, mobiles, or individually. Cut accordion paper dolls (or birds, snowmen, or flowers) from paintings and tape them together. Cut triangles and attach them to ribbon for a festive garland (see page 125) to use for a party or just because. Cut strips out of colorful paintings and glue or staple them into a paper chain. The ways to reuse artwork for decorations are endless!

- *Accordion books.* Take a large painting from easel paper and fold it in half lengthwise. Then fold in half horizontally and fold each end to the center. You now have the foundation for an accordion book. Add and decorate cardboard covers from cereal boxes and write a story in your book.
- *Collage.* You can also repurpose old artwork into new through collage. Cut or tear the art into smaller pieces to glue onto paper or card stock as part of your collage making.
- *Notecards.* Cut small sections from large art and glue to blank notecards.
- *Envelopes.* Use an existing envelope as a template to cut out new envelopes from paper-based artworks (see page 126).

No-Sew Festive Banner

Even nonsewers can make festive banners for birthdays, holidays, and general decoration.

For ages 5 and up

MATERIALS

- Card stock
- Pen
- Colorful pictures (from artwork, an old book, or a calendar)
- Scissors
- Ribbon
- Hot glue gun

INSTRUCTIONS

1. Cut a triangle from a piece of card stock to use as a template.
2. Using this template and a pen, trace triangles onto the artwork.
3. Cut out the triangles.
4. Line them up in the order desired.

5. Cut a piece of ribbon the length of the lined-up triangles, leaving enough extra on each end for hanging your banner.
6. Using the glue gun, run a thin line of hot glue along the top front of the first paper triangle and attach the ribbon. Continue with the next triangle and so on, until your banner is complete.
7. Hang and enjoy.

Artful Envelopes

Jazz up your mail and repurpose old artwork by creating artful envelopes.
For ages 4 and up

MATERIALS

- One envelope (the same size as the one you're going to create) to use as a template
- Paper artwork
- Marker or pen
- Scissors
- Glue stick or transparent tape

1. Carefully deconstruct the envelope until all the flaps are open.
2. Lay the open envelope on the wrong side of your artwork and trace around it with your pen.
3. Cut along the outline.
4. Fold your new envelope the same way the original envelope was folded.
5. Glue the flaps of your artful envelope closed with the glue stick, leaving the top flap open. Alternatively, use transparent tape to fasten the edges.
6. Depending on how busy or dark the image on the envelope is, you may need to use address labels (or tape on pieces of plain paper) rather than write the address directly on the envelope.
7. Insert your letter and seal the envelope using a glue stick or tape.
8. Keep the deconstructed envelope as a template for future artful envelopes.

VARIATIONS

- Use magazine pages or old calendars to create colorful and unique envelopes.
- Make a matching card by gluing a square of the leftover artwork to a blank card (or piece of folded paper).

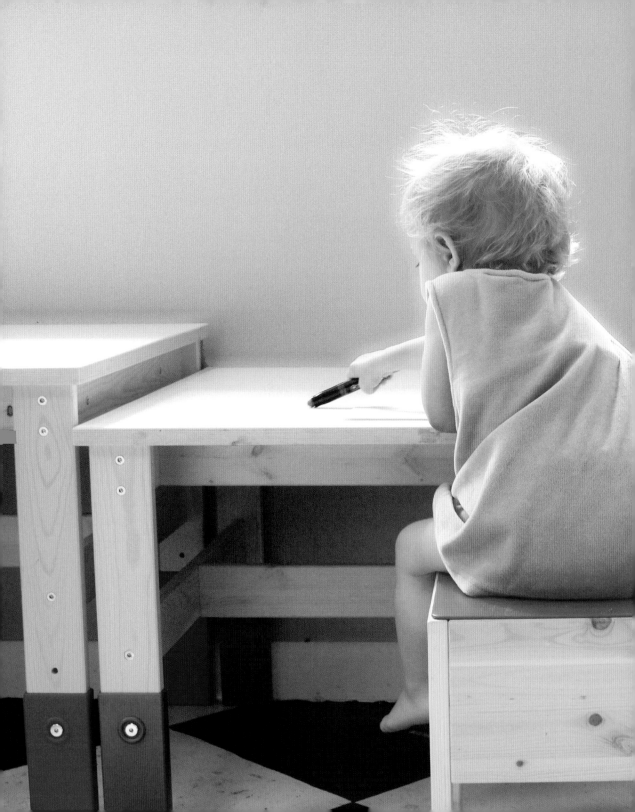

part **2** | artful activities

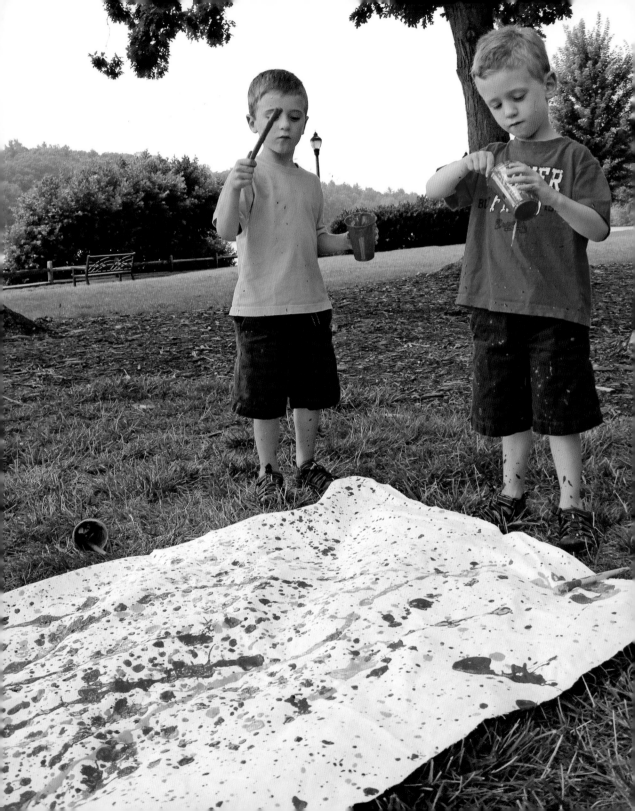

8

First Forays into Art

A child's mind is not a container to be filled but rather a fire to be kindled.
—Dorothea Brande

Sometimes we need to ease into art with simple and rewarding art activities. Perhaps with those that are appropriate for a toddler just beginning to explore materials and the art world. Or those suitable for a family that is relatively new to art. This chapter includes several projects that are both easy and engaging introductions to art, as well as several of our favorites. We've continued to do many of them long after they could have been considered "first forays." Activities such as monoprinting, scribble challenge drawings, and salty watercolors have remained central to the art making we do together as a family and in our art group.

For example, contact paper suncatchers, the first activity in this chapter, is one that we've done over and over with countless variations. We've tried a range of materials, made a variety of frames, explored both two- and three-dimensional versions, and used them to decorate for and celebrate just about any holiday you can think of.

So while this chapter is titled "First Forays," don't assume you'll be leaving these activities behind anytime soon. I hope they'll become your favorites as they've become ours!

Artful Activity 1 | Contact Paper Suncatchers

Make easy and beautiful suncatchers with simple materials.
 For ages 18 months and up

MATERIALS

- Colored tissue paper
- Scissors
- Clear contact paper

- Feathers, flowers, natural items, and ribbon (optional)
- Masking tape

INSTRUCTIONS

1. Tear or cut the tissue paper into small pieces.

2. Cut the contact paper into a square or whatever shape and size you

want your suncatcher to be. This is the base of the suncatcher.

3. Tape the contact paper down, backing side up, on the table. Use small curls of tape on the clear side of the contact sheet.

4. Pull off the protective paper cover.

5. Stick pieces of colored tissue paper to the sticky contact paper. Add natural items, feathers, or ribbon, or use them instead of the tissue paper, if desired.

6. When you're satisfied with your design, cut another piece of contact paper to cover the first. Peel off the backing and lay it on top, sticky side to sticky side.

7. Trim the edges and add a masking tape frame, if desired.

8. Hang in the window and let the light shine through your suncatcher!

VARIATIONS

- Use a paper plate with the center cut out as a frame for your suncatcher.
- Try making seasonal suncatchers: flower petals are gorgeous in spring or summer; autumn leaves are spectacular in fall.
- Make suncatchers directly on the window by taping your clear contact paper to the window, sticky side out, and work standing up.
- Draw a picture on the contact paper with markers then fill it in with different colors of tissue paper.

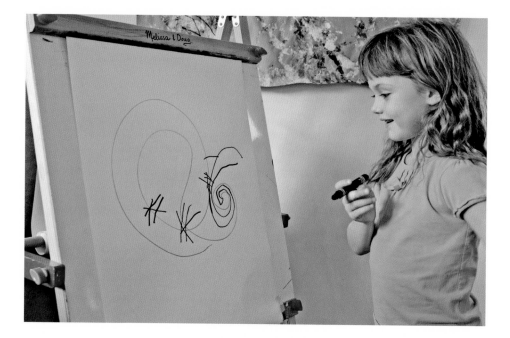

Artful Activity 2 | Scribble Challenge Drawing

Get the wheels of your brain turning with this drawing activity that works as well one-on-one as it does with a family or other group.

For ages 3 and up

MATERIALS

- Drawing paper
- Pens, crayons, or markers
- Timer or hourglass (optional)

INSTRUCTIONS

1. Each person starts with a sheet of drawing paper and a drawing implement, and scribbles something abstract on the paper.

2. Everyone hands their scribble to the person to their left (or just swaps with someone).

3. Set the timer for a predetermined time, perhaps two to three minutes.

4. Each person finishes the drawing they've been handed, using the scribble as a starting point. If the scribble reminds you of a fish, you can draw a fishbowl or an ocean. If the scribble reminds your child of a cloud, she can finish the scene with mountains or a house. Anything goes. Younger children may continue with abstract drawings or just color in the scribbles.

5. When the timer goes off, drawing stops and the group shares the finished drawings.

PARROT

Artful Activity 3 | Body Tracing and Painting

This activity gets children seeing and thinking about their bodies and helps them work on their sense of self.

For ages 2 and up

MATERIALS

- Large paper such as contractor's paper, butcher paper, or two long sheets of easel paper taped side by side
- Tape

- Markers
- Tempera paint
- Paintbrushes

INSTRUCTIONS

1. Tape the paper to the floor.
2. Have your child lie on the paper and spread her arms and legs a bit

or make a fun pose (jumping, dancing, flying), if she likes.

3. Trace the outline of her body with a marker.
4. Invite her to paint in the outline with color, designs, or features.
5. Let the tracing dry, then hang it on the wall.

VARIATIONS

• Offer your child fabric scraps and glue and let her "dress" the body outline.
• Give her printing materials such as sponges, bubble wrap, a mesh bag, or scrunched-up paper. Press them to an ink pad or dip them in paint, then press them on the paper to add texture prints.

• Ask if she'd like to add any of her features (such as eyes, nose, or ears) or inner organs (heart, lungs, or veins). Read a book about the body together first, such as *See Inside Your Body* by Katie Daynes and Colin King (Usborne Books, 2006).

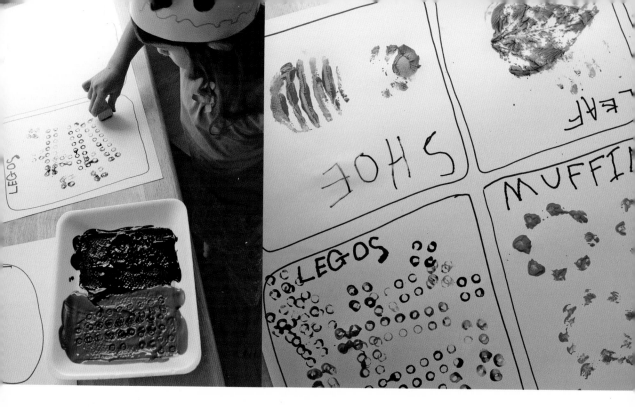

Artful Activity 4 | Printing with Everyday Materials

Experiment with textures and patterns by making prints using a variety of found objects.

For ages 18 months and up

MATERIALS

- Heavy paper or poster board
- Tempera paint
- Everyday materials for printing, such as the following:
 - Thread spools
 - Fruit (lemon, star fruit, strawberries, or apple), cut in half
 - Vegetables (cauliflower, broccoli, or onion), cut in half

- Kitchen tools (potato masher, fork, whisk, or cookie cutters)
- Scrunched-up foil, paper, or plastic wrap
- Bubble wrap
- Fabric of different weaves
- Sponge, sea sponge, or Scrubbie
- Leaves, grass, pine boughs, or flowers
- Doilies

- Hands, feet, or shoes
- Toys (Legos, Tinkertoys, action figures, cars, or animal figurines)
- Playdough or clay
- Yarn, string, or cooked spaghetti
- Anything else you want to try

INSTRUCTIONS

1. Prepare by setting out your paper and printing tools. Pour the paint into a shallow dish or create a temporary stamp pad. Spread a sponge or washcloth in a dish, add a thin layer of paint all over, and let the fabric or sponge soak it up.

2. Take a printing tool, dab it in the paint or press it on the stamp pad, then press it firmly to the paper. Lift to reveal the print.

3. Repeat with as many found objects as you like (perhaps spread out over several art sessions).

VARIATION

- If desired, divide a large sheet of paper or poster board into sections, add labels, then place appropriate prints within each section.

Artful Activity 5 | Salty Watercolors: Watch the Paint Travel

Watch the paint travel along lines of salt-covered glue as if by magic. These paintings dry into sparkly, colorful works of art.

For ages 2 and up

MATERIALS

- Salt (one or two containers of inexpensive table salt)
- A large baking pan with sides or an art tray
- Card stock, poster board, or heavy watercolor paper
- Squeeze bottle of white school glue
- Watercolor paints (Liquid watercolors work best for this project, either the kind that comes premixed or the kind that comes in tubes that you mix with water.)
- Paintbrush

1. Pour a layer of salt into the baking pan.
2. Draw a design on the card stock with the glue bottle.
3. Set the card stock in the baking pan. Scoop up the salt and sprinke it generously over the glue design. Tip the card stock and tap the excess salt into pan. Repeat until the glue lines are completely covered with salt.
4. Dip a paintbrush in the paint and gently touch it to a salt-covered glue line. Watch the paint travel. Repeat with different colors of paint at different points until the design is covered.
5. Let dry (this may take two to three days).

NOTE

- Even when you instruct children just to lightly touch the brush to the paint, younger children may still paint or scrub with their brush, spreading the glue, salt, and paint around. That is okay and normal. If you repeat the activity periodically as they get older, they will resist painting with the brush and will instead be enchanted by watching the paint travel with the lightest touch of the brush.

Artful Activity 6 | Pick and Paint a Rainbow: A Color Mixing Activity

Pick a "rainbow bouquet" of flowers, bring them indoors, and mix paints to match the colors. Primary colors (red, yellow, and blue) can be mixed to make secondary colors (orange, purple, and green). White can be mixed with any of them to create lighter tints.

For ages 3 and up

MATERIALS

- Flowers or other items in an assortment of colors
- Tempera paints in red, yellow, blue, and white

- Cups to hold the paint—both the primary colors and the newly created mixed colors (A muffin tin works well.)

- Spoons
- Paintbrushes

- Heavyweight paper, poster board, or card stock

INSTRUCTIONS

1. Head outdoors with your child to find flowers in each color of the rainbow (or just several different colors), then bring them inside to your art space. If it's winter, you can either buy a bouquet of flowers from the florist or go on a hunt through your house for other colorful items, such as Matchbox cars, pencils, or bouncy balls.

2. Pour an inch or two of the red, yellow, blue, and white paint into separate cups. Add a spoon to each cup.

3. Use the spoons to move the paint to the empty (color mixing) cups. Encourage your child to mix two or more colors of paint together to get the closest match for each flower, such as red and yellow for orange, red and white for pink.

4. Test the paint colors on the paper.

5. When your child is satisfied with the colors, he can use them to paint a picture.

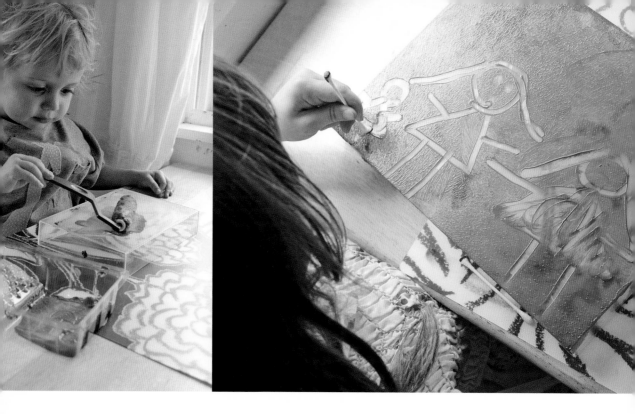

Artful Activity 7 | Monoprinting on a Plexi Frame

This easiest of printmaking activities produces a unique result each time.
For ages 2 and up

MATERIALS

- Tempera paint in one or more colors
- Shallow dish to hold paint (A plate works well.)
- Paint roller or foam brush
- Acrylic (plexiglass) box frame or a baking dish with a smooth bottom
- Q-tips
- Heavy paper
- Damp sponge or rag

INSTRUCTIONS

1. Pour a small puddle of tempera paint in the shallow dish.
2. Coat the roller evenly with paint.
3. Roll a thin layer of paint over the

top of the acrylic box frame to cover it.

4. Use a Q-tip to draw a scribble, design, or picture in the layer of paint.

5. Lay a sheet of paper over the frame and use your hands to press it evenly all over the image. An adult can help a younger child hold the paper in place as he presses it.

6. Lift the paper carefully to see the transferred image—a monoprint.

7. Wipe the paint off the frame with a damp sponge and repeat.

Having Fun with Crafts

Cassi Griffin

Take a moment and have a look at everything around you, from the carpet to the car, books to bridges, and furniture to clothing. It was all created by someone. Maybe it came from a factory, but the equipment and tools were designed by someone too. Most of what we have nowadays is made using automated processes, but at some point, it was made by hand based on the idea of a creative mind. When you begin crafting with your children, you foster a connection to all that has come before, and at the same time, you show them that they too can create something of value with their hands. Crafting involves and teaches patience, dexterity, attention to detail, tool mastery, following directions, and practical skills at the same time that it requires imagination. It inspires creativity while you work within the confines of a planned outcome.

You probably have some wonderful childhood memories that center around crafting and want to create some of those same memories with your own children. Think about what made those moments special and try to recreate the experience or consider the following ideas.

Make crafting time special by creating a warm, pleasant atmosphere. Decide if you want an intimate time with just one or two children and engaging conversation, or if you prefer to include family and friends of all ages for more of a party mood. Set aside at least a couple of hours when you are not worried about finishing at a certain time. Be happy and relaxed. Try not to have any preconceived ideas about how the project will turn out. Turn on some music in a space where there's comfortable seating and accessible work surfaces, along with plenty of light. It's important to use the best-quality tools you can afford, since tool manipulation will be enough of a challenge for some children without the added stress of using tools of inferior quality or ones that aren't right for the job. It's also nice to plan a little teatime break so you can discuss your project and address any frustrations. Make some homemade cookies

or pick up some fancy ones at the store, and serve juice or tea in special cups on a tablecloth with cloth napkins.

Don't feel bad if you're worried about the mess; with a little preparation and thought to your choice of materials, you can make cleanup as painless as possible. Have some water nearby, cover your surfaces with newspaper, and begin with materials that are easy to clean and leave little mess. Organize your materials and tools into containers so there is a place for everything. An empty garage is good for foul weather and messy projects, but when weather permits, consider working outside too. Last, make sure the kids are included in the cleanup process as well.

For most adults, confidence in crafting comes from experience, but children are more open to experimentation, so if you don't feel you have the confidence to get started, consider letting your child take charge. Start with simple projects that involve only a few steps and materials and then move on to more complicated ones. Some of my favorite projects are ones that are useful or that make lovely keepsakes. Ornaments, garlands, handprint crafts, and children's drawings that are embroidered or made into softies are just a few.

Waiting for glue or paint to dry will take patience, and having to complete more than a few steps for a project may test your own and your child's fortitude, but the moment when your project is completed and your child can say, "I made that!" will make you both proud. It's exciting and imbues children with a can-do attitude that connects them to earlier generations. It's a salient moment that you will want to repeat again and again.

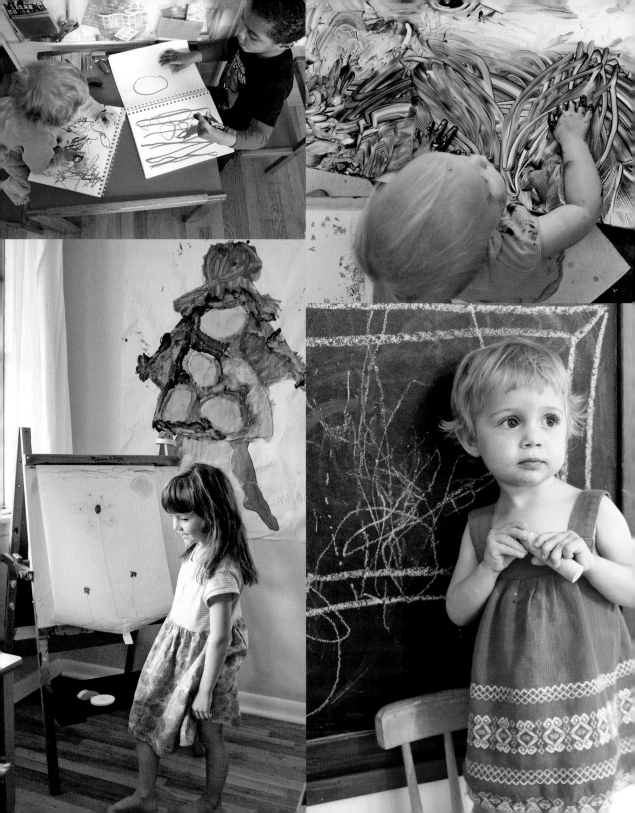

9

Quick and Easy Art

There are two lasting bequests we can give our children. One is roots. The other is wings.
—Hodding Carter, Jr.

As parents and teachers, we all want to have some quick and easy art activities up our sleeves to pull out when we have only a small window of time to use for art. We often need something that we can do immediately that doesn't require hand-holding, multiple steps, or lots of explanation. This chapter offers a selection of activities that require little preparation and are easy to incorporate into a family's day on the fly. These activities are as valuable as more elaborate options, but they are more accessible, faster, and easier. Most require just one or two materials that can be explored for either a few minutes or over an hour.

The most rewarding projects are often the simplest ones that children can do repeatedly on their own, building their skills over time and adding their own modifications. Basic activities such as drawing, painting, collage, or sculpture are perfect for this. For example, in making mosaics with dried beans, your child may create faces or scenes one day and patterns the next. The potential variations in just this one activity are endless.

Pointillism (creating pictures with dots) is another simple, low-mess activity with countless possibilities. You can use the point of a pen or marker. Try different thicknesses or colors. Outline a word or an image. Use Q-tips or cotton balls and

paint. Try watercolors or watercolor crayons. Stamp with a bottle cap or half a potato. Create the illusion of color mixing by placing dots of two different colors side by side.

It's okay to offer the same simple materials and activities over and over. Children learn through repetition. They can also explore the potential of these materials and activities in multiple ways.

Artful Activity 8 | Mondrian-Style Postcards

Use black electrical tape to mark off squares and lines in the style of Piet Mondrian, filling in spaces with small bursts of color.

For ages 3 and up

MATERIALS

- 1 sheet white poster board
- Ruler
- Scissors

- Black electrical tape or masking tape
- Markers, crayons, or paint

INSTRUCTIONS

1. Cut poster board into 4" × 6" pieces, using a ruler. Alternatively, you can use an existing postcard as a template.

2. Create a design of right angles, squares, and lines with black electrical or masking tape. Look at

some of Mondrian's works in a book or online first, if you like, to familiarize yourself with his style.

3. Use markers to color in one or more of the spaces. You can use bright primary colors (as Mondrian often did) or any colors that suit your artistic sensibilities.

4. Turn the postcard over and draw a line down the middle. Add a square in the upper right-hand corner for the stamp.

5. Write a note, add the address and a postage stamp, and send it off.

NOTE

• Younger children love to work with tape and can do a variation of this activity. For toddlers, place pieces of precut tape around the edge of a tuna can (or something similar) so it's easy for them to peel off and use.

Artful Activity 9 | Bean Face Mosaics

Use glue and a variety of beans to create faces, designs, and other mosaics.
For ages 3 and up

MATERIALS

- Glue bottle
- Heavy paper, card stock, poster board, or cardboard
- Dried beans arranged in small bowls, a muffin tin, or an egg carton (Try the bulk section of a natural foods store for a variety of colors, kinds, and sizes.)

INSTRUCTIONS

1. Use the glue to draw a face on the paper (if desired, your child can draw the face first with a pen).

2. Place beans in the glue in the desired pattern.

3. Continue with more glue and beans until the bean face mosaic is complete.

4. Let dry.

VARIATIONS

- Once the mosaic is dry, you can use another piece of paper and the side of a crayon to make a rubbing of your completed bean face.

- You can also try other collage items for the mosaic, such as beads, pasta, seeds, or crumbled dried leaves.

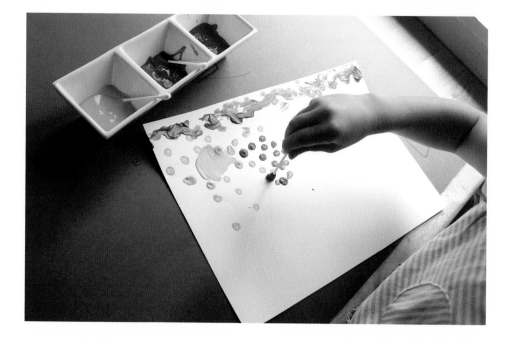

Artful Activity 10 | Q-Tip Pointillism

Create art in the pointillist style by making an entire picture with dots instead of solid brushstrokes. This technique was developed in the late nineteenth century by Georges Seurat as a branch of Impressionism. If desired, look at paintings by Seurat or other pointillists first, either at a museum, online, or in a book. *Sunday with Seurat* by Julie Merberg and Suzanne Bober (Chronicle Books, 2005) is a children's book showcasing his work.

For ages 2 and up

MATERIALS

- Q-tips, one for each paint color
- Tempera paint in one or more colors
- Paper

1. Dip a Q-tip in paint, then press it on the paper, making a dot.
2. Continue painting dots with the Q-tips to create any sort of image desired.
3. Try writing your name with dots or experiment with mixing colors; for example, red dots intermingled with yellow dots to give the illusion of orange. Stand back to see the illusion better.

VARIATION

- Use cotton balls to make larger dots or the tip of a pen to create smaller dots.

NOTE

- Younger children especially may choose to paint (that is, scrub back and forth) instead of make dots. It's okay to let them explore that option.

Artful Activity 11 | How Big Can You Draw? How Small? How Curly? How Blocky?

Explore different drawing styles with these prompts and challenges.

For ages 3 and up

MATERIALS

- Paper (You'll need different sizes, depending on the drawing activity. If drawing small, then provide small paper such as sticky notes, index cards, or pieces of paper cut into 2" or 3" squares. If you're asking, "How big can you draw?" provide butcher paper or contractor's paper. If asking how curly or blocky, any size is fine, but I tend to offer larger paper rather than smaller.)
- Drawing tool, such as pen, marker, or crayon

1. Set out paper of the appropriate size and a drawing implement.
2. Ask your child a challenge question, such as "How small can you draw?"
3. Let him draw.
4. Afterward, talk about how small he drew: "Wow, did you know you could draw that small? Look how tiny those people are." Or ask, "Can you draw even smaller than that? Show me." The same types of questions apply for curly drawings—can he draw curlier, less curly, big curls, tiny curls?

Artful Activity 12 | Trace Shadow Shapes

Observe the shadows anywhere there is a strong light source, whether it's the morning sun streaming through a window onto the dining table or a strong lamp set up behind a bouquet of flowers or arrangement of dolls. How interesting they are! Trace the designs and learn about shadows.

For ages 4 and up

MATERIALS

• Paper

• Drawing implement, such as pen, marker, or pencil

INSTRUCTIONS

1. Find a strong light source. Is there a shadow interesting enough for you to trace? Or can you put something (a bouquet, toy car, doll, family

member, action figure, or animal) between you and the light source to create an interesting shadow?

2. Tape your paper down so the shadow falls on the paper and the paper doesn't shift as you work.

3. Trace the outline of the shadow.

4. Hold your tracing up against the original item. Do you see the resemblance? How is it similar? How is it different? Is it longer or shorter? Do you know why?

VARIATIONS

• Try tracing the same item at different times of the day when the sun is higher or lower. You can also move the lamp or light source.

• If desired, you can fill in the shape with watercolor paints or crayons.

Artful Activity 13 | Paper Fun: Fold, Cut, Decorate

Have fun making different shapes and forms with paper using scissors, tape, a stapler, and a hole punch.

For ages 3 and up

MATERIALS

- Any kind of paper (construction paper, copy paper, drawing paper, recycled paper, origami paper, tissue paper, or coffee filters)

- Glue stick, transparent tape, hole punch, stapler, and string (optional)
- Scissors
- Drawing tools, such as pens, pencils, crayons, or markers (optional)

INSTRUCTIONS

1. *Make a tube* by rolling a square or rectangular piece of paper and taping or stapling the ends. If desired, decorate the paper first with a drawing tool, by cutting designs into it, or by punching holes around it.

2. *Make an accordion fold.* Fold over an inch or so of paper, press along the crease, then fold back the other way, again pressing along the crease. Continue until the entire paper is folded into an accordion. Fasten the bottom with a staple to create a fan.

3. *Create hanging spirals* by cutting inward spirals from a circle or a square. Hold the inner end and lift to reveal the three-dimensional spiral you created. Attach a string to

the top and hang. Decorate it with drawings or with holes cut out with a hole punch, if desired.

4. *Coffee filter snowflakes and doilies.* White paper coffee filters are inexpensive and work best for this project. Fold the filters in half, then in half again. Using scissors, cut out triangles and other designs. Open the filter to reveal the snowflake. If desired, paint with watercolor paints. These look beautiful hung in a window so the light shines through. You can affix them directly to the window with dabs from a glue stick (the glue washes off the glass easily when you're ready to remove it).

5. *Fold three-dimensional triangles* by folding a sheet of paper into thirds toward the center. Fasten the two outer edges with tape, glue, or staples.

6. Create *fringe* by making multiple perpendicular cuts along a piece of paper. It's fun to cut and can be used for decoration or weaving.

7. Draw *faces and people* and cut them out.

8. Make simple *pop-up cards* by adding a cutout to an accordion folded paper inside a homemade greeting card. Attach the cutout to one flat

end of the accordion fold and attach the other end to the inside of the card.

9. Draw a *scribble or squiggle line,* then cut along it for a fun way to practice cutting.

10. Make *a simple paper box.* Decorate before or after the box is made.

11. Fold *paper airplanes* and fly them.

Using Recycled Materials for Art and Craft Projects

Maya Donenfeld

I am constantly inspired by the limitless possibilities of ordinary materials. This stems from my own childhood, when resourcefulness not only was a necessity but was highly regarded. Keeping our planet healthy is the obvious benefit, but the process of transforming something humble, something we look at every day but might not truly see, is very exciting! Children have this vision. They can look at a cardboard box and recognize its unlimited potential for play. The ability to identify possible art materials in the recycling bin comes naturally to them. Collecting multiples of things lends itself best to art and craft projects, and abundance tends to increase children's natural desire to sort, explore, and discover.

Making materials available and accessible is key for maintaining a dynamic and creative environment for all ages. It's no different with items from the recycling bin. Incorporate them into your crafting area by keeping a basket of recyclables on a low shelf adjacent to the paints, markers, and glue. Make a practice of sorting the recycling with your children. Talk about the different properties of plastic, paper, and tin. Keep a designated bin just for them to claim their own treasures for future crafting. Ask questions like, "What does this look like to you?" or "What could you make this into?"

My favorite recycled materials for children are all paper-based items like

cereal boxes, egg cartons, and toilet paper tubes. They don't take up a lot of space when deconstructed or flattened and can handle a lot of manipulation like folding, cutting, gluing, and hole punching. In addition, paint, crayon, and marker all adhere well to the surfaces.

Tube Art

It doesn't take long to save up several empty toilet paper tubes. Enlist your children's help by keeping a basket in the bathroom for collecting, and ask them to let you know when there are three or four. The cylindrical shape makes the tubes an intriguing canvas for paint or collage. Let your children explore both mediums separately and then together. Set out tempera paints, tubes, and brushes, and see what happens. Do the same with ripped pieces of thin paper and glue. Demonstrate how to paint watered-down glue on the tube and then stick colorful paper scraps to it.

Nesting Tubes

By cutting a couple of tubes down in size, a simple set of nesters can be made. These are wonderful tools for talking about size and proportion and are in-

spired by Russian *matryoshka* dolls that fit inside one another. Keep one tube in its original size. Snip off a bit from the rest of the tubes to create graduated heights. Make a vertical slit down each of the smaller tubes, and overlap the edges a little to make them fit into one another. Tape the slit edges together. Paint and/or decorate the nesting tubes.

10

Getting Fancy

Children spell love . . . T-I-M-E.
—Dr. A. Witham

While all parents need some simple art activities in their repertoire, we also want special projects to do with our children. This chapter offers memorable activities that everyone will enjoy and want to do again and again. Many of them are more elaborate than those in other chapters, requiring a bit more preparation and time, but they are all well worth it.

You may want to save these projects for weekends, a free afternoon, or a special occasion. It's usually best to plan ahead a bit—read through the instructions, corral the materials you'll need, buy anything you don't have, and think about preparation and cleanup. There's no need to go overboard with the planning though. And if planning ahead crimps your style (as it does mine sometimes), then just go ahead and do it. You'll work it all out.

As you work side by side with your children to craft monsters from the recycle bin, try Styrofoam printing, or create a three-dimensional, flower-petal stained glass, you'll be constructing memories as well as artful creations. Experiment, learn through the process, enjoy the time together, and share in the pride of accomplishment. There's magic in art.

Just remember that "more elaborate" doesn't have to mean the activity isn't process-oriented or appropriate for younger kids. Some of these projects may be better suited to school-age children, but just as many can be completed by preschoolers or even toddlers with adult guidance and supervision.

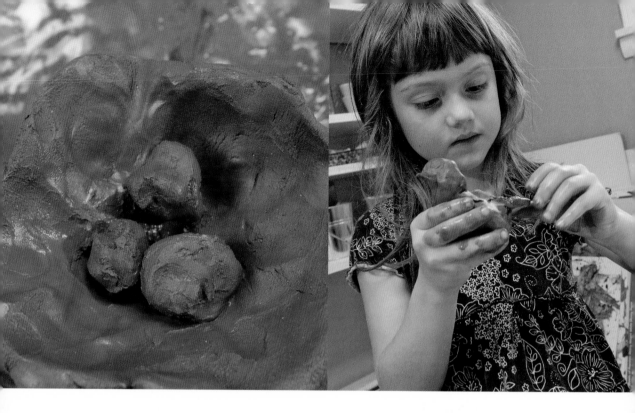

Artful Activity 14 | Clay Pinch Pot Nest with Eggs and Bird

This bird's nest is a fun, introductory project for working with clay. You can make pinch pots with playdough of course, but I recommend you buy a hunk of real clay and give it a try.

For ages 3 and up

MATERIALS

- Clay
- Bowl of water and rag

- Feathers (optional)

INSTRUCTIONS

1. Set up your work space. You'll need a surface to work on (a board, plastic place mat, or splat mat), plus a small bowl of water and a rag or washcloth for cleaning hands.

2. Cut off three lemon-size pieces of clay. Set two aside.

3. Let your child roll one of the pieces of clay into a ball. As she holds it, have her press a hole in the center with her thumb. (You can demonstrate this process with a ball of your own.)

4. With her thumb in the hole, she can work the clay around in a circle, pressing the edges outward as she goes and continuing until the pinch pot nest is a satisfactory size and shape.

5. Take the second piece of clay and divide it into three small pieces (or however many you like). Have your child roll each into a ball, either between the palms of her hands or between her hand and the table. Squish them slightly to make oblong eggs or keep them as spheres. Add them to the nest.

6. Take the third piece of clay and have your child fashion it into a bird with head, beak, wings, and tail (or any way she likes).

7. Add feathers to the bird, if desired, sticking them into the clay for the tail and/or wings.

8. Let the bird and nest air-dry and keep them as is, or enjoy them temporarily before letting your child squish them back into a clay ball that can be reused for future clay explorations. If you do the latter, make sure to take a photograph first!

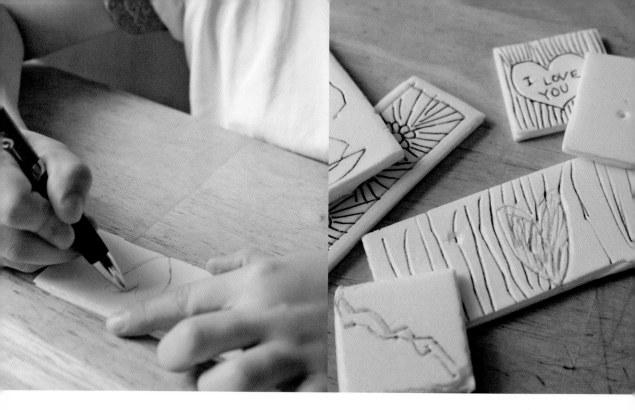

Artful Activity 15 | Styrofoam Prints: Make-Your-Own Stickers

Create Styrofoam designs, then use them to print your own stickers.

For ages 4 and up

MATERIALS

- Styrofoam or grocery foam trays (I get mine from the meat section at the grocery store by asking if they have a few clean ones. You can also reuse trays your food, such as nuts or vegetables, comes in.)
- Scissors
- Ballpoint pen
- Newspaper or splat mat

- Hard rubber brayer (from the art supply store)
- Plate or acrylic box frame (I keep one just for various printing projects.)
- Water-based printing ink (from the art supply store)
- Sheet of sticker paper and/or sheet of large address labels

INSTRUCTIONS

1. Cut the Styrofoam into desired sticker shapes—squares, circles, and so on.
2. Use the ballpoint pen to draw designs on the Styrofoam pieces, letting the pen sink into the surface as you work.
3. Set up your printing space. Protect the table with newspaper or a splat mat. Lay out your brayer, plate, ink, and sticker sheets.
4. Squirt ink on the plate and rub it all over with the brayer to get a thin, even layer of ink on the brayer.
5. Roll the brayer over the Styrofoam design to transfer the ink evenly.
6. Press the ink-covered Styrofoam to your sticker sheet, centering it over an address label, if that's what you're using, or just pressing it on a full sticker sheet (leaving room for more prints). Rub your hand or the back of a spoon over the Styrofoam to press it down evenly.
7. Lift the Styrofoam carefully to reveal the print.
8. Repeat to create as many stickers as desired.
9. Let the stickers dry.
10. If you're using a full sticker sheet, cut around the individual prints.
11. Use your stickers to decorate envelopes, stationery, letters, notebooks, or labels.

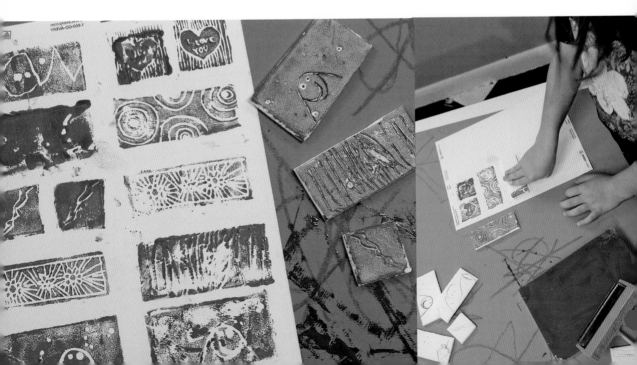

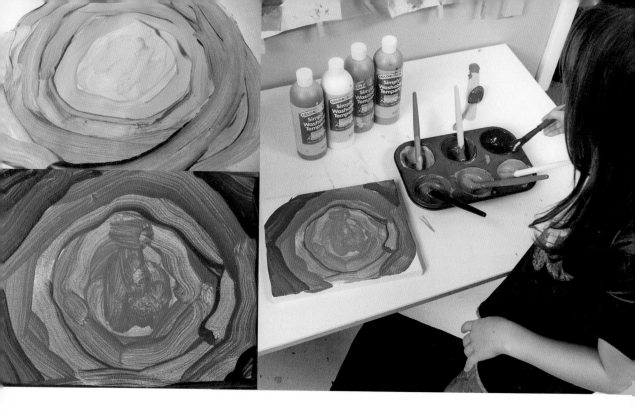

Artful Activity 16 | Create in the Style of an Artist You Admire

Children can learn about art history and art techniques by creating in the style of an artist they like.

For ages 5 and up

MATERIALS

• Whatever materials the chosen artist uses (or a close approximation)

INSTRUCTIONS

1. Choose an artist to work with.
2. As you study the artist and her work, think about the following:
 • What subjects does the artist work with? Still lifes? Political figures? Landscapes? Patterns? How could you try this yourself?
 • Does the artist combine art ma-

terials in an interesting way—for example, a paint-and-paper collage on top of old photographs? Is this something you could try?

- Does the artist work very big or very small? How does it feel when you work at that scale?
- What do you like about the art? The subject matter, the medium, the colors, the textures? Try making a piece of art with the same or a similar subject or style.
- What most attracts you about this artist and his or her work, and what would you like to try?

3. Now do some art inspired by your chosen artist.

4. Talk about the process. What did you learn from the experience? Do you want to do more? Or would you rather try something a little different? If so, what would you do differently next time? What other artists work in a similar style or with a similar subject matter? Did this experience raise new questions about the artist or his technique?

Artful Activity 17 | Melted-Crayon Spirals: Snakes and Snails

Use heat to melt your crayon as you draw, creating a smooth drawing experience and an especially vibrant artwork.

For ages 3 and up

MATERIALS

- Heavy cookie sheet or a warming tray
- Towel
- Paper
- Crayons with paper peeled back from the tip (Don't use stubs—you'll want long crayons to keep fingers away from the heat.)
- Oven mitt or winter mitten
- Watercolor paints (optional)

INSTRUCTIONS

1. If you're using a warming tray, turn the heat on low. If you're using a cookie sheet, set it in a 250°F oven to preheat.
2. Protect your work surface with an old towel that's been doubled over. Set the heated cookie sheet on top. (You can skip this step if you're using a warming tray.)
3. Lay a piece of paper on the warming tray or hot cookie sheet.
4. Hold a long crayon in your writing hand and protect the other hand with an oven mitt. Slowly draw spirals and squiggles on the hot paper. The crayon melts as you draw, creating intense lines.
5. Scribble and experiment as much as you like. You can also draw spiral snails and squiggle snakes. Use as many colors as you want, adding features such as eyes or designs on the snake.
6. Rewarm the cookie sheet between each drawing or anytime the crayon is no longer melting.
7. If desired, add a watercolor wash over the melted crayon drawing for a watercolor resist.

VARIATION

- Cover the back of the painting with vegetable oil to make it translucent. Hang it in a window as "stained glass."

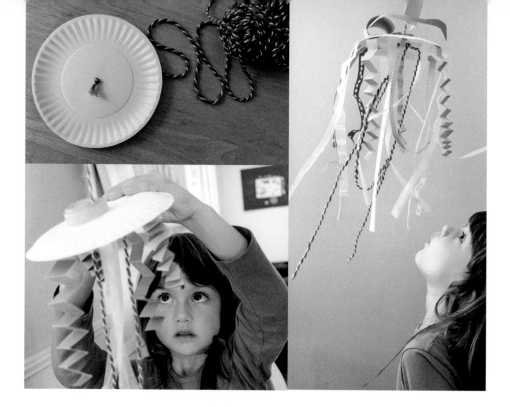

Artful Activity 18 | Paper Jellyfish Mobile

Create colorful mobiles out of paper that dance in the breeze.

For ages 3 and up

MATERIALS

- Paper plate
- Scissors
- Yarn
- Transparent tape

- Colored construction paper or other fun papers (try crepe paper, wax paper, tissue paper, newspaper)
- Hole punch and zigzag scissors (optional)

INSTRUCTIONS

1. Poke a hole in the center of the paper plate with the tip of the scissors.

2. Thread the yarn through the hole and add a knot on the right (eating)

side of the plate to hold it in place.

3. Turn the plate over and hang it from the ceiling or doorway using tape or a hook.

4. Cut, fold, and decorate thin strips of the papers as desired, using regular or zigzag scissors and a hole punch.

5. Tape the paper strips to the plate.

6. If desired, add paper sculptural elements such as curled paper strips to the top of the jellyfish mobile as well.

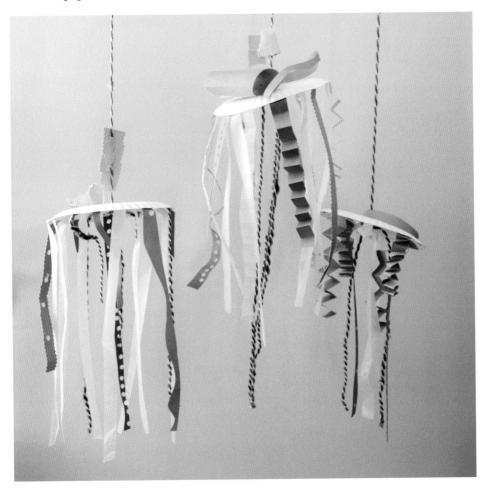

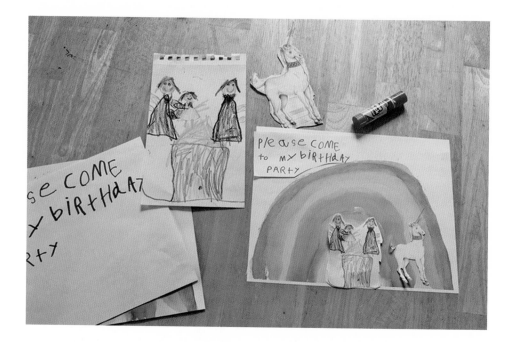

Artful Activity 19 | Copy Machine Art

Use the copy machine to create repetition, enlarge and shrink text and images, and combine multiple images and text.

For ages 3 and up

MATERIALS

- Collage papers or old magazine (to cut up)
- Scissors
- Copy paper

- Tape or glue stick
- Drawing tools, such as markers or pens
- Copy machine (many home printers double as copiers)

INSTRUCTIONS

1. Assemble drawn and cutout images as well as written and cutout text on one sheet of copy paper, using tape or glue to hold the various pieces in place.

2. If anything needs to be enlarged or shrunk before adding it to the main paper, do it on the copy machine. You can also create multiple copies of the same image, if desired.

3. Add your own hand-drawn designs, pictures, or text.

4. Use the copier to make as many copies of your finished artwork as you wish.

5. Use the finished work to send letters to friends and family, as invitations or thank-you notes, as posters, or simply as exploratory art.

VARIATIONS

- Create patterns by grouping multiple images or small items (coins or buttons work well) in piles and having your child create and repeat a pattern on the copy machine. Use the finished product as wrapping paper for small gifts, if you like.

- Experiment with color copies versus black and white.

- Draw on top of the copies, then copy again (a favorite method in our house).

- Explore math concepts by doubling the size of an object or reducing it to half its size.

- Copy three-dimensional objects to make them two-dimensional.

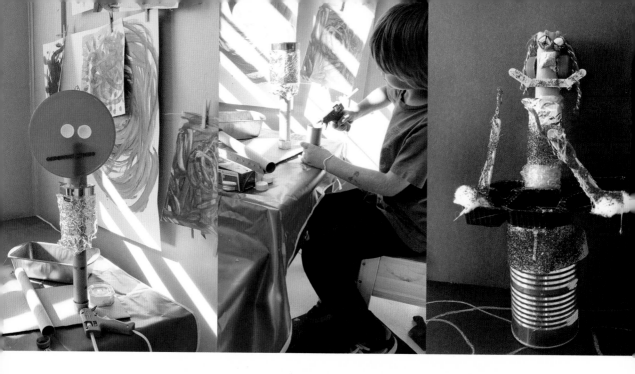

Artful Activity 20 | Crafting Monsters and Robots from the Recycle Bin

Assemble your own unique monsters and robots from boxes, bottle caps, and other recycle-bin treasures.

Ages 4 and up

MATERIALS

- Boxes, cans, toilet paper tubes, paper towel rolls, bottle caps, papers, cardboard, tinfoil, and other recycle bin and trash materials
- Glue (A hot glue gun works great—no waiting around holding the two items together while they dry—but you need to teach your children about glue gun safety first and be comfortable with the idea of them using one.)
- Tempera or acrylic paint (optional) Any extra tools your child might need, such as scissors, tape, and a hole punch.

INSTRUCTIONS

1. Choose the boxes or other items that will be used for the head and body, as well as the arms and legs if your monster or robot will include them.

2. Glue the boxes and other items together and let dry.

3. Add arms, legs, or other items until the monster, robot, or sculpture is complete.

4. Paint your creation, if desired, or cover it with a collage of papers or tinfoil.

5. Add details such as eyes, buttons, and ears with smaller recycle-bin and trash items.

6. Make sure to take a photograph when you're finished!

Children Can Use Glue Guns Too

While traditionally used by adults, some parents and teachers let their children and students use glue guns after teaching them about safety. As the preschool teacher and *Teacher Tom* blogger (www.teachertomsblog.blogspot.com) Tom Hobson says, "I think what I love best of all is using glue guns with the kids. A lot of schools ban them because of the worry about burns—and the kids *do* burn themselves—but for most of the children, that's a very small price to pay for the power of using that tool. Regular glue really limits them to horizontal creation, collage-like pieces. Maybe if they are very patient and work over many days, they can get into making three-dimensional art, but with a glue gun, it's instant. They envision a tower or a house or whatever, and bam, bam, bam, they can make it. Usually we use cardboard or wood scraps. I love watching the children create with glue guns; they concentrate so hard and are so proud of what they've made."

Tom's advice for getting children started with a glue gun:

- Begin by pointing out the hot tip and say, "If you touch this part, you will get burned." Also point out that the glue will be pretty hot for a few seconds as well (although it won't leave a mark like the glue gun tip will).
- It's important to give kids a proper place to set their glue guns down to avoid inadvertently putting a hand on it while they're concentrating on something else. An old pie pan works well.
- Keep a bucket of cold water nearby to plunge fingers into if they get burned.

Artful Activity 21 | 3-D Flower-Petal Stained Glass

Create a colorful, three-dimensional stained-glass artwork with flower petals and contact paper.

Ages 3 and up

MATERIALS

- Contact paper (transparent)
- Scissors
- Flexible wire (from the hardware store)
- Wire cutters or strong scissors
- Flowers and leaves
- LED votive candle light (optional)

INSTRUCTIONS

1. Cut a piece of the contact paper to the desired size and pull off the backing. Lay it on the table, sticky side up.

2. Cut a length of wire to form your outline and bend it into a circular or loose square shape over the contact paper.

3. Trim the contact paper around the wire, leaving a ½" to 1" margin. Fold this extra paper over the wire all around.

4. Tear petals off the flower blossoms and arrange them on the contact paper as desired.

5. Cut another piece of contact paper large enough to cover the first one. Pull off the backing and press it over the flower-petal design.

6. Trim off the excess contact paper.

7. Bend the wire to mold it into a dome or any other three-dimensional shape.

8. Hang your stained glass in the window to let the sunlight shine through. Or place it over an LED votive candle or a lightbulb in a darkened room.

VARIATIONS

- Use colorful autumn leaves in the fall.

- Use torn or cut pieces of colored tissue paper instead of flower petals.

NOTE

- As beautiful as this flower-petal artwork is, it won't last forever. The flowers will fade and some may decay. If you'd prefer to create something that will last longer, you can press and dry your flowers first between the pages of a book (phone books are good for this).

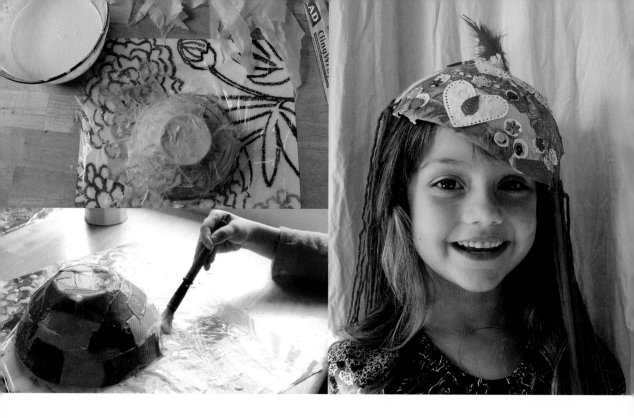

Artful Activity 22 | Papier-Mâché Dress-Up Hats

Add to your dress-up chest by making your own papier-mâché hats.
 For ages 3 and up

MATERIALS

- Bowl to fit on top of head
- Plastic wrap
- Colored paper, such as construction paper, tissue paper, or paper napkins, torn into strips
- Papier-mâché paste (see recipe that follows)
- Scissors
- Decorations, such as paper doilies, feathers, buttons, sequins, ribbon, yarn, or glitter
- Glue

1. Cover the outside of the bowl with plastic wrap that extends over the edge and is taped to the inside of the bowl. Set the bowl upside down on a work surface that is also covered with a piece of plastic wrap.
2. Dip paper strips in the paste and spread them over the bowl. Repeat with more paper and paste until you have two or three layers of papier-mâché covering the bowl.

Create a hat brim as you work by letting some of the paper strips extend down past the bowl and onto the covered work surface.
3. Let dry completely.
4. Gently pull the hat off the bowl and table. Trim the hat brim with scissors to shape and neaten the edges.
5. Decorate the hat by gluing on feathers, ribbon, sequins, or other decorations as desired.

VARIATIONS

- Dip paper doilies in paste and spread them over the hat for a pretty, lacy addition.

- Use newspaper rather than colored paper and paint the hat once it's dry.

NOTE

- Your child may like to use his hands to spread the paste-covered paper over the bowl, or he may prefer to use a brush.

Papier-Mâché Paste

Whisk 1 cup flour, 2 cups water, 3 tablespoons salt, and ½ cup white Elmer's glue together in a bowl.

Artful Activity 23 | Decorate Your Own (Pillow-case) Cape with Glue Batik

Make and decorate your own simple superkid cape with a pillowcase and glue batik.
For ages 2 and up

MATERIALS

- White pillowcase
- Splat mat or large plastic garbage bag
- Elmer's washable blue gel glue
- Acrylic paints
- Paintbrushes

- Tub of hot water for removing glue
- Stiff-bristled brush, such as a nail-brush or scrub brush
- Needle and thread
- Velcro

INSTRUCTIONS

1. Spread the pillowcase over the splat mat or plastic bag.
2. Use the glue to draw a design, name, or picture in the center of the pillowcase.
3. Let dry completely (this may take a couple of days).
4. Thin the acrylic paints with water (about half and half works well).
5. Paint over the pillowcase and glue design with the watered-down paints.
6. Let dry completely.
7. Soak the pillowcase in a tub of hot water for an hour to soften the dried glue.
8. Scrub the glue off with a stiff-bristled brush.
9. Let dry again.
10. Sew Velcro to both sides of the closed end of the pillowcase so you can fasten the cape around the neck (or use adhesive Velcro).

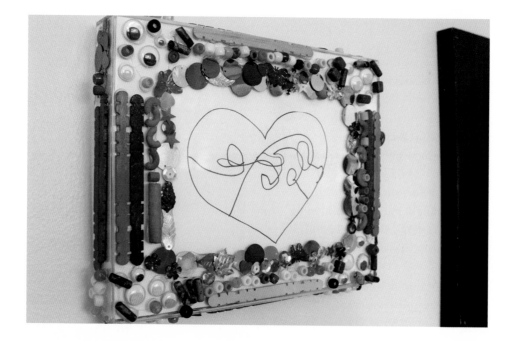

Artful Activity 24 | Make-Your-Own Collage Frame

Create your own interchangeable art frame using an inexpensive acrylic box frame and an assortment of collage items.

For ages 3 and up

MATERIALS

- Hot glue gun
- Small collage items, such as beads, buttons, and little figurines
- Acrylic box frame, 8" × 10"

INSTRUCTIONS

1. Use the hot glue gun to attach the collage items around the edge of the box frame. See page 181 for tips on glue guns and children, but if your child is young, you may prefer to wield the gun yourself. If so, you can

squeeze out a line of glue while your child carefully sets collage items in it before it cools and dries. You can also have her arrange the collage items on a piece of paper while you transfer them to the frame.

2. Insert artwork in the frame and hang.

Exploring Clay

Cathy Weisman Topal

There is no medium quite like natural clay for engaging children. Purchase moist, all-purpose, low-fire modeling clay from an art supply dealer, or look up local pottery studios in your area and ask about purchasing clay. Visiting a studio or local clay source to pick up your material can be an inspiring adventure. Natural clay usually comes in twenty- to twenty-five-pound bags.

Setting Up

There are so many ways to offer clay. Of course, you can always begin with a fist-size chunk. But also try placing a big block of it in the center of the work space and watch what happens. In summertime, set the block or roll of clay on a mat or tray placed on the floor or ground outside. Children can explore with both hands and feet. Try putting out thick cylinders of clay. Some can be lying down, and some can be standing up. Try making arches made from coils, balls, or slabs made by slicing the clay with a wire tool or a piece of wire attached to two beads or buttons. Enjoy experimenting. Find out what works for you. You can work directly on a table or use a board or mat.

Wonder Together

When introducing a new material, it just makes sense to wonder a little with your child by posing who, what, when, where, why, and how questions. What is this new material? Where does it come from? What do you know about it? What do you wonder? I'm always surprised by what children know and intrigued by what they wonder. And of course, "How can we find out?" is a great question to get everyone thinking and researching.

Getting Started

Working with clay engages the mind, body, and spirit. Clay gives instant feedback. All sorts of wonderful descriptive language can come from touching and manipulating it. Some children cannot wait to touch it and are instantly ready to jump right in. Others can be much more reluctant, especially if the clay is cold. Some just need to stand back and watch for a while as others explore. Don't force them, just delight in the feel of the clay squishing beneath your own fingers. Children will take the plunge when they're ready.

Hands Are the Most Important Clay Tool

There is no feeling quite like sinking hands and fingers into soft, malleable clay. In the beginning, tools just get in the way and interfere with this important sensory connection. Try posing a question such as, "How can you use your hands and fingers to change the surface of the clay?" Hand and finger actions elicit descriptive words and associations such as *poke, pinch, stretch, slide,* and *pound.* Each hand element—the fingers, thumb, knuckle, or fist—can affect the clay differently. Listing descriptive words as you hear them is a great way to build vocabulary!

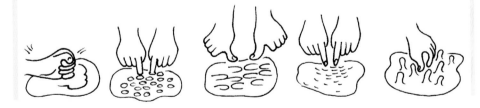

Squeeze, Poke, and Pull

Muscle action is necessary to squeeze, poke, and pull strong shapes from a block or ball of clay. Help your child gather strength by drawing attention to the muscles needed to change the shape of the clay. Start by standing up straight, taking a deep breath, and engaging your abdominal muscles. Bring energy and power up through your back and shoulders, then down your arms all the way to your fingers. (I place my hand on my children's backs to help them find the source of their own power and strength.)

- Let's squeeze a really tall shape.
- Let's try pulling out some strong protuberances or parts that stick out.
- Let's try poking some places in.
- Can you create a see-through place?

Practice Rolling Balls and Coils

One of my favorite ways to engage children is to challenge them to roll coils of many sizes and lengths. It helps to stand up when you're rolling and close your eyes. This way, your sense of touch takes over, and your hands seem to know just where to go and how hard to press.

Rolling balls is another action to practice. Try rolling balls and coils of different sizes and joining them together in a new way. People, animals, and all kinds of forms emerge as random shapes are joined together.

COILS and BALLS

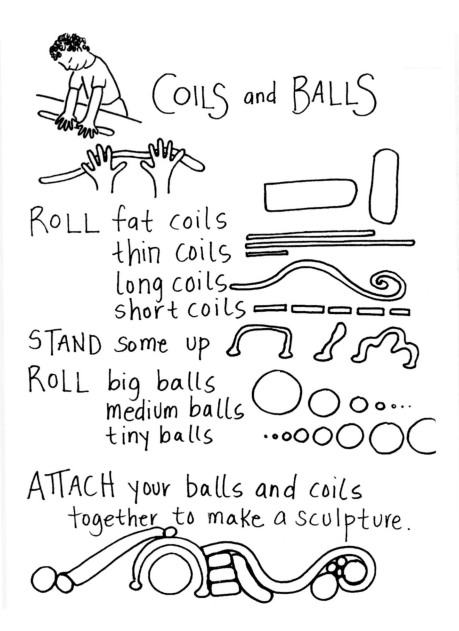

ROLL fat coils
thin coils
long coils
short coils

STAND some up

ROLL big balls
medium balls
tiny balls

ATTACH your balls and coils
together to make a sculpture.

Water

As you and your child use clay, it will begin to dry out. So you will need a little dish with a very small amount of water to offer when the need arises. Many people think that clay is messy. But it is really the amount of water that makes the difference. Offer the smallest amount, smooth it over the clay, and squeeze it in. Make the addition of water another adventure.

Keep a Notebook and Camera Handy

From the educators in Reggio Emilia, Italy, I have learned to pay close attention to the extraordinary insights and ideas of children that happen in every-day moments. I keep a notebook nearby to record their ideas and observations, and I write down quotes that strike me as unusual. When I want to inspire children to work a little longer, I read back my notes. A camera is another great tool to have handy. Use it to record images of work before the clay is put away for the day or for recording stages in the development of a project.

Clean Up

Use a scraper to get clay off your work surface (a spatula will also work). Roll the clay back into a ball. Poke a hole in the ball and pour in a little water. Close the hole before returning the clay to its plastic bag. Or store the clay in an air-tight, plastic container. When you take it out again, knead it like bread to even the consistency. If there is something you want to keep moist for continued work, place the clay on a board or piece of cardboard and cover it with a plastic bag sealed to be airtight. If the clay is drying out, drape a moist cloth over it before covering it with plastic.

Clay as a Building Material

You can also use clay as a building material—along with sticks, stones, shells, seedpods, small branches, and other natural materials—to create forts, hiding places, fairy houses, bridges, and other structures. Adventures with clay are endless!

11

Action Art

Creativity is an area in which younger people have a tremendous advantage, since they have an endearing habit of always questioning past wisdom and authority.
—Bill Hewlett

Action art may have been pioneered by grown-up artists such as Jackson Pollock, but it is wonderful for children too. It's perfect for young bodies that are eager to move and experiment ("What would happen if I dropped this paint-filled balloon off a chair?"). It's for kids who can't sit still. You know if you have one (I do). They are action personified; they run while other kids walk. They stand on top of the table when others sit quietly in their seats. They wriggle and move and fidget. Action art was made for these kids.

Action-based activities are also great for children who need a little encouragement to be more active. They will entice more sedentary or cautious kids to "rev up" a little. In my world, art is always a good way to encourage anything. It's fun and colorful. Some action art experiences may appeal more, and some may be outside your child's (or your) comfort zone at first. That's okay. There's no need to push. You can encourage without badgering.

Toddlers (and preschoolers) use their entire bodies when doing anything, including art. Since their whole world is action-oriented, this is just one more way of

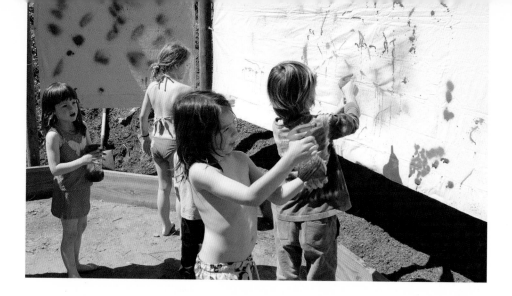

learning how to use their bodies to interact with the world in an exciting way. Toddlers work best when standing as they paint and draw (often big). Splatter painting, car painting, flyswatter painting, paint dancing—these are all joyful ways of celebrating their bodies, movement, and art all at once.

Action art is the antithesis to working carefully at a detailed drawing in a sketchbook. It is big, bold, and *active*. While it's not something you will do with your kids every day, the times that you do take the plunge will be well remembered.

The activities in this chapter may be a bit messier than others, requiring more thought as to where they can be done, extra preparation in protecting surfaces, and more cleanup time, but they are great fun for kids and adults alike. Most of them are well suited to being done outdoors, which can eliminate some of the preparation and cleanup, so consider doing them in the backyard or park. Creating art outdoors also makes it easier to work big, be messy, and shed inhibitions.

Your children will love it when you encourage them to be bigger, bolder, and messier than usual. Many of the action art experiences in this chapter are liberating in ways that other art activities aren't: "You mean I can splatter the paint?" "I get to build as big as I want?" "It's okay to make a mess?" With this type of art, there are generally fewer restrictions and more freedom to experiment. Art can be so much fun! It doesn't need to be a careful rendering of a still life or staying inside the lines of a coloring book.

Action art generally involves a broader sensory experience than many other art activities. You'll feel the paint on your hands, hear the splat of the flyswatter against the canvas, smell the shaving cream, see the changes as the colors mix, dance to the music while painting, and (possibly) taste the salt in the playdough. A range of sensory experiences makes children more comfortable with their bodies and the world around them, as well as with the art materials themselves.

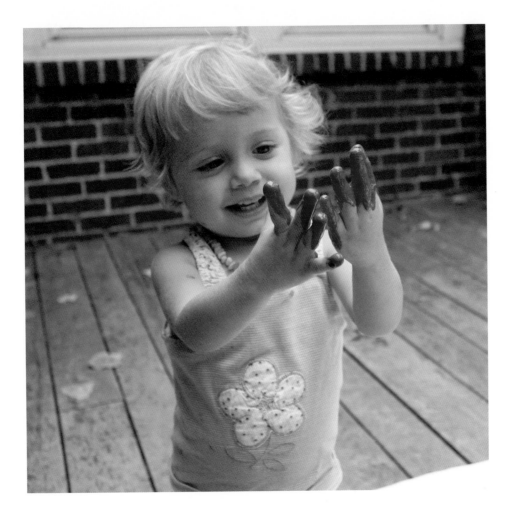

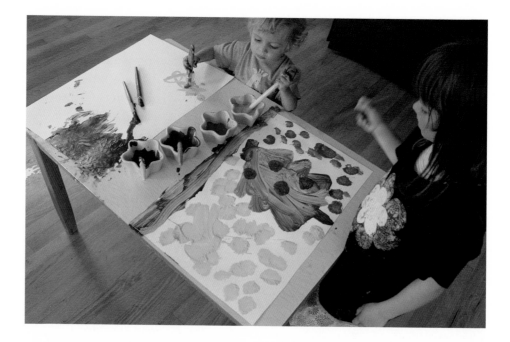

Artful Activity 25 | Paint a Song

Paint to music and attempt to transcribe the music to images.
For ages 3 and up

MATERIALS

- Paper
- Paint

- Paintbrushes
- Music (CD, Pandora, or digital music player)

INSTRUCTIONS

1. Prepare for painting. Protect your work surface and lay out the paper, paints, and brushes.

2. Listen to a song together. Close your eyes and really listen to it closely.

3. Talk about the concept of the activity. Choose colors the song reminds you of. Paint big or small, fast or slow. Enjoy the music and try to transcribe it to the paper using the materials in front of you. You can even move your arms as if you are conducting or dancing.

4. Start the song again, and paint to it this time.

5. Try this again and again with different kinds of music. For example, if you painted to a song with words, try an instrumental piece. Or if you painted to classical music, try jazz or hip-hop.

VARIATION

• See Musical Chairs Art on page 262 for a group variation on this activity.

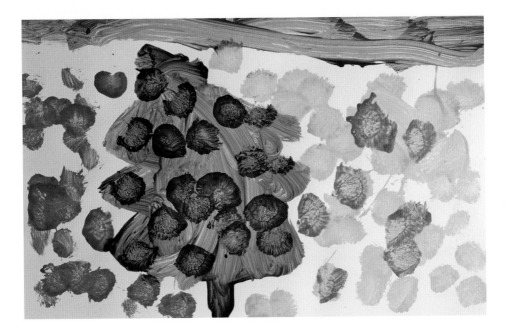

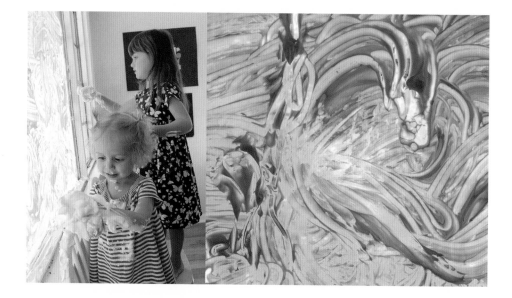

Artful Activity 26 | Shaving Cream Painting on the Window: A Sensory Experience

Young children revel in the opportunity to sink their hands into piles of shaving cream and smoosh it around with their fingers.

Ages 1 and up

MATERIALS

- Shaving cream; *not* gel (Choose an unscented or lightly scented, sensitive-skin variety.)

- Window (or mirror)

INSTRUCTIONS

1. Squirt some shaving cream on the window. Depending on the age and manual dexterity of your child, he may be able to do this himself.

2. Let him smooth the shaving cream around the window with his fingers and hands.

3. If he doesn't try it himself after a

while, consider showing him that you can "draw" in the shaving cream with a finger. He can create designs, images, or scribbles in the shaving cream and see the light shine through the drawing.

4. Discuss the process and the feel of the shaving cream as you work with it.
5. When you're finished, wipe the shaving cream off the window (your child may like to do this as well), and wash the window.

VARIATIONS

- If you've done this activity a few times and want to try a new variation, consider adding some washable tempera paint, using a paintbrush or your fingers to apply the paint to the layer of shaving cream on the window.

- You can also paint with shaving cream and tempera or watercolor paint on paper. While no light shines through, it is still fun!

NOTES

- Is your child hesitant to touch the shaving cream? If he gets it on his skin, does he want to wash it off immediately? Some children love the tactile experience, and some would really rather not touch wet, squishy materials. For most children, this is a temporary stage, but for some kids it may be a more long-lasting sensory aversion or personality preference.
- If your child is hesitant about touching the shaving cream, even after you demonstrate and encourage him, consider letting him use a chopstick or paintbrush to draw in the shaving cream. A tool provides a layer of protection between the child and the material in question, giving him a sense of security. He may decide to touch the material later, after he's familiar with it in this way.
- Another way to help him get over his hesitation is to lay a sheet of plastic wrap over the shaving cream and let him feel it and draw in it through the plastic wrap. Or squirt some shaving cream in a ziplock bag and let him squish it, squeeze it, and draw in it. This will help him become more familiar with the material (this also works for playdough, paint, finger paint, and so on), and he may be more likely to touch it the next time you bring it out.

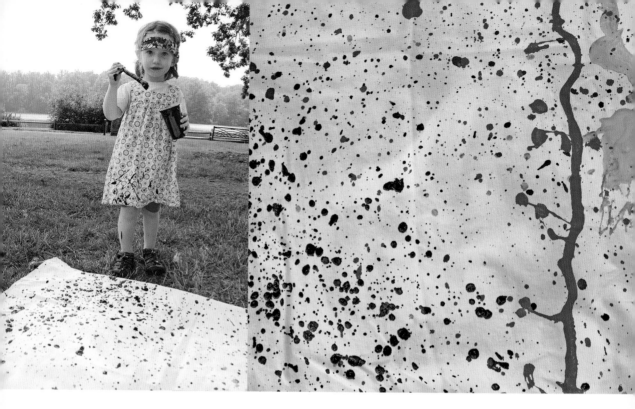

Artful Activity 27 | Jackson Pollock–Inspired Splatter Painting

Work outside for this fun but messy art project. Read *Action Jackson* by Jan Greenberg and Sandra Jordan (Square Fish, 2007) if you're not familiar with Pollock and his painting style.

For ages 2 and up

MATERIALS

- Old white sheet (or butcher paper, poster board, or large stretched canvas)
- Paintbrushes
- Tempera paint in cups

INSTRUCTIONS

1. Spread the sheet or paper on the ground outside, weighing it down at the corners with rocks, if neces- sary. Alternatively, hang or drape it over a fence or clothesline.

2. Dip a brush in paint, then dribble the paint over the sheet. Simply let it drip.
3. Dip the brush in the paint again and flick your wrist to splatter the paint across the sheet.

4. Continue to experiment with different ways to drip, dribble, and splatter.
5. Let dry.
6. Hang and admire.

VARIATIONS

- You can do this activity as small or as big as you like. We've made small paint-splattered notecards as well as queen-size paint-splattered sheets (great for indoor forts).

- If you want a more permanent design on your sheet (for example, if the artwork will be hung outside or used to cover an outdoor tepee), use watered-down acrylic paint.

Artful Activity 28 | Stone Sculptures and Cairns

Build and create outdoor art with rocks or other nature items. First, learn a bit about land art by looking at one of Andy Goldsworthy's books—such as *Stone* (Abrams, 1994) or *Time* (Abrams, 2008)—or by viewing *Rivers and Tides* (New Video Group, 2004), the documentary about him. For ideas specific to children, see one of the *Land Art for Kids* books (http://landartforkids.com).

For ages 3 and up

MATERIALS

- Stones, rocks, and pebbles

- Bucket or kid-size wheelbarrow for carrying rocks (optional)

1. You'll work outside for this one. See if your backyard has enough rocks. If not, consider an excursion to someplace that does—a riverbed, park, or rocky beach.
2. Start building your stone sculptures. You can begin by stacking three or more rocks as a cairn or by making a line, a circle, or even a face out of rocks. Play around and experiment with the idea of using stones to create sculptural or pictoral art.
3. Take a photo of your completed sculptures, especially if they were created away from home.

VARIATIONS

- If your backyard lacks stones and you foresee a lot of stone work in the future, you can buy a pallet of rocks from your local stone yard—any kind, any size. They may even deliver them.

- You can make outdoor sculptures and land art with just about anything, not just rocks. Try bricks, sticks, logs, mud, twigs, leaves, flowers, and grasses.

Artful Activity 29 | Action Painting with Cars

Using car wheels to transfer paint to paper is a novel and fun way for toddlers and preschoolers to create art.

 For ages 18 months and up

MATERIALS

- Masking tape
- Paper
- Tempera paint

- Shallow dishes, such as plates or pie pans, to hold the paint
- Toy cars and tractors

INSTRUCTIONS

1. Tape the paper to your work surface to hold it in place.
2. Pour a puddle of paint in a shallow dish and position it near the paper (or pour a small puddle of paint directly on the paper).

3. Roll the wheels of the toy cars through the paint, then onto the paper. Drive the cars all around or back and forth.

VARIATIONS

- Spread an old sheet or a piece of contractor's paper outside, weighing down the corners with rocks. Roll the cars through puddles of paint and then around the paper.

- A child who is already drawing realistic images might experiment with drawing a figure or scene with the car wheels.

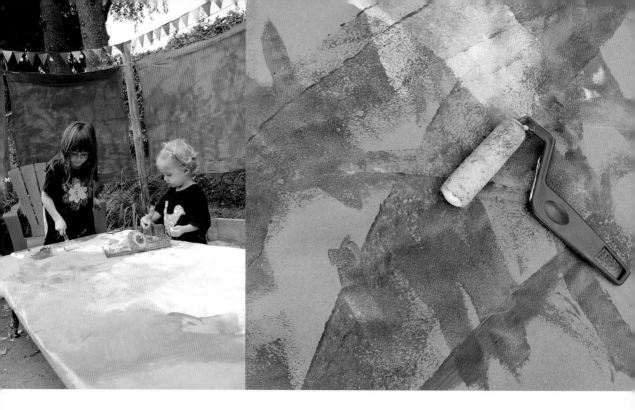

Artful Activity 30 | Action Painting with Rollers

Use regular and mini paint rollers to roll your way to painting nirvana.
 For ages 18 months and up

MATERIALS

- Tape
- Heavy paper, the larger the better
- Tempera paint
- Shallow dishes, such as plates or pie pans, to hold the paint

- Mini paint rollers (from the hardware store; often sold as "trim" rollers) or regular-sized rollers

INSTRUCTIONS

1. Tape the paper to your work surface to hold it in place.

2. Pour shallow puddles of paint in the dishes and position them near the paper.

3. Coat the rollers with paint, then
 roll and roll and roll on the paper.

VARIATIONS

- Use mini paint rollers and water
 on a chalkboard, or use large, regular
 (house-painting) rollers and a bucket
 of water on the outside of the house
 or directly on the sidewalk.
- Use a rolling pin for another paint-
 rolling variation. Try slipping rubber
 bands along its length first and watch
 the lines and patterns you create. Or
 attach foam stickers to the rolling
 pin to create repeat images (good
 for making wrapping paper; test one
 first to make sure it is easily remov-
 able).
- Use a corncob or pinecone to roll
 interesting designs onto paper.

Artful Activity 31 | Bubble Prints

Make dainty bubble prints from colorful bubbles.

For ages 3 and up

MATERIALS

- Commercial bubble-blowing solution
- Food coloring or liquid watercolors
- Pie pan or other shallow baking dish
- Pin or needle
- Drinking straw
- Paper

INSTRUCTIONS

1. Mix the bubble solution with food coloring or liquid watercolors in the pie pan.

2. Poke a hole halfway down the straw. This allows children to blow out but not suck in the bubbles.

3. Insert the straw in the bubble solution and blow until you have a big mound of bubbles.

4. Press a piece of paper lightly over the bubbles, then lift to reveal the bubble print.

Artful Activity 32 | Paint-Blowing with a Straw

Children love to use a straw to blow the paint around the paper.

For ages 2 and up

MATERIALS

- Pin or needle
- Drinking straw
- Liquid watercolors or watered-down tempera paint
- Watercolor paper or card stock

INSTRUCTIONS

1. Poke a hole in the middle of the straw. Kids will still be able to blow out but will be less likely to suck paint in.
2. Squirt some paint on the paper.
3. Blow at the paint through the straw, moving it around the paper in different directions.
4. Add more paint and repeat as desired.

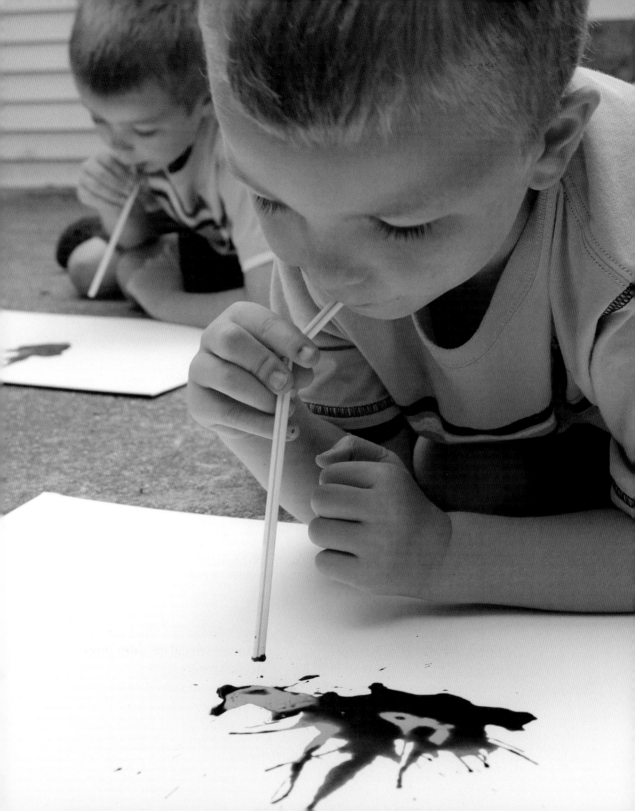

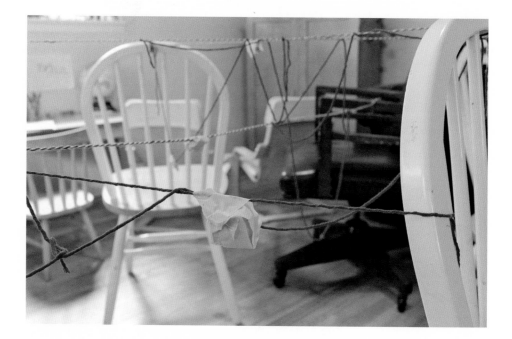

Artful Activity 33 | Installation Art with Tape and String

Children enjoy tying, taping, and stringing, and they will have fun creating an installation in a corner of their home.

For ages 3 and up

MATERIALS

- String, yarn, and/or roll of masking tape
- Scissors

INSTRUCTIONS

1. Talk about the concept of installation art with your child; perhaps visit an exhibit of installation art or look up some images online (do a Google image search for "string installation art"). Many kids readily do this activity without knowing about the concept of installation art, but it's fun to connect what they do to the professional art world.

2. Let kids tie string between chairs and tables and other pieces of furniture as desired. Or have them start looping masking tape between pieces of furniture or along the floor. Just make sure the masking tape is the kind that peels off easily.

3. Take a photo before dismantling your installation art.

VARIATION

- Add other elements, such as beads, feathers, or colored paper, to your installation art.

NOTE

- Talk to your children ahead of time about the need to dismantle the art at some point afterward so you can use the room. Or use a room such as a garage or basement, where it can be left up longer and perhaps worked on over time. You can also do this activity outside, where you can leave it up longer and even use natural materials that biodegrade over time.

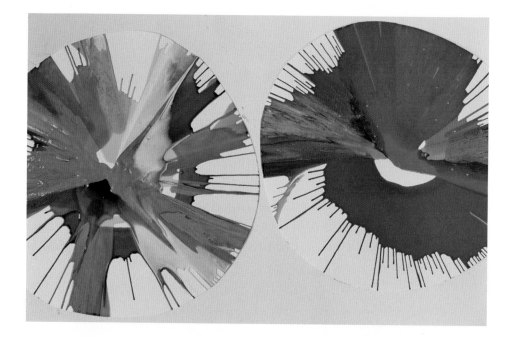

Artful Activity 34 | Spin Art

This is a perennial favorite. It's exciting to spin the paint around and see the beautiful designs created as centrifugal force pushes the paint to the edges of the art surface.

For ages 2 and up

MATERIALS

- Paper plates to fit inside the salad spinner, or paper cut into circles
- Salad spinner
- Tempera paint

INSTRUCTIONS

1. Set the paper plate or paper at the bottom of the salad spinner.
2. Drop one or more colors of paint in the center of the paper with a spoon.
3. Close the top of the salad spinner and spin!
4. Open the top, and ooh and aah over your spin art.
5. Let dry.

- If you have a lazy Susan, circular revolving tray, or old record player, set a piece of paper on it, give it a spin, and draw or paint on it as it goes around.

Artful Activity 35 | Flyswatter Painting

Swat, swat, swat the paint. Outdoors is best for this messy activity!
For ages 2 and up

MATERIALS

- Large paper or old sheet
- Tempera paint
- Shallow dish or pie pan to hold the paint

- Inexpensive plastic flyswatter ($1 or $2 at the grocery store, drugstore, or dollar store)

INSTRUCTIONS

1. Spread out a large sheet of paper or an old bedsheet on the ground, or tape it up on a wall or fence.

2. Pour a shallow layer of paint into the pie pan.

3. Dip the end of the flyswatter in the
 paint, then swat at the paper as
 many times as desired.

The Exploration Tool Kit: Developing an Experimental Approach to Everyday Life

Keri Smith

As a parent and an artist, I do not believe in the separation of art from life. This practice is encouraged and perpetuated by our culture at large and has the result of putting "creativity" into its own little neat and tidy, easily cleanable box. It creates the perception that art or creativity can only be applied to a narrow field or body of work (such as drawing, painting, or craft), and it also encourages a tendency to label specific tools and materials (pens, paint, and paper) as art-making tools. The unfortunate result is that children begin to see "art" as only falling into these categories, and they do not learn to apply creative thinking to other aspects of life. It also limits their exploration of "tools" to what they are shown or to specific methods of use as opposed to fostering a true experimentation with materials.

I feel it is important to demonstrate an experimental approach to as many different tasks as possible in the midst of everyday life. We can do this at the grocery store ("How many colors of rice are there?"), at the playground ("How many different sounds can you hear?"), or while watching an ant move. We all grow up with limited definitions of what art is and can be. Thus, I prefer to steer away from such labels as *art* and *creativity* as much as I can, in the hopes of encouraging a much more open-ended response to world exploration. How is this accomplished? By encouraging experimentation and observation in a variety of different contexts and applications.

As a parent, you quickly find that children completely lack any of the worry of experimentation often exhibited by adults, so they are often able to take leaps where we might hold back for fear of getting dirty, making mistakes, or having a bad outcome. In this sense, we need only give them the basic framework; in turn, they become our teachers. I propose that, as parents, it is necessary to open up our own definitions of art or creative thinking to encapsulate

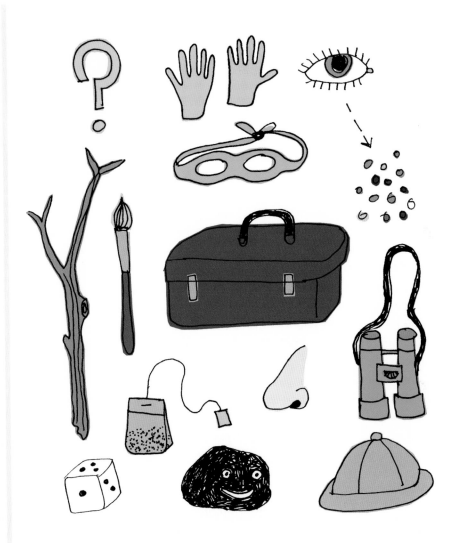

a wide realm of experiences. In this way, we give our children the potential to think creatively in all areas, with fewer limits to the experimentation process. I admit this can be challenging at times, especially when your day feels like one

constant cleanup. But I believe the more we allow *ourselves* to experiment, the more we are able to let go of the need to control our everyday experiences and thus enjoy the natural ebb and flow of life (which is always in a constant state of flux and change, no matter how much we resist this fact).

How to Encourage Methods of Exploration

The basic question to work with is "What happens if?" "What happens if we try painting with dirt or tea? Can we use this stick as a drawing tool? How many different colors of stones can you find in the gravel at the playground? What if these leaves were a kind of paper? What if your bowl were an instrument?"

It is also important to work within the realm of imagination as much as possible. In my book *How to Be an Explorer of the World* (Perigee Books, 2008), I talk about Einstein's use of thought experiments, or questions that can only be solved using the imagination. "If you were able to fly, how would the world look? What if every tree had a secret door in it?"

We can also work with role-playing to put us in the imaginary realm. "You are a secret agent looking for clues; how do you investigate the playground? What tools in the immediate vicinity can you use in your investigations?"

"What if the world we live in is alive and animated? What personality do you think that rock has? What if we name the mailbox, the car, or a tree?" Create a story with your child about each of the objects in your world.

Another tool we can use is incorporating indeterminacy or chance. This makes an experience into more of a game and allows kids (and adults) to try things they might not do on their own. For example, come up with six different ways of moving (hop on one foot or move like a turtle), assign a number to each. Have each person roll a die to determine how he must move around the current location.

Incorporate the use of rituals into your daily routine. "Let's put on our explorer uniform (old hat and binoculars). What if we decorate our collecting bag for when we go hunting for materials? We need a special walking stick for when we go searching for owls. Can we make a magic ruler to measure animal tracks?"

12

Quiet Activities for Downtime and Transition

*You can't use up creativity. The more you use,
the more you have.*
—Maya Angelou

Some families schedule art time specifically to help smooth everyday transitions. Family drawing time after breakfast can be a way to ease into the day. Art time after lunch can be a regularly scheduled quiet time for a preschooler who has recently dropped her nap. You can plan some quiet art for an older sibling while the baby naps, and perhaps even have a special quiet-time art box stocked with a sketchbook, markers, stickers, and other materials that she can access herself. You can make it extraspecial by including some supplies (such as scented markers, glitter crayons, or fun stickers) that are only for this quiet time.

Involving a minimum of materials and little mess, the calmer activities in this chapter are ideal for transition times as well as for peaceful downtime. Many can even be set up ahead of time for a child to do on her own.

I often try to have a few things, including an art material or activity, set up for Maia when she gets home from school. I might put a new library book on the sofa, the playdough and playdough tools on our red table, and some papers and a hole punch at the kitchen table. She and her younger sister may ignore a couple of the things I've set out but really get into one or two of the others.

You can encourage quiet-time art by having a dedicated art space for your child to work anytime she wishes. She may head to the space on her own, or she may need a little encouragement to get started.

While it may be important for you that your child is able to work on art activities by herself during quiet time, it can be equally wonderful to work side by side with your child, bonding peacefully over a shared activity such as drawing or modeling bread dough into suns, moons, and stars.

Artful Activity 36 | Hole Challenge Drawings

Unusual papers, shapes, and negative spaces challenge children to think creatively and approach their art differently than usual.

For ages 2 and up

MATERIALS

- Any kind of paper (big, small, white, colored, copy paper, or poster board)
- Scissors
- Drawing tools, such as markers or crayons

INSTRUCTIONS

1. Prepare the challenge paper for your children by cutting a hole out of the paper. It can be small or large, centered or off center, circular or square, or an abstract blob.
2. Set the hole paper out, along with drawing tools.

3. Stand back and see what your child comes up with. Let him approach the paper and his drawing any way he desires.

VARIATIONS

- Offer the cutout piece of paper instead of the paper with the hole.
- Continue to offer challenge drawings regularly, changing them up so it's a new challenge each time—a different size, shape, or number of holes; different sizes, colors, or shapes of paper; or paper with paper shapes glued to it. Consider keeping a basket of various challenge drawing paper filled and handy. You can also offer different kinds of tools to use— pens, pencils, crayons, watercolors, colored pencils, tempera paint, glitter glue, and collage items.
- Children may like to make challenge drawing papers for each other.

NOTES

- If your child is confused or thinks the paper is defective because of the hole, just explain that it's a new kind of drawing and that he can draw on the paper any way he likes. If he remains hesitant, you can suggest he draw around the hole.

Artful Activity 37 | Self-Portrait on the Mirror

Drawing a self-portrait directly on a mirror can help children make the correlation between what they see and what they draw.

For ages 4 and up

MATERIALS

- Large mirror (not a hand mirror)
- Window crayons

INSTRUCTIONS

1. Have your child stand or sit in front of a large mirror and look at herself carefully. Talk about her different features as she looks—eyes, nose, hair, eyelashes, and eyebrows.
2. Ask which feature she'd like to draw first on her portrait.
3. As she draws, remember that she may not draw the features as you would; that's okay. If she seems finished, you can always ask if there's anything else she could add or if she sees anything else. Or you can say, "I see eyelashes on your eyes. Would you like to draw those?" and "I see freckles on your nose. How would you show those?"
4. Take a photo of the finished self-portrait, perhaps with your child standing beside it.
5. You can leave the portrait up for a while before washing it off with soap and water. Baby wipes work well too.

VARIATIONS

- Use tempera paints and a fine paintbrush to paint a self-portrait on the mirror. The tempera paint washes off easily with soap and water.
- Draw a portrait of another person on the opposite side of a window or glass door. The child looks through the glass and draws the other person's features.

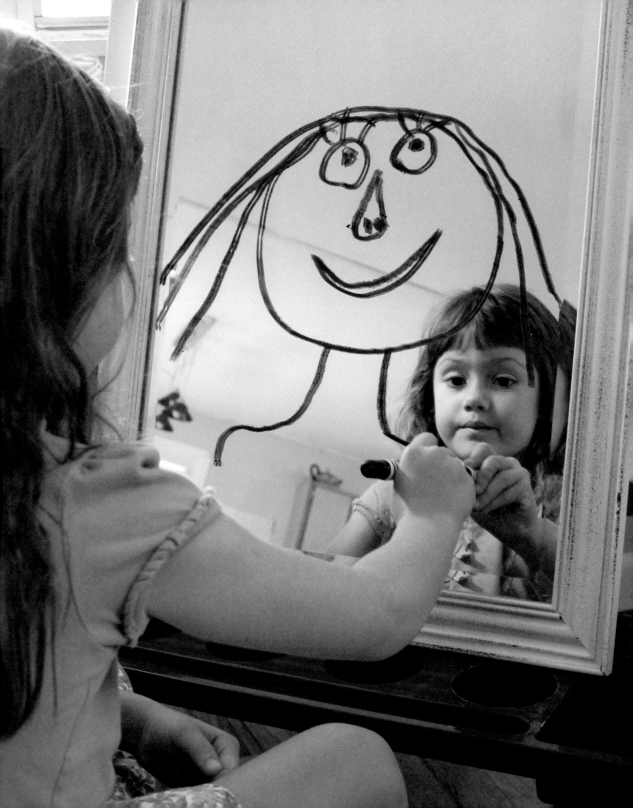

Artful Activity 38 | Design-Your-Own Magnets

Refrigerator art takes on a whole new meaning when children design and make the magnets that hold up their drawings or family photographs.

For ages 3 and up

MATERIALS

- Small wooden disks (available at the art supply store)
- Fine-point Sharpie or other permanent marker
- Liquid watercolor paints

- Fine paintbrushes
- Glue gun
- Magnetic disks (available at the art supply store)

INSTRUCTIONS

1. Draw a design or picture on the wooden disks using the Sharpie.

2. Paint the disks with the liquid

watercolors. These vibrant colors will stain the wood beautifully.

3. Let dry.
4. Using a glue gun, attach the magnetic disks to the back of the painted wooden disks. (See page 181 for advice about children and glue guns; you may want to do this step for younger children.)
5. Use the finished magnets to hang artwork on the fridge.

VARIATIONS

- Paint the disks without using the marker first.
- Glue paper, fabric, or small collage items on the wooden disks.

Artful Activity 39 | Observational Drawing for Young Children

Even young children can begin to draw what they see, especially with gentle guidance.
 For ages 4 and up

MATERIALS

• Paper

• Drawing tool, such as pen or marker

INSTRUCTIONS

1. Choose something to draw from your surroundings and set it on the table in front of you, if possible. You may like to begin with something simple, such as oranges and bananas. Or your child may prefer to draw something he is really into, such as a toy truck.

2. Get out your paper and drawing tool.

3. Talk about the shape(s) of the item and how it might be possible to translate that shape to paper. For example, you could ask, "What shape is that orange? . . . Yes, it's round like a circle, isn't it? . . . Can you draw that round orange on the paper?"

4. Once the basic shapes are drawn, you can talk about the detail you see in the item. For example, "Look at the texture on that orange. How could you show that on your drawing?" or "Those bumps look like little dots, don't they? Would you like to draw little dots on your orange to show the texture?"

NOTE

• Observational drawing is a skill that can be acquired over time through practice and with a child's natural development.

Artful Activity 40 | Glue Drawings and Crayon Rubbings

Draw a picture with glitter glue or regular white glue, then do a crayon rubbing of the raised image.

For ages 3 and up

MATERIALS

- Card stock
- Squeeze bottle(s) of glitter glue or white school glue
- Paper (Copy paper or other thin paper works well.)

- Tape
- Chunky crayons with outside paper removed

1. Draw a picture on the card stock with the glue.
2. Let dry completely.
3. Lay your paper over the raised glue drawing, taping down the edges to hold it in place.
4. Rub evenly all over the paper with the side of the chunky crayons to reveal the glue design.
5. Make as many rubbings of your glue drawing as you wish.

VARIATION

- You can also do crayon rubbings of leaves (a favorite in our house) or anything with texture.

Artful Activity 41 | Continuous Line Drawing

Keeping the pen tip on the paper can be more challenging than you may think! Continuous line drawing is an art school staple, but young children can learn to do it too. If you like, you can read one of Laura Ljungkvist's *Follow the Line* books (Viking Children's Books) first, tracing the lines on the pages with your finger and inviting your child to do the same. Talk about the drawings and how they were created with one long line rather than a series of smaller lines. Notice how two separate images are connected.

For ages 3 and up

MATERIALS

• Paper

• Drawing tool, such as pen or marker

INSTRUCTIONS

1. Get out your drawing materials.
2. Have your child draw a picture and suggest that she keep the pen tip on the paper as she does so. The idea is to draw without lifting the pen—to make one continuous line, scribble, or design. Start with a spiral, if you like, to get the idea.
3. Older children may draw recognizable figures, such as faces, cars, and shapes, while younger children will likely make abstract scribbles.

VARIATIONS

• Follow a line through the house. Let your child create a line through your home using masking tape or string. He can keep the line on the floor (to follow with his feet), or he can make the line go up walls and across the sofa.

• If your child is having trouble keeping the pen tip on the page, consider trying this activity with a small toy car and paint. Children are more accustomed to keeping car wheels on the ground and will have fun drawing designs or images with their car.

• If your child is already learning to draw what he sees in front of him (see observational drawing on page 232), have him try looking only at the object and not the paper while doing a continuous line drawing of it. Although the first few completed sketches may elicit giggles and not look much like the object in question, this is a great drawing exercise that improves hand-eye coordination over time.

Artful Activity 42 | Collage Your Favorite Animal

Use paper scraps and collage items to construct a child's favorite animal while discussing preferences and features.

For ages 3 and up

MATERIALS

- Paper scraps (It's fun to use different colors, textures, and patterns, such as from paper bags, magazines, old notecards, calendars, construction paper, and old artwork.)
- Scissors
- Glue, stapler, or tape

- Heavy paper, card stock, or poster board
- Markers or paints (optional)
- Other collage items, such as beans, pasta, googly eyes, feathers, bottle caps, tinfoil, leaves, twigs, flowers, and so on (optional)

1. Help your child choose an animal to collage by asking, "What is your favorite animal?" or "If you could be any animal, what would you be?"

2. An older child can work on her own, but a younger child may enjoy sitting down with you and having you prompt her with questions such as those that follow (or she may simply prefer to make an abstract collage). Ask questions such as, "Why is the cheetah your favorite animal?" or "What is it about butterflies that you really like?" or "If you were a dog, what color would you be?" You're trying to help your child find out her reasons for choosing the animal as well as the distinguishing colors and features that attracted her. Is it because the cheetah is superfast? Is it because butterflies are beautiful and colorful? Is it because a dog is fun?

3. Help your child choose papers to use to collage the animal, keeping in mind her answers to your questions. Ask, "What papers will make the fastest cheetah?" or "Which of these materials will make the most beautiful butterfly?" Look at pictures of the chosen animal together first, if desired. Or bring out a favorite stuffed animal to look at while working.

4. Let your child cut out or tear papers as desired to make the appropriate shapes for the animal's body, head, legs, ears, and tail. If it seems appropriate, or if she seems stumped, you can keep asking playful prompting questions, such as, "If you were a dog, what kind of tail would you have? How are you going to make your butterfly wings? Does your cat need ears?"

5. Have your child glue the collage materials on as she works, building up the animal piece by piece.

6. Add details with markers, paint, or collage materials (such as beans or feathers), if desired.

VARIATIONS

- You can also do this activity using cars, trees, buildings, people, or dinosaurs.

Playful Exploration of Art Ideas and Materials

Rachelle Doorley

Great art makes its own rules.

—Matisse

A large, blank sheet of paper covers the table in front of us as an open invitation full of endless possibilities. My three-year-old and I each hold a marker; mine is orange and hers is blue. I start the game by drawing a row of small circles surrounded by a random constellation of dots. My daughter watches closely as I make these marks, studies them for a moment, and then picks up her own marker. She links the circles with fat lines, connects the dots one to another with a continuous, loopy line, and then says, "Your turn." We go back and forth like this: I make suggestive marks; she interprets them with addi-

tional lines, dots, dashes, and loops; and we laugh over the silly wonders that materialize on the page. Once the page is full, she exclaims that we're done, asks for another piece of paper, and the game begins again. It's art, it's play, and it's entirely surprising.

Why Surprise?

The artist and author Robert Henri wrote about art, "What we need is more sense of the wonder of life and less of the business of making a picture." Once the foundation is laid for how art materials function, art making itself can push beyond technical mastery toward the articulation of ideas, expression of emotion, and exploration of wonder. The world is full of moments that can't be explained and experiences that fill us with inexplicable emotions. When we get lost in the joy of a baby's kiss, a surprise birthday party, or a free-falling roller coaster, we are filled with feelings that transcend our daily routines. And it is this transcendence past the usual that I propose through building games and surprises into everyday art making.

People take risks when they play. Think of children invested in an imaginative game of dress-up. They become their characters and act in ways they wouldn't normally act. It's through play and risk taking that we push our creativity to new heights and possibilities. While there's certainly a place on the art table for drawing still lifes or learning the color wheel, adding in playful surprises can pique a child's interest, raise consciousness, and build a safe space for taking risks.

FIVE RULES FOR (SURPRISING) ART GAMES

1. *Be present.* Set aside some time for the game and be wholly invested in it. If you're really playing well, time will seem to lose its meaning.
2. *Don't be an expert.* While you have more education than your child, think of these games as an opportunity to colearn. Giving in to your child's knowledge will leave more room for playfulness.
3. *Make mistakes.* Let your child see you "fail" and recover. When you make mistakes—big and little—you show your child that things don't always go as planned. And when she sees you work though these mistakes, she learns how

to recover from her own mishaps. Mistakes can be surprising, and they often lead to fresh discoveries and insights.

4. *Change the rules.* If you've ever played games with children (or remember playing them yourself), you know that kids often change rules midstream. Be open to this, and you may be surprised at the rules they come up with.

5. *Ask open-ended questions.* In any art-making experience or art-viewing encounter, be sure to ask questions such as, "How did you make this picture?" or "What's going on in this picture?" Do your best to avoid assumptions or closed questions such as, "Is that a cloud?"

13

Art for Playdates, Parties, and Groups

They teach you there's a boundary line to music.
But man, there's no boundary line to art.
—Charlie Parker

Making or seeing art with a group of peers is different from doing it on your own or just within your family. It has a whole different level of energy and can be a lot of fun! Group art experiences can also do a lot to encourage the inexperienced or reluctant young artist (or parent). By providing a setting where children create art side by side, you are giving them an example of their peers happily engaged with art materials and activities. Not only does it encourage them to do the same, but it also shows them that those around them value art.

Please note that peer influence can work both ways. If there are reluctant artists in the group, they can inhibit the enthusiasm of the others. If a toddler is hesitant to touch the playdough or paint, those next to him may pick up on that and become hesitant as well. But if the other children are engaged, it can often encourage the shy one. You can try placing a reluctant artist next to an enthusiastic one or just allow him the time and space to observe without pressure.

Group art experiences can be a great help to parents who have little practice in facilitating art activities themselves. Experiencing art in action can sometimes be more effective than reading a how-to book. You not only see how the art materials are used and how other parents interact with their children in an art setting, but you

also observe how your own child interacts with art. Once a parent watches a parent-child class, an art group, or an art party, she is likely to feel more inspired and better able to re-create that art experience at home.

While group art can be incredibly fun and beneficial, there are challenges inherent in doing anything with several children at the same time. While the extra energy a group generates will likely get everyone enthused, productive, and creative, it can also spiral out of control if you're not careful. One child may start splattering paint excessively or misusing art materials, and everyone else may follow his example. The possible mess factor can be magnified with groups. Art can be messy at times with just one kid. Add in more, and the mess may grow proportionally. Keep this in mind when choosing your activities and where you do your art. I save many of the messier art projects for days when the weather is nice and the group can work

outside. Cleaning up under the hose or in the pool is stress-free and fun for the kids. After five years of regular art groups in our house, I still think the benefits outweigh any potential drawbacks.

How to Start a Children's Art Group

Children's art groups can be informal, parent-run playgroups with a regular art component. You can start one yourself by finding and inviting other interested families with children of similar ages to your own. This is a fun way to get your kids doing art in a group environment and to learn as you go, especially if you're armed with ideas from an art book. A regular children's art group captures all the benefits of group art and helps parents learn from each other as they introduce art into their families' lives in a social setting. Here are some guidelines to get you started.

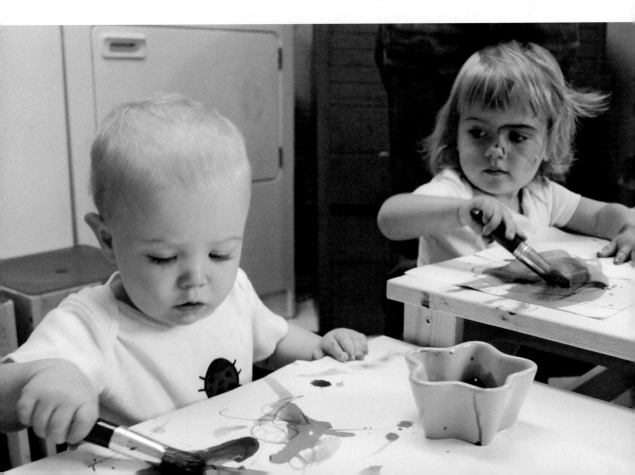

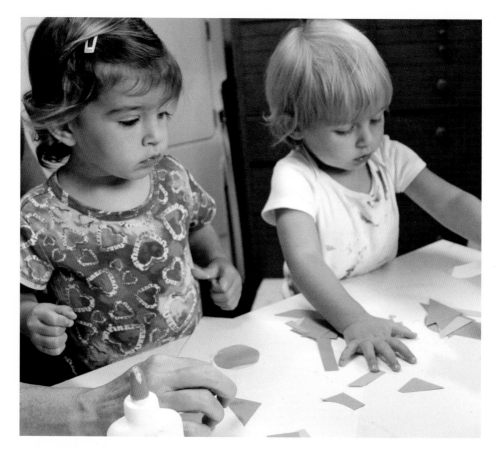

What Kind of Group Do You Want?

Do you want a playgroup for your child (and a parent group for yourself) as we did? Or would you rather have a more structured art class? Keep in mind that young children are not likely to stay focused on an art activity (or anything) for very long.

How Large or Small Do You Want the Group to Be?

We have had as few as four families and as many as ten in our groups, but smaller may be better, especially to begin with. You'll need to consider the amount of space you have and your tolerance for large groups of children. Even just getting two or

three families together regularly can be good. An ideal size may be closer to four or five families, just because someone, maybe two someones, may not be able to make it one week.

How Do You Find Other People Who Are Interested in Your Art Group?

You can ask current friends and acquaintances. You can post on Facebook or put an e-mail out to a local listserv, Yahoo Group, homeschooling group, or local parenting group. You can post a flyer in a coffee shop, co-op, library, or anyplace where other parents and kids hang out. Describe the kind of group you are hoping to start and ask interested families to contact you.

How Will You Pay for Materials?

One option is to ask each family to bring a set amount each week such as $2 or $3 to go toward art supplies and other materials, such as masking tape, paper towels, soap, snacks, and so on. The money can go into a jar to be used as needed. A second option is to buy the supplies for the group, then tell the group how much you spent and what their contributions will be to help pay for the materials. A third option is to rotate hosting duties and have each host take charge of materials for that week. Yet another option would be to set it up as a class with the idea of being paid for both your time and supplies (especially if you are confident in your level of experience in doing art with children).

Where and How Often Will You Meet?

Will you meet weekly or every other week? Will you meet in your house each time, or will you alternate hosting with one or more other families? Or will you try to find another space to use, such as a community center?

What Else Do You Need?

The requirements for group art are similar to those for individual art making. You will need a space that you don't mind getting messy, especially since so many great art projects for young children involve paint or glue. You will need a child-size table for the kids to work at. You'll also need a few basic art supplies, but to start off, you need only what you'll be working with the first week. You don't need to have a completely stocked

art supply cabinet before beginning! Finally, you may want to suggest to other parents that their kids come in clothes they don't mind getting messy (even "washable" paint doesn't always wash out completely) or that they bring a smock or large T-shirt to wear over their regular clothes.

How Much Art Will the Children Do?

Remember that young children, especially toddlers, often have short attention spans. They may paint for five minutes and be finished. Or they may paint for half an hour. It will likely be different each time, depending on the project, the child's mood, and the group dynamic. (See Julie Liddle's excellent ideas for extending art activities on page 266.) So what do you do with the rest of your time?

For our group, we allow time at the start for people to arrive and reconnect and for the kids to play together (usually about forty-five minutes or so). Then we head into the studio, which is generally set up ahead of time, for the art project of the week. The kids work on the prepared activity for twenty or thirty minutes until they've had enough, then wash up and have a snack and play some more. Some kids want to paint for five minutes (or not at all), and some kids stay in the studio painting after everyone else has gone back in to play and eat a snack.

We have good days and bad days. Often, it's peaceful and everything goes smoothly. At other times, sharing toys is difficult for the kids, the project doesn't go as planned, and things feel chaotic.

What Kinds of Art Projects Do You Want to Do with Your Group?

Some art activities and materials lend themselves to group art experiences more than others. In general, activities that require less one-on-one attention are best, as are activities that require fewer steps. Painting is always easy and popular, and there are many different kinds of paint and countless ways to use them. Collage activities also lend themselves well to groups, as do many sculpture activities, playdough and clay, art games, and some drawing.

You don't have to be an artist yourself to start a children's art group, and you don't have to have a degree in art education. You *do* need some degree of enthusiasm for art, a willingness to deal with messes, a space (either yours or someone else's), and

a few basic art supplies. You also have to be willing to organize and plan. I send out an e-mail a few days before our Wednesday meeting, saying what our art activity will be that week and anything group members might need to bring. Sometimes we talk about future art activity ideas during our meetings, and sometimes I send out a list of possible future activities and ask for votes.

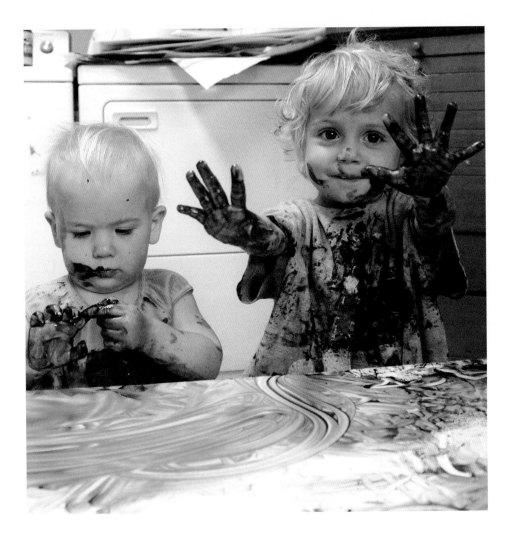

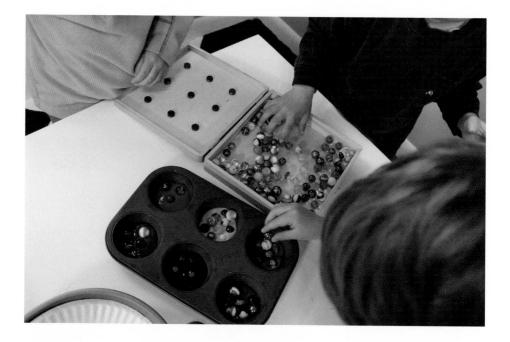

Art Activity 43 | Marble Rolling for Modern Art

Roll paint-covered marbles around on paper to create a modern piece of art.
 For ages 3 and up

MATERIALS

- Rimmed cookie sheet, baking pan, or shallow cardboard box
- Paper to fit cookie sheet
- Tempera paint
- Muffin tin or egg carton to hold the paint
- Spoons
- Marbles

INSTRUCTIONS

1. Lay the paper on the cookie sheet.
2. Pour a small amount of each paint color into the muffin tin sections and add a spoon to each.
3. Drop marbles into the paint, rolling them around with a spoon so they are completely covered.

4. Use the spoons to drop the paint-covered marbles onto the paper.
5. Tilt the cookie sheet to roll the marbles around. Children can work alone or in pairs, each holding a cookie sheet side so they're working in tandem as they tilt and roll the marbles.
6. Replace the used marbles with fresh paint-covered ones and continue as long as desired.

VARIATIONS

• For a larger version of marble rolling, use a large sheet of stiff foam core (or a sheet of primed plywood or a large stretched canvas) and add temporary sides by taping pieces of cardboard along the edges. Add the marbles and roll. More children can participate, holding and tilting. When you're finished, remove the temporary sides and display your creation.
• See the swimming pool ball painting activity on page 260.

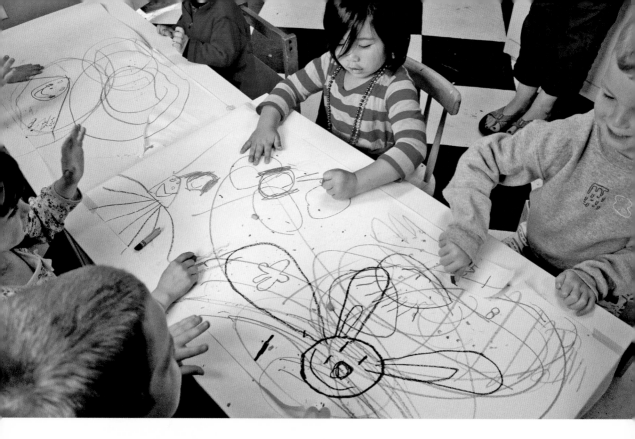

Artful Activity 44 | Simon Says, Draw!

Watch the fun unroll as Simon says to draw dots, squiggles, and funny faces. This is a great family or party game. It is also one of my daughter's all-time favorite quiet-time activities to do one on one with me. Whether we are at home, at a café, or at the doctor's office, this is the activity she requests over and over.

Ages 3 and up

MATERIALS

- Roll of large paper (easel paper, contractor's paper, or butcher paper)
- Masking tape
- Drawing tools, such as markers or oil pastels

INSTRUCTIONS

1. Cover a table with a large sheet of butcher paper, taping the corners down.
2. Have everyone circle around the table, each with a different color marker.
3. Here are some possible directions: Simon says,
 - Draw dots
 - Draw stripes
 - Draw squiggles
 - Switch places with the person across from you
 - Draw zigzags
 - Draw a funny face
 - Hand your marker to the person to your right
 - Draw a monster
 - Draw something really tiny
 - Take five steps to the left around the table
 - Draw something really *big*
 - Draw something that lives under the sea

 Have fun making up your own Simon says directions.
4. When the drawing is finished (Simon says, "Stop!"), stand back and admire the group effort.

VARIATIONS

- Group members can take turns directing the drawing by being Simon.
- Simon says, "Paint!" You can use any paints for a variation on this activity.
- Give each person an individual piece of paper rather than sharing one large piece.
- Simon says, "Dance (or play music)." This idea is easily adaptable to other forms of art.

Artful Activity 45 | Combination Man

Create hilarious drawings of composite people when each group member contributes different body parts. This is a game we played in my family when I was growing up.

Ages 4 and up

MATERIALS

- Paper

- Drawing tool, such as pen, pencil, or marker

INSTRUCTIONS

1. Each group member starts with a sheet of paper, oriented vertically, and a drawing implement.

2. Draw a head and neck (of a person, animal, alien) at the top of your paper, without letting anyone else see your drawing.

3. Fold the top of the paper down to cover the head, letting only the bottom of the neck show.

4. Hand the drawing to the person on your left.

5. Draw the torso and arms of the person, using the visible neck lines as a starting point, and again fold the paper down to cover your drawing, leaving only the bottom of the waist showing. Hand the drawing to the person on your left.

6. Draw the person from the waist down to the knees. Again fold the paper down, and hand it to the person on your left.

7. Finish by drawing from the knees to the feet, fold the paper down, and hand the paper to the person on your left, or keep passing it back and forth between those in your group.

8. Older children and adults have fun adding a name before the drawing is opened, such as Grandma, Brad Pitt, Queen Elizabeth, and so on. If you're including this step, pass the paper to your left again.

9. Now everyone opens their drawings to see the silly people they've helped create. Go around the circle, sharing the finished drawings and the names.

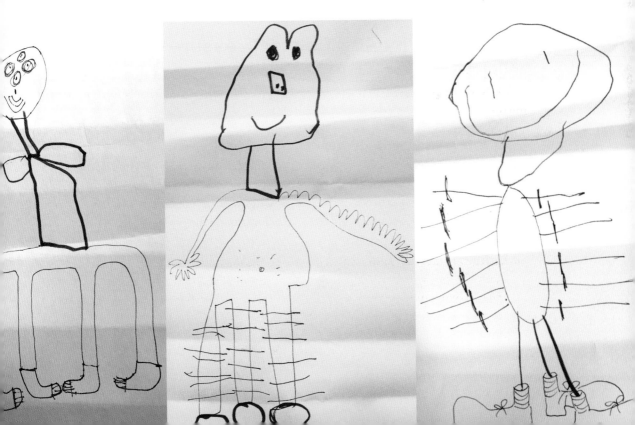

Art Activity 46 | Plaster Treasure Keeper

Add bits of treasure to wet plaster to create a unique sculpture.
 For ages 18 months and up

MATERIALS

- Plastic container from the recycling bin, at least 2" deep
- Petroleum jelly
- Little treasures, such as beads, buttons, sequins, fabric scraps, or old toy pieces

- Plaster of Paris
- Milk carton or old bowl (for mixing the plaster)
- Old spoon or wooden paint stirrer (for mixing the plaster)

1. Grease the inside of the plastic container with petroleum jelly so your sculpture will be easy to remove.
2. Arrange some of your treasure items on the bottom of your container.
3. Mix up the plaster of Paris according to the instructions on the package—generally two parts plaster to one part cold water. (This is an adult's job to be done carefully, as the fine plaster dust is not good to breathe.)
4. Pour wet plaster over the items in the container.
5. Have the children add and arrange additional treasure items in the wet plaster. Kids usually *love* this part.
6. Let dry completely.
7. Remove the plaster treasure keeper from the container and display it, or use it as a paperweight.

VARIATION

- Use objects from nature, such as flowers, leaves, acorns, pebbles, seedpods, and twigs. Note that fresh natural items, such as leaves and flowers, are fun to use but will likely decay after a few days. If you prefer a more long-lasting treasure keeper, dry everything for a week or so first or use items that won't decay.

NOTE

- Pour leftover plaster of Paris in the trash, *not* down the sink. It will clog your drains.

Artful Activity 47 | Paint with Flowers, Pine Boughs, and Feathers

Use pine boughs and flowers as paintbrushes to create a variety of artful effects. For ages 1 and up

MATERIALS

- Large paper, such as easel paper or butcher paper
- Masking tape
- Paint

- Shallow dishes, such as plates or pie pans, to hold paint
- Nature brush materials (flowers, sticks, leaves, feathers, or pine boughs)

INSTRUCTIONS

1. Cover the table with one large piece of paper (for a group painting), taping the corners down, and put out paint in shallow dishes.

2. Set out an assortment of potential natural brush materials. If desired, go for a nature walk first around the

neighborhood or yard, and let the children choose the items they'd like to try painting with.

3. Dip a pine bough or other natural brush in paint, then use it to paint on the paper. Use as few or as many "brushes" as desired to create a unique work of art.

VARIATIONS

- Rather than doing a joint project on a large piece of paper, each child can paint on his own piece.
- For a more analytical approach, make a grid on a piece of poster board and paint with each "brush" in appropriately labeled sections, comparing and contrasting the different marks each makes.

Artful Activity 48 | Swimming Pool Ball Painting

Artists will need to cooperate to roll paint-covered balls around on a large sheet of paper in a kiddie pool.

For ages 3 and up

MATERIALS

- Masking tape
- Contractor's paper or butcher paper
- Child's plastic wading pool
- Tempera paint
- Pie pans
- Several balls of different sizes

INSTRUCTIONS

1. Tape down contractor's paper in-side the kiddie pool.

2. Pour a shallow layer of paint in each of the pie pans.

3. Dip and roll balls in the paint.
4. Drop the paint-covered balls into the kiddie pool.
5. Two or more children can hold different sides of the pool and tilt the balls back and forth to each other or wiggle the pool around to create a unique design with the paint-covered balls.

VARIATION

• For a smaller or single-person variation of this activity, see page 250 for marble rolling.

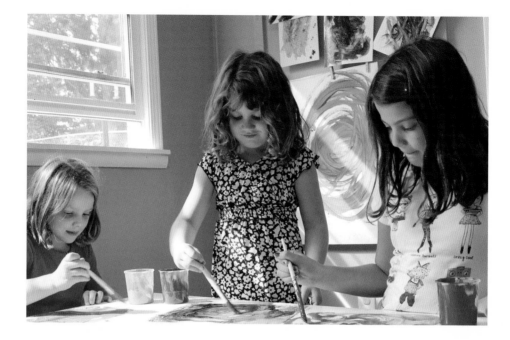

Artful Activity 49 | Musical Chairs Art

Trade places at the art table as the music changes.

For ages 3 and up

MATERIALS

- Paper
- Paint in cups, one color per participant

- Paintbrushes
- Music (CD, digital music player, or Pandora)

INSTRUCTIONS

1. Set up at a table large enough to hold the group (this version of musical chairs does not eliminate participants). Place a sheet of paper, a cup of paint, and a brush at each child's spot.

2. Have participants take their places.

3. Explain the game. Tell them that

they will paint during the music and *to* the music. When the music stops, they will stop painting, pick up their paint cup and brush, and move around the table clockwise, stopping at a new painting spot when the music starts again. At their new spot, they will once again paint to the music.

4. If desired, use different kinds of music each time and let the kids try to match their painting to the style of the music (however they interpret that).

VARIATION

- See Paint a Song on page 198 for a single-person variation of this activity.

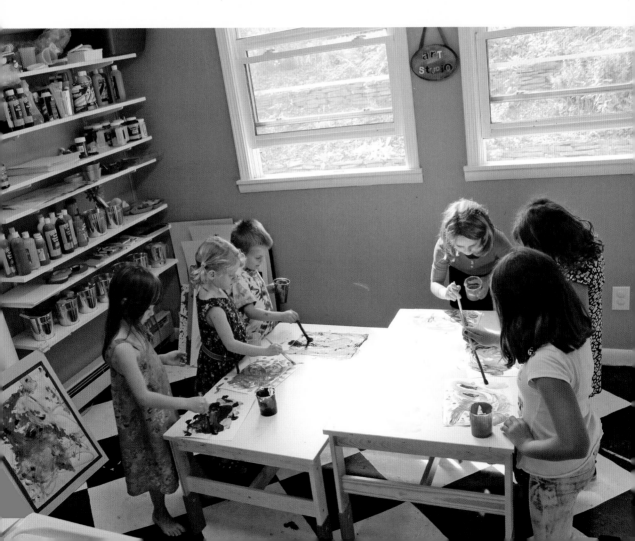

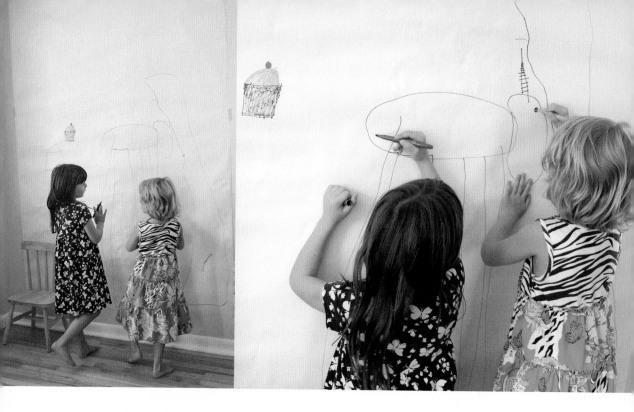

Artful Activity 50 | A Collaborative Mural

Children work together to create a themed mural.
For ages 4 and up

MATERIALS

- Masking tape
- Mural-size piece of paper, such as butcher paper or contractor's paper
- Drawing tools, such as markers, crayons, or pens
- Tempera paint in no-spill paint cups
- Paintbrushes

INSTRUCTIONS

1. Tape the butcher paper along a wall or fence or on the floor.
2. Discuss the mural with the participants before beginning. Can everyone agree on a theme? If one child wants to draw the ocean and an-

other insists on a castle, talk about incorporating both and/or have each child be in charge of a different section. Can each participant agree to be in charge of a particular aspect of the mural? For example, if the mural is an ocean theme, can one child be in charge of the fish (or one kind of fish), while another does the jellyfish, another the seaweed, another the whales, boats, waves, starfish, dolphins, or bubbles?

3. Let participants start with drawing materials, if desired, to sketch in the outlines in their mural.

4. Have them paint their mural (or skip step 3 and just start with paint).

VARIATIONS

- Paint an actual wall inside or outdoors.

- Simply use markers or other drawing materials instead of paint.

NOTE

- You may want to have an adult moderator available to help guide the children and work out any possible conflicts such as "He's working in my space!" "I'm in charge of the starfish!" or "She's using all the red paint!"

Success with Group Art

Julie Liddle

Materials and possibilities abound for igniting your child's creativity. Once you have begun to dabble at home, you may start to wonder about involving others as you and your child explore. Group art experiences add many new dynamics to the process; they can be lively, chaotic, intensely focused, or any combination of these. To be sure, art groups with young children are not for the faint of heart, as they are a hands-on, unpredictable, high-energy undertaking. The only thing that is predictable is the likelihood that there will be a healthy dose of messiness and a few unexpected surprises along the way.

There are four key ingredients that I encourage both parents and teachers to consider when preparing for a successful group art experience. First, set age-appropriate expectations. If your group is composed of little ones ranging from toddlers to young school-age kids, this means offering materials that engage the senses in a variety of ways and planning activities that provide plenty of opportunity for open-ended exploration and discovery, without the expectation of a certain prescribed outcome.

Second, set the stage for success. Some ways to do that include the following:

- Prepare the physical space by protecting surfaces with drop cloths as necessary and having all art and cleanup supplies at the ready. If your goal is to engage your group in a sustained art experience, as opposed to having them dabble and move on, it is best to have a designated space for art making that is relatively free of other distractions such as toys, books, or snacks.
- Consider the time of day. Group art experiences can be highly stimulating, and young children are often at their best for such activities early in the day, when they are well rested and well fed.
- Similarly, time group art for when you, the leader, have plenty of energy.
- Try out a new idea or material with your own child first, before introducing it to the group. While there is no anticipating all of the possible ways the young artists in your group may interact with the materials you provide, it helps to begin with some level of familiarity.
- Consider establishing predictable routines or rituals so the participants come to know what to expect and feel a sense of mastery over the transitions that occur during each session. Parents and children alike will respond with a greater sense of calm and increasing feelings of confidence if each session follows a predictable rhythm. This can be accomplished by opening each group with a story, a song, or introductions, and by repeating similar phrases from week to week to mark the time for winding down art making or beginning cleanup.
- Enlist the children, no matter how young, in the cleanup process. Parents can help and support, but discourage them from taking over for their little ones entirely, as it is important for children to learn that cleaning up is part of the art process. In so doing, they are learning respect for the materials and a sense of responsibility. Make sure enough time is built in to allow for cleanup, as it always takes longer than you think.

Third, offer appropriate materials and present them so they are accessible, inviting, and capable of inspiring a sense of wonder. This means considering the ages of your participants as well as the goals of your activity. For example, if you are working with large butcher paper making life-size portraits, you will want to have something on hand in addition to markers, which may be

appropriate for details for older kids or for scribbling by younger ones but will ultimately frustrate anyone who wants to fill a large area with color. Tempera paints with modest-size brushes might be a good option in this case. Conversely, offer watercolors to young children when you are looking for a fluid design with colors but not when they are attempting to depict detail or create a controlled pattern or design. Offering materials in good repair and displayed in uniform containers in which the contents are easily seen, touched, and manipulated invites exploration, inspires creativity, and instills respect for the materials and the art makers.

Fourth, the key to providing a group art experience where children from tots to teens are engaged in sustained exploration with materials is to be prepared to extend the experience. There are limitless ways in which to do so, and this is where you, as the group leader, get to exercise your own creativity. Introducing materials gradually serves multiple purposes. It minimizes the likelihood of overwhelming little ones who are easily overstimulated, and perhaps more important, it allows all children to explore at their own pace and take their time getting to know the materials. As a group leader, you walk a fine line between balancing the need to allow time for exploration with the need to keep wanderers engaged. Effective "extenders" to keep the process flowing include introducing a new painting tool (brushes, rollers, Q-tips, sponges, droppers, feathers, pine needles, and toy trucks); introducing a new drawing or painting surface (papers of different colors, textures, sizes, and shapes); varying the sensory stimulation by adding a new color, texture, scent, or sound to the process; and adding "special" materials (feathers, shiny papers, something to sprinkle such as salt or birdseed, or treasures from nature). By introducing materials and possibilities in stages, you can effectively and meaningfully extend both the duration and the breadth of the creative experience.

Armed with these strategies you will find immense satisfaction in bringing children together to explore materials and make art. Having their grown-ups on hand to help out with supplies, model good social skills, assist with cleanup, and witness their children's creative journey enhances the experience for everyone involved.

14

Homemade Art Materials to Make and Enjoy

Too often we give children answers to remember rather than problems to solve.

—Roger Lewin

Did you know that you can make your own paints, playdough, and paste with simple ingredients you already have around the house? For example, playdough is mostly just flour, oil, and salt. Finger paints can be made with cornstarch and water. And air-dry clay is essentially baking soda, cornstarch, and flour.

Homemade art materials are economical, which is naturally great, but they are also just as much fun for kids to help make as they are to use. When we're putting together a new paint or dough, I make sure to involve my daughters (or the art group) in the creating as well as the using. It's a fun opportunity for them to mix and make and to see the concrete results of their efforts. We've made our own salt paint, salt dough, paste, papier-mâché paste, finger paints, watercolor paints, playdough, and more. Even if you have the resources to buy unlimited art supplies, I encourage you to try making some of your own with your children. Adding color to your homemade paints or kneading your own playdough for the first time is very satisfying.

Sometimes we make our own materials because they are superior to commercial alternatives (as with playdough), because commercial versions aren't available (salt dough), because it is cheaper to make our own (finger paints), or just because we want to experiment (air-dry clay).

So whether you are interested in making your own materials out of economy, through a sense of adventure, or to extend the art activity, the recipes in this chapter will get you started. They are some of our favorites. If you really get into this, you can seek out other recipes online and in art books (there are countless recipes for playdough alone) or experiment and tweak these until you come up with your own (if the latter, please share your successes with me!).

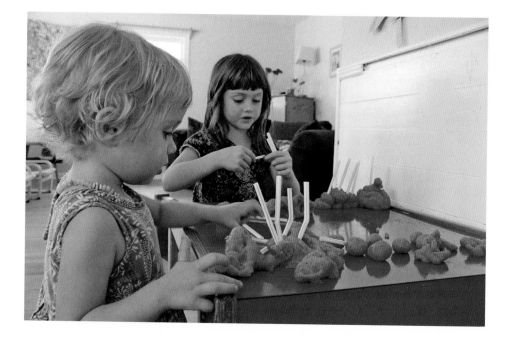

Artful Activity 51 | Making and Playing with Homemade Playdough

We love our homemade playdough so much (the texture, smell, quantity, and process) that we never purchase commercial versions.

Ages 1 and up

MATERIALS

- 2½ cups water
- 1¼ cups salt
- 1 tablespoon cream of tartar
- 4 tablespoons vegetable oil

- Food coloring or liquid watercolors
- 2½ cups flour
- Glitter (optional)
- Essential oils (optional)

INSTRUCTIONS

1. Mix the water, salt, cream of tartar, oil, and food coloring in a large pan.
2. Heat it on the stovetop to simmering point.
3. Stir the flour into the hot mixture and cook for just a little longer, until the dough is no longer sticky (you can pinch it between your fingers to test its consistency).
4. Dump the dough on the counter and let it cool until you can safely manipulate it with your hands. Knead until smooth.
5. Knead in glitter and essential oils, if desired.

NOTES

- *Tools to use to play with playdough.* A rolling pin, butter knives, forks, toothpicks, plastic utensils, candles, a garlic press, small toys, a whisk, a potato masher, and cookie cutters.
- *Ideas to try with playdough.* Rolling balls and snakes; cutting out "cookies"; making pretend food, such as cake or cookies; poking things such as beads, toothpicks, or straws, into the playdough.
- *To store playdough.* This playdough will keep for several months if placed in an airtight container. Store it at room temperature in a freezer bag or in a glass jar with a lid.

Artful Activity 52 | No-Cook Playdough

The texture of this no-cook recipe is different and doesn't last as long as the cooked version, but it's quicker and easier to make.

Ages 1 and up

MATERIALS

- 2 cups flour
- 1 cup salt
- 2 tablespoons cream of tartar

- 2 tablespoons vegetable oil
- Food coloring or liquid watercolors
- 2 cups boiling water

INSTRUCTIONS

1. Mix all the dry ingredients in a medium bowl.

2. Make a well in the center and add the oil and food coloring.

3. Pour in the boiling water and mix well.

4. The mixture will look too goopy and wet at first, but let it sit for a

few minutes; it will firm up as it cools.

5. Dump the dough onto the countertop and knead to form a ball. As with the cooked playdough, you can knead in glitter or essential oils if desired.

6. Store the mixture in an airtight container.

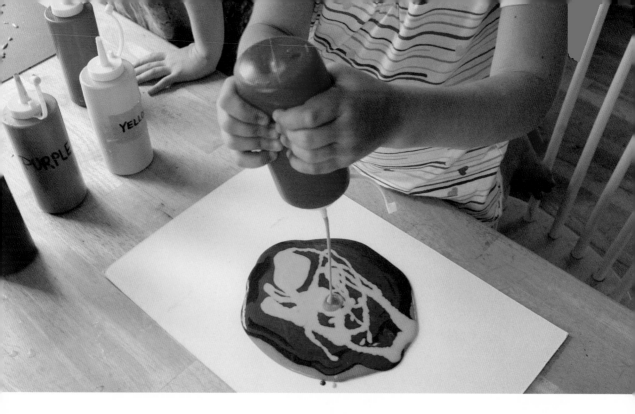

Artful Activity 53 | Puffy Paint: A Paint-Squeezing Experience

Children love to squeeze the paint directly out of the bottle and experience painting in a different way. These paints dry into hard, sparkly, three-dimensional creations.

 For ages 18 months and up

MATERIALS

- 1 cup salt
- 1 cup flour
- 1 cup water
- Squeeze bottles (Old ketchup and mustard bottles work well. You can

also buy squeeze bottles from hair salon supply stores, drugstores, or dollar stores.)
- Tempera paint in four colors
- Poster board or card stock

INSTRUCTIONS

1. Whisk together the salt, flour, and water.
2. Divide mixture into three or four squeeze bottles.
3. Add 1 tablespoon tempera paint to each squeeze bottle, add lid, and shake or stir to mix evenly.
4. Squeeze the paint onto the card stock in any design you like. With toddlers, you may end up with big puddles of paint. Older kids may try to write or draw specific images.
5. Let dry completely (this will take two to three days).

NOTES

• Children like to help make this paint as much as to create with it.
• Leftover paint will keep for two to three days in the refrigerator if you keep it covered.
• If the tip is very narrow, you may need to cut the hole larger.

Artful Activity 54 | Salt Dough Ornaments

Here's an easy salt dough recipe for making and baking ornaments, pretend food, and sculptures.

For ages 3 and up

MATERIALS

- 4 cups flour
- 1 cup salt
- 1½ cups cold water
- Rolling pin
- Cookie cutters
- Cookie sheet lined with parchment paper

- Drinking straws
- Glass beads, stamps and stamp pads, and toothpicks (optional)
- Tempera paints, BioColors, or acrylic paints and paintbrushes (optional)

INSTRUCTIONS

1. Mix the flour and salt in a medium bowl.
2. Add the water and stir until mixed. If necessary, add more water a little at a time, until the dough comes together.
3. Dump it onto the counter and knead it a bit to form a cohesive ball.
4. Use a rolling pin to roll the dough out until it's about a ¼" thick.
5. Use cookie cutters to cut shapes out of the dough. Transfer them to a cookie sheet lined with parchment paper.
6. Use a drinking straw to punch a hole in the top of each ornament (for hanging).
7. You can also decorate the ornaments before baking if you like with stamps and a stamp pad, by pressing small glass beads into the dough, or by punching lacy designs into the dough with a straw or toothpick.
8. Bake at 250°F for three to four hours or until hard and dry, turning after two hours.
9. Remove from the oven and cool.
10. Paint the finished ornaments, if desired.

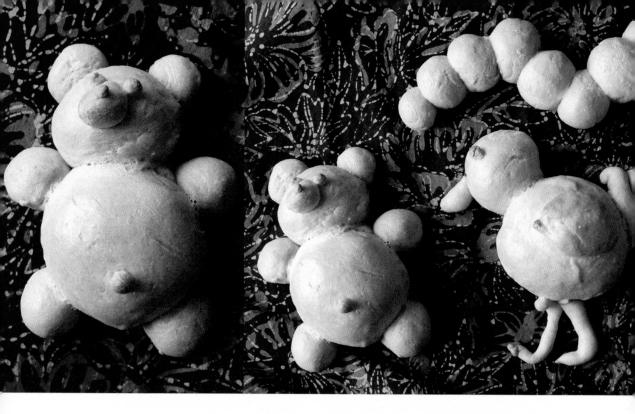

Artful Activity 55 | Teddy Bear Bread and Caterpillar Rolls

Shape this easy, whole-wheat bread dough into fun animals, faces, and sculptures.
For ages 2 and up

MATERIALS

- Bread dough (see the recipe that follows)
- Cookie sheet
- 1 egg
- 2 tablespoons water
- Pastry brush

INSTRUCTIONS

1. Make the bread dough (or buy uncooked pizza dough from your local pizza shop or bakery).

2. Roll the dough into balls and snakes and use it to form animals, faces, suns, and other shapes.

3. Place your bread dough shapes on a greased cookie sheet and set it in a warm, nondrafty place to rise until doubled.

4. Make an egg wash by whisking together the egg and water.

5. Gently brush the tops of the bread shapes with the egg wash.

6. Bake at 350°F for twenty minutes or until golden brown. Watch them closely, as the smaller bread shapes may need less time; larger ones may need more.

Easy Whole-Wheat Bread Dough

INGREDIENTS

- 1½ cups warm water
- 1 package active dry yeast
- 3 tablespoons honey
- 4 cups white wheat flour (a lighter whole-wheat flour sold by King Arthur Flour), or 2½ cups all-purpose flour and 1½ cups whole-wheat flour
- 1 teaspoon salt
- 1 tablespoon olive oil

INSTRUCTIONS

1. Mix the warm water, yeast, and honey in a large bowl. Add half of the flour, mix, and let it sit for thirty minutes.

2. Mix in the salt, olive oil, and remaining flour.

3. Dump the dough onto the counter and knead for five minutes, adding extra flour as necessary if the dough is too sticky.

4. Place in a greased bowl, cover with a dish towel or loose plastic wrap, and let the dough rise until doubled.

5. Punch it down, then use it to make bread dough shapes.

Artful Activity 56 | Painting Cookies with Edible Paint

Mix up your own edible paint and use sugar cookies as your canvas.
For ages 2 and up

MATERIALS

- Sugar cookies (see the recipe that follows)
- Powdered sugar
- Water
- Fine-tip paintbrushes or Q-tips

- Food coloring (Note: India Tree makes a set of all-natural, vegetable-based food colorings. See www.india tree.com.)

INSTRUCTIONS

1. Buy or make sugar cookies.
2. Mix powdered sugar with water to make icing (about 2 tablespoons water per 1 cup powdered sugar). Divide into separate small bowls or into the sections of a muffin tin.

3. Add food coloring to each bowl to tint the icing paint as desired.
4. Using a fine-tip paintbrush or Q-tip, paint the cookies however you like with your edible paint.

5. Let the icing paint dry before serving (if you can wait).

Basic Sugar Cookie Recipe

INGREDIENTS

- 2 cups all-purpose flour
- ½ teaspoon baking powder
- ¼ teaspoon salt
- 1 stick unsalted butter, softened
- 1 cup sugar
- 1 egg
- 1 teaspoon vanilla
- 2 tablespoons milk

INSTRUCTIONS

1. Mix the flour, baking powder, and salt in a small bowl and set aside.
2. Cream the butter and sugar in a medium bowl, then mix in the egg, vanilla, and milk
3. Add the flour mixture to the butter mixture and stir until combined.
4. Divide the dough in half and wrap each half in plastic wrap, molding them into slightly flattened disks.
5. Refrigerate for at least an hour, until the dough is firm enough to work with.
6. Roll out the cookie dough on a lightly floured countertop.
7. Cut out shapes with cookie cutters and place them on a parchment-lined cookie sheet.
8. Bake at 350°F for twelve to fourteen minutes.
9. Remove the cookies from the cookie sheet and let cool on a wire rack.

Artful Activity 57 | Air-Dry Clay

Make your own air-dry clay for sculptures, pretend food, or school projects.
For ages 3 and up

MATERIALS

- 2 cups baking soda
- 1 cup cornstarch
- 1½ cups cold water
- Food coloring (optional)

INSTRUCTIONS

1. Whisk together all the ingredients in a large pot (I keep an old one just for making playdough and other artsy projects). Add food coloring to tint the dough if desired.

2. Heat the mixture over medium heat, whisking constantly until it starts to bubble.

3. Continue to mix as the dough cooks, thickens, and pulls together.

4. Dump the dough onto the counter or into a bowl, and cover loosely with a damp cloth or paper towel, leaving it to sit until cool.

5. Knead the dough a bit, then use it to create sculptures as desired.

6. Let the artwork air-dry. Depending on the size of the sculpture, this may take two to four days.

7. Once the sculpture is dry, you can paint it with tempera or acrylic paints.

NOTE

- If you want to save some of this air-dry clay to use later, make sure to store it in an airtight container, such as a ziplock bag or a glass container.

Artful Activity 58 | Cloud Dough

This supersimple mixture feels like flour but is moldable. It's a fun sensory table or playtime activity for young children.

Ages 1 and up

MATERIALS

- 8 cups flour
- 1 cup baby oil

INSTRUCTIONS

1. Measure the flour into a large bowl and add the baby oil.
2. Mix and squeeze the ingredients with your hands for a few minutes, until the oil is worked through all the flour and the dough holds together when squeezed.
3. Dump the dough into a shallow bin or box. Offer cups, bowls, or sandbox toys to use as molds, or just let the kids squeeze and play with it in their hands.

Artful Activity 59 | Homemade Finger Paints

Make your own easy finger paints for pennies with this recipe.

Ages 1 and up

MATERIALS

- 3 cups water
- 1 cup cornstarch

- Food coloring or liquid watercolors

INSTRUCTIONS

1. Bring the water to a boil in a medium saucepan.
2. Quickly whisk in the cornstarch until mixed.
3. Stir constantly until the mixture thickens.
4. Remove from the heat and let cool.
5. Divide the mixture into individual bowls or storage containers, and add food coloring or liquid watercolors to create the colors desired.
6. Paint with your new finger paints!

- *Ideas to try with finger paints.* Use a spoon to drop some finger paint onto smooth finger paint paper or directly onto a tabletop, and let your child smoosh it around and paint with his fingers. Add more paint as desired. You can also use tools such as a comb or chopstick to create designs in the paint. If painting directly on the tabletop, you can make a monoprint by pressing a piece of paper over the paint design and lifting it up. For an increased sensory experience, let your child paint with his fingers on bubble wrap (and make monoprints if desired).
- Store the finger paints in airtight containers.

Artful Activity 60 | Dyed Pasta and Rice

Dye your own colorful pasta and rice to use in collages, mosaics, and jewelry.
Ages 2 and up

MATERIALS

- Pasta in various shapes *or* white rice
- Plastic ziplock storage bags
- Rubbing alcohol
- Food coloring

INSTRUCTIONS

1. Divide the pasta or rice into separate plastic storage bags, one for each color.
2. Working with one bag of pasta at a time, add 1 teaspoon rubbing alcohol, close the top, and shake until the alcohol is evenly distributed.
3. Open the bag and add the food coloring.
4. Close the bag again and work it between your hands until the color is evenly distributed.

5. Dump the contents out onto a baking sheet to dry.

6. Repeat with the other bags and colors.

IDEAS TO TRY WITH DYED PASTA OR RICE

- String the pasta onto yarn or pipe cleaners to create necklaces and other jewelry.

- Use the pasta or rice in collages or mosaics.

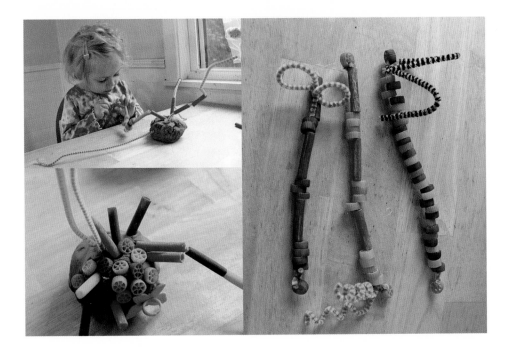

Artful Activity 61 | Recycled Crayon Shapes

Repurpose old crayon stubs into multicolored crayon hearts, stars, or disks.
Ages 2 and up

MATERIALS

- Crayon stubs with paper removed (This works best with regular crayons rather than the washable variety.)

- Silicone muffin tin or ice mold (Look for one with hearts, stars, or other fun shapes.)

INSTRUCTIONS

1. Place the crayon stubs in the silicone muffin tin, filling each shape. (As the crayons melt, they will settle.)

2. Place the muffin tin on a foil-lined baking sheet in a 275°F oven for twenty minutes or until melted.

3. Remove the tin from the oven and let cool.

4. Take your new crayon shapes out of the mold and use, or give as gifts.

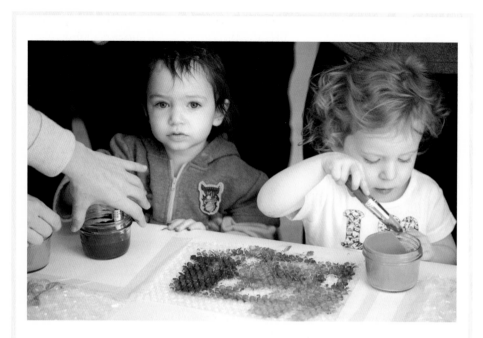

The Natural Artist

Diana Mercer

It was a spring green paintbrush in the mouth of a toddler that got me started. During a tot's art class at Clementine, my children's art studio, a parent discovered that her toddler had placed the fully loaded, dripping bristles in her mouth, much like a lollipop. We both flinched as the paint smeared around her little girl's lips, fully coating the inside of her mouth.

Springing to action, we rinsed and wiped her daughter clean. This mother turned to me with a worried look and asked, "Is this really okay?"

"Our paint is nontoxic," I replied with assurance. For more than twenty years as a teacher, I have understood that nontoxic is as good as it gets for children's art supplies. That label means the product is not related to any toxin or

poison. I am confident that this means it will not kill anyone. For many years, the American National Standards Institute (ANSI) has been certifying that art supplies meet nontoxicity standard ANSI D-4236 and that any toxins be clearly listed on the label.

Still, I couldn't shake my unease. After the paint-in-mouth incident, I felt besieged by unanswered questions about what children's paint is made of. I wondered why the ingredients aren't available on the label. The colors, odor, and seemingly infinite shelf life of children's paint made me wonder what kind of chemicals, synthetic dyes, and preservatives are contained in my non-toxic bottle of paint. "Why can't paint be made with natural colors like plants, fruits, vegetables, and minerals?" I wondered. The Native Americans were successful making paint this way.

So I rolled up my sleeves and headed into the kitchen to make art supplies the old-fashioned way. I chose ingredients I would like to find in my food: flour, salt, oil, and natural extracts. I trolled herbal apothecaries for natural colorants, scents, thickeners, waxes, oils, and natural preservatives. I experimented with *hundreds* of plant, mineral, and vegetable colorants to discover which were the most vibrant, long-lasting, and stable. I made a whole lot of messes.

If you've ever seen a toddler eat a bowl of spaghetti, you know it's a full-body experience. Toddler art is the same way. A rich and fully developmental experience of exploring paint for our youngest children *requires* contact with skin (and almost always includes contact with hair, noses, ears, and mouths). Pure, clean, and easily recognizable ingredients help parents feel confident when allowing this tactile process for their children.

As global awareness of the dangers of certain chemicals and additives grows, parents everywhere are making more careful and ecological purchasing choices: organic, hormone-free milk for their families; toxin-free cleaning products for their homes; and wooden toys as an alternative to BPA- and phthalate-laden plastics. One easy and economical way to go green at home is to try making your own art supplies. It's great fun to mix up a batch of modeling dough with ingredients found right in your kitchen. Simple pastes are a snap to make with flour and water. You can even dye eggs using vegetables from the garden!

Acknowledgments

Thank you to those who have visited my blog over the years—reading, providing motivation and encouragement, leaving comments, asking and answering questions, and sharing ideas. As a community of artful parents and teachers, you have kept me going. We all need the kinship of like-minded folks, and I am so thankful for yours.

To the families in our art groups, past and present, for being enthusiastic test subjects as we explored art with our little ones.

To my editor, Jennifer Urban-Brown, for seeing the book in me, and to my agent, Holly Bemiss, for making it all happen smoothly.

To MaryAnn Kohl, from whom I have learned so much. I especially appreciate your positive approach and your unflagging enthusiasm about children's art.

To all the children's art authors and experts I have talked with, interviewed, and learned from over the years and to those who have so generously contributed to this book.

To my friend Marin for being a beloved second "mama" to my toddler during my many writing hours this past year.

To Discount School Supply and Stubby Pencil Studio for providing art materials to test and use during the creation of this book. And to Asheville's Frame It to a T for the mat board remnants they kindly allow me to take in the name of children's art.

To my friends and colleagues who have read various stages of this work and provided crucial feedback, support, and encouragement along the way, including Kathie Engelbrecht, Molly McCracken, Christina Katz, Barbara Zaborowski, Marin Leroy, Missy Kemp, MaryAnn Kohl, Manjula Subramanian, Molly Montgomery,

Sarah Welch, and—last, but far from least—my mom, Julie Gibson, who remains one of the best writer/editors I know.

To my mom, also, for providing the freedom to be creative during childhood, and to my grandmother, Jean Gibson, for being a kindred spirit, the first real artist I knew, and a continuing inspiration.

Most of all, thank you to my family. To Maia and Daphne—you are the reason I started down this path and the reason I continue. And to Harry for building this wonderful family with me and making it all possible.

Artful Parent Resources

The following resources have been carefully selected to provide more information and inspiration as you explore artful family living.

My Art Supply Picks

Tempera Paint

Colorations Simply Washable Tempera Paint (Discount School Supply) for its quality, color, and price. Melissa & Doug Poster Paint (toy stores) is also a good option. For babies and toddlers, try Clementine Art Natural Paint (toy stores and Whole Foods grocery stores).

Watercolor Cakes

Crayola Washable Watercolors (drugstores or big-chain art supply stores), Melissa & Doug Watercolor Sets (toy stores), and Jolly Watercolors (Stubby Pencil Studio).

Watercolor Tubes

Reeves brand (chain art supply stores).

Liquid Watercolors

Colorations Liquid Watercolor Paint (Discount School Supply).

Finger Paints

Colorations Washable Finger Paint (Discount School Supply), Crayola Washable Finger Paint (drugstores or art supply stores), and homemade finger paints (see my recipe on page 288).

Crayons

Stockmar Beeswax Stick Crayons or Stockmar Beeswax Block Crayons (For Small Hands or Magic Cabin) and Crayola Washable Crayons—jumbo for toddlers, thin for older children (drugstores or art supply stores). We also love the novelty of Crayon Rocks (Stubby Pencil Studio) and shaped crayons (Earth Grown Crayons).

Oil Pastels

Colorations Outstanding Oil Pastels (Discount School Supply), Crayola Oil Pastels (art supply stores or Discount School Supply), and Crayola Twistables Slick Stix (art supply stores and drugstores).

Chalk

Melissa & Doug Jumbo Triangular Chalk Sticks (toy stores and art supply stores) for indoor use, and Crayola Sidewalk Chalk (drugstores or Target) for outdoor use.

Colored Pencils

Alpino Tri Colored Pencils and Alpino Trimax (chunkier) both with triangular barrels (Stubby Pencil Studio). Art Grip EcoPencils by Faber-Castell are good for older children (Stubby Pencil Studio or Amazon), as are Prismacolor Scholar Colored Pencils (art supply stores).

Markers

Crayola Washable Markers and Crayola Pip-Squeaks Washable Markers (drugstores or art supply stores), and Colorations Washable Markers (Discount School Supply). We also love our chunky Alpino SuperColor markers (Stubby Pencil Studio).

Paper for Drawing, Painting, and Collage

Heavyweight white sulphite paper (Discount School Supply), poster board (Target or drugstores), and mat board (some frame shops let you take remnants for free).

Paper for Watercolor Painting

For basic-quality watercolor paper, Canson XL Watercolor Paper (art supply stores), Real Watercolor Paper (Discount School Supply), and Strathmore 200 Series Watercolor Paper (art supply stores and Amazon.com).

Paper for the Easel

Easel Paper Roll (Discount School Supply).

Paper for Working Big

Contractor's paper (from a mega home store).

Construction Paper

Tru-Ray Sulfite Construction Paper (Discount School Supply) and Mala Paper, assorted colors (IKEA).

Glue

Elmer's Washable School Glue and Elmer's Glue Sticks (drugstores, art supply stores, stationery stores) and glue guns (art supply stores).

Modeling and Sculpture Materials

Homemade playdough, my preference (see my recipes on pages 272 and 274). Potter's clay (pottery studios or Discount School Supply), playdough, and pipe cleaners (art supply stores).

Paintbrushes

For toddlers, Melissa & Doug Jumbo Paint Brushes (toy stores or art supply stores). For older children, Colorations Plastic Chubby Paint Brushes (Discount School Supply) and a variety of sizes and brands found at art supply stores.

Paint and Water Cups

Melissa & Doug Spill-Proof Paint Cups (toy stores or art supply stores) for younger children. Colorations Double-Dip Divided Paint Cups (Discount School Supply), which hold two colors each, for older children who need more color options.

Art Smock

Make your own from large T-shirts (see page 46), or just use a T-shirt. Crayola Beginnings Tidy Top Art Smock (art supply stores or Amazon).

Art Trays

Brawny Tough Large Plastic Art Trays (Discount School Supply) or an old rimmed cookie sheet or plastic serving tray.

Glitter

Any glitter from art supply stores, Colorations Glitter Glue and Colorations Washable Glitter Paint (Discount School Supply).

Fun Paints

BioColor Paint and Colorations Activity Paint (Discount School Supply). For acrylic paint, Reeves Acrylic Paint and Liquitex BASICS Acrylic Paint (art supply stores).

Window Crayons and Markers

Crayola Window Crayons (Target or art supply stores).

Fabric Crayons, Markers, and Paint

Pentel Fabric Fun Pastel Dye Sticks (Amazon and Dick Blick) and Jacquard Textile Color (Dharma Trading Company or art supply stores).

Places to Buy Art Supplies (Brick and Mortar)

A.C. Moore (almost everything related to arts and crafts)

IKEA (some children's art supplies)

Michael's (almost everything related to arts and crafts)

Drugstores, including superstores such as Target and Walmart (Crayola, Prang, and RoseArt art supplies, including crayons, markers, scissors, glue, poster board, construction paper, and sketchbooks)

Grocery stores (pasta, beans, flour, salt, cornstarch, contact paper, foil, wax paper, food coloring)

Hardware stores (contractor's paper; wire; wing nuts, bolts, and other items that can be used for collage and sculpture; wood)

Independent art supply stores (often oriented more toward adults or college students)

Office supply stores (pens, pencils, stickers, address labels, circle stickers)

School supply stores (more teacher-oriented; bulk supplies)

Thrift stores (dishes for paint and art supplies, fabrics, collage trays, old warming trays, salad spinners, muffin tins)

Toy stores (some basic art supplies, such as easels, paint cups, stickers, brushes; many carry Melissa & Doug or Alex brand art supplies)

Places to Buy Art Supplies (Online)

Amazon (books as well as many arts and crafts supplies): www.amazon.com

Artterro (eco-art kits): www.artterro.com

Bare Books (blank books, puzzles, and games): www.barebooks.com

Clementine Art (eco-art supplies, including crayon rocks and paints): www.clementineart.com

Dick Blick Art Materials (almost everything related to art, including the Blick brand of art supplies): www.dickblick.com

Discount School Supply (almost everything related to arts and crafts, including Colorations paints, liquid watercolors, papers, brushes, oil pastels): www.discountschoolsupply.com

Earth Grown Crayons (soy crayons in fun shapes): www.earthgrowncrayons.com

For Small Hands (Stockmar crayons, child-size tools): www.forsmallhands.com

Kiwi Crate (subscription-based art and creativity boxes by mail): www.kiwicrate.com

Magic Cabin (select art supplies, including colored pencils, Stockmar crayons): www.magiccabin.com

Stubby Pencil Studio (eco-art supplies, including colored pencils, sketchbooks, markers): www.stubbypencilstudio.com

Wallies (chalkboard wall decals): www.wallies.com

Books about Children's Art and Creativity (for Adults)

Cassou, Michele. *Kids Play: Igniting Children's Creativity*. New York: Penguin Group, 2004.

Kohl, MaryAnn F. *The Big Messy Art Book: But Easy to Clean Up*. Beltsville, Md.: Gryphon House, 2000.

———. *First Art: Art Experiences for Toddlers and Twos*. Beltsville, Md.: Gryphon House, 2002.

———. *Preschool Art: It's the Process, Not the Product*. Beltsville, Md.: Gryphon House, 1994.

———. *Scribble Art: Independent Creative Art Experiences for Children*. Bellingham, Wash.: Bright Ring Publishing, 1994.

Kohl, MaryAnn F., and Kim Solga. *Great American Artists for Kids: Hands-On Art Experiences in the Styles of Great American Masters*. Bellingham, Wash.: Bright Ring Publishing, 2008.

Smith, Keri. *The Guerilla Art Kit*. New York: Princeton Architectural Press, 2007. (Not about children's art per se, but lots of creative ideas that are easily adaptable for use with children.)

Solga, Kim, and MaryAnn F. Kohl. *Discovering Great Artists: Hands-On Art for Children in the Styles of the Great Masters*. Bellingham, Wash.: Bright Ring Publishing, 1997.

Soule, Amanda Blake. *The Creative Family: How to Encourage Imagination and Nurture Family Connections*. Boston: Trumpeter Books, 2008.

Striker, Susan. *Young at Art: Teaching Toddlers Self-Expression, Problem-Solving Skills, and an Appreciation for Art*. New York: Henry Holt and Company, 2001.

Topal, Cathy Weisman. *Children, Clay and Sculpture*. Worcester, Mass.: Davis Publications, 1983.

Topal, Cathy Weisman, and Lella Gandini. *Beautiful Stuff! Learning with Found Materials*. Worcester, Mass.: Davis Publications, 1999.

Wiseman, Ann Sayr. *The Best of Making Things: A Hand Book of Creative Discovery*. Blodgett, Ore.: Hand Print Press, 2005.

Other Parenting Books

Bruehl, Mariah. *Playful Learning: Develop Your Child's Sense of Joy and Wonder*. Boston: Trumpeter Books, 2011.

Carlson, Ginger. *Child of Wonder: Nurturing Creative & Naturally Curious Children*. Eugene, Ore.: Common Ground Press, 2008.

Cohen, Lawrence J. *Playful Parenting*. New York: Ballantine Books, 2002.

Faber, Adele, and Elaine Mazlish. *How to Talk So Kids Will Listen & Listen So Kid Will Talk*. City: Harper Paperbacks, 1999.

Hallissy, Jennifer. *The Write Start: A Guide to Nurturing Writing at Every Stage, from Scribbling to Forming Letters and Writing Stories.* Boston: Trumpeter Books, 2010.

Kuffner, Trish. *The Preschooler's Busy Book: 365 Creative Learning Games and Activities to Keep Your 3- to 6-Year-Old Busy.* Minnetonka, Minn.: Meadowbrook Press, 1998.

———. *The Toddler's Busy Book: 365 Creative Learning Games and Activities to Keep Your 1½- to 3-Year-Old Busy.* Minnetonka, Minn: Meadowbrook Press, 1999.

Payne, Kim John, and Lisa M. Ross. *Simplicity Parenting: Using the Extraordinary Power of Less to Raise Calmer, Happier, and More Secure Kids.* New York: Ballantine Books, 2010.

Books for Children about Famous Artists

The Art Book for Children. New York: Phaidon Press, 2005.

Artist to Artist: 23 Major Illustrators Talk to Children about Their Art. New York: Philomel Books, 2007.

Greenberg, Jan, and Sandra Jordan. *Action Jackson.* Illustrated by Robert Andrew Parker. New York: Square Fish, 2007.

Johnson, Keesia, and Jane O'Connor. *Henri Matisse: Drawing with Scissors.* Illustrated by Jessie Hartland. New York: Grosset & Dunlap, 2002.

Mayhew, James. *Katie and the Spanish Princess* (and other Katie books). London: Hodder and Stoughton, 2009.

Merberg, Julie, and Suzanne Bober. *Sharing with Renoir* (and other Mini Masters Board Books). San Francisco: Chronicle Books, 2005.

Montenari, Eva. *Chasing Degas.* New York: Abrams Books for Young Readers, 2009.

Rodriguez, Rachel. *Through Georgia's Eyes.* Illustrated by Julie Paschkis. New York: Henry Holt & Co., 2006.

Sellier, Marie. *Renoir's Colors.* Los Angeles: The J. Paul Getty Museum, 2010.

Yolleck, Joan. *Paris in the Spring with Picasso.* Illustrated by Marjorie Priceman. New York: Schwartz & Wade, 2010.

Children's Picture Books about Art and Creativity

Brennan-Nelson, Denise, and Rosemarie Brennan. *Willow.* Illustrated by Cyd Moore. Ann Arbor, Mich.: Sleeping Bear Press, 2008.

Clayton, Dallas. *An Awesome Book.* New York: HarperCollins, 2012.

Johnson, Crockett. *Harold and the Purple Crayon.* New York: HarperCollins, 1998.

Lionni, Leo. *Frederick.* New York: Dragonfly Books, 1973.

Reynolds, Peter H. *The Dot.* Cambridge, Mass.: Candlewick, 2003.

———. *Ish.* Cambridge, Mass.: Candlewick, 2004.

Saltzberg, Barney. *Beautiful Oops!* New York: Workman Publishing Company, 2010.

Thomson, Bill. *Chalk.* Tarrytown, N.Y.: Marshall Cavendish Childrens Books, 2010.

Wiesner, David. *Art & Max.* New York: Clarion Books, 2010.

Winter, Jonah. *Gertrude Is Gertrude Is Gertrude Is Gertrude.* Illustrated by Calef Brown. New York: Atheneum Books for Young Readers, 2009.

Children's Picture Books about Color, Line, and Shape

Emberley, Ed. *Picture Pie.* Boston: LB Kids, 2006.

Greene, Rhonda Gowler. *When a Line Bends . . . A Shape Begins.* Illustrated by James Kaczman. Boston: Houghton Mifflin, 2001.

Hall, Michael. *Perfect Square.* New York: Greenwillow Books, 2011.

Jonas, Ann. *Color Dance.* New York: Greenwillow Books, 1989.

Lionni, Leo. *Little Blue and Little Yellow.* New York: HarperCollins, 1995.

Ljungkvist, Laura. *Follow the Line.* New York: Viking Juvenile, 2006.

The Metropolitan Museum of Art. *Museum Shapes.* New York: Little, Brown and Company, 2005.

Micklethwait, Lucy. *I Spy: An Alphabet in Art.* New York: Greenwillow Books, 1996.

———. *I Spy Shapes in Art.* New York: Greenwillow Books, 2004.

Sidman, Joyce. *Red Sings from Treetops: A Year in Colors.* Illustrated by Pamela Zagarenski. New York: Houghton Mifflin Books for Children, 2009.

Songs, Steve. *The Shape Song Swingalong.* Illustrated by David Sim. Cambridge, Mass.: Barefoot Books, 2011.

Walsh, Ellen Stoll. *Mouse Paint.* New York: Voyager Books, 1995.

Whitman, Candace. *Lines That Wiggle.* Maplewood, N.J.: Blue Apple Books, 2009.

Songs as Children's Picture Books

Berkes, Marianne. *Over in the Ocean: In a Coral Reef.* Illustrated by Jeanette Canyon. Nevada City, Calif.: Dawn Publications, 2004.

Boynton, Sandra. *Barnyard Dance!* New York: Workman Publishing, 1993.

Harter, Debbie. *The Animal Boogie.* Cambridge, Mass.: Barefoot Books, 2005.

Keats, Ezra Jack. *The Little Drummer Boy.* New York: Viking Juvenile, 1990.

Liu, Jae-Soo. *Yellow Umbrella.* Music by Dong Il Sheen. Tulsa, Okla.: Kane Miller, 2002.

McQuinn, Anna. *If You're Happy and You Know It.* Illustrated by Sophie Fatus. Cambridge, Mass.: Barefoot Books, 2011.

Pinkney, Jerry. *Twinkle, Twinkle, Little Star.* New York: Little, Brown and Company, 2011.

Sweet, Melissa. *Fiddle-I-Fee.* New York: Little, Brown and Company, 1992.

Zelinsky, Paul O. *The Wheels on the Bus.* New York: Dutton Juvenile, 1990.

Children's Picture Books about Making Music

Atinuke, and Lauren Tobia. *Anna Hibiscus' Song.* Tulsa, Okla.: Kane Miller, 2011.

Cox, Judy. *My Family Plays Music.* Illustrated by Elbrite Brown. New York: Holiday House, 2003.

Ehrhardt, Karen. *This Jazz Man.* Illustrated by R. G. Roth. Boston: Harcourt Children's Books, 2006.

Johnson, Angela. *Violet's Music.* Illustrated by Laura Haliska-Beith. New York: Dial, 2004.

Moss, Lloyd. *Zin! Zin! Zin! A Violin.* Illustrated by Marjorie Priceman. New York: Aladdin Picture Books, 2000.

Perkins, Al. *Hand, Hand, Fingers, Thumb.* Illustrated by Eric Gurney. New York: Random House Books for Young Readers, 1969.

Wheeler, Lisa. *Jazz Baby.* Illustrated by R. Gregory Christie. Boston: Harcourt Children's Books, 2007.

Art in Nature

Aston, Diana Hutts. *An Egg Is Quiet.* Illustrated by Sylvia Long. San Francisco: Chronicle Books, 2007.

———. *A Seed Is Sleepy.* Illustrated by Sylvia Long. San Francisco: Chronicle Books, 2007.

Baylor, Byrd. *Everybody Needs a Rock.* Illustrated by Peter Parnall. New York: Aladdin Paperbacks, 1985.

Ehlert, Lois. *Leaf Man.* New York: Harcourt Children's Books, 2005.

———. *Planting a Rainbow.* New York: Sandpiper, 1992.

Goldsworthy, Andy. *A Collaboration with Nature.* New York: Harry N. Abrams, 1990.

Goldsworthy, Andy, and Thomas Riedelsheimer. *Rivers and Tides.* DVD. New York: New Video Group, 2004.

Lionni, Leo. *On My Beach There are Many Pebbles.* New York: HarperCollins, 1995.

Lovejoy, Sharon. *Roots, Shoots, Buckets & Boots: Activities To Do in the Garden.* New York: Workman Publishing, 1999.

Sidman, Joyce. *Swirl by Swirl: Spirals in Nature.* Illustrated by Beth Krommes. New York, Houghton Mifflin Books for Children, 2011.

Poetry for Children

Frost, Robert. *Stopping by Woods on a Snowy Evening.* Illustrated by Susan Jeffers. New York: Dutton Children's Books, 2001.

Graham, Joan Bransfield. *Flicker Flash.* Illustrated by Nancy Davis. New York: Sandpiper, 2003.

Janeczko, Paul B. *A Poke in the I: A Collection of Concrete Poems.* Illustrated by Chris Raschka. London: Walker Children's Paperbacks, 2005.

Morris, Jackie. *The Barefoot Book of Classic Poems.* Introduction by Carol Ann Duffy. Cambridge, Mass.: Barefoot Books, 2006.

Opie, Iona, ed. *My Very First Mother Goose.* Illustrated by Rosemary Wells. Cambridge, Mass.: Candlewick, 1996.

Sidman, Joyce. *Meow Ruff: A Story in Concrete Poetry.* Illustrated by Michelle Berg. New York: Houghton Mifflin Books for Children, 2006.

Silverstein, Shel. *A Light in the Attic*. New York: HarperCollins, 1981.

Swanson, Susan Marie. *The House in the Night*. Illustrated by Beth Krommes. New York: Houghton Mifflin Books for Children, 2008.

Yolen, Jane, and Andrew Fusek Peters. *Here's a Little Poem: A Very First Book of Poetry*. Illustrated by Polly Dunbar. Cambridge, Mass.: Candlewick, 2007.

Websites

Disney's FamilyFun: http://familyfun.go.com

Google Art Project: www.googleartproject.com

Land Art for Kids: www.landartforkids.com

Pinterest: www.pinterest.com

Blogs on Children's Art and Creativity

Childhood 101: http://childhood101.com

The Chocolate Muffin Tree: www.thechocolatemuffintree.com

The Crafty Crow: www.thecraftycrow.net

The Imagination Tree: www.theimaginationtree.com

Inner Child Fun: www.innerchildfun.com

Littlest Birds Studio: www.littlestbirdsstudio.blogspot.com

Making Art with Children (from the Art Studio at The Eric Carle Museum): www.carlemuseum.org/studioblog

Play at Home Mom: www.playathomemom3.blogspot.com

TinkerLab: http://tinkerlab.com

Games and Activities

Clarke, Catriona, ed. *100 Things for Little Children to Do on a Trip* (and other *Usborne Activity Cards*). Illustrated by Non Figg. London: Usborne, 2008.

Fairytale Spinner Game from http://eeBoo.com.

Tell Me a Story cards from http://eeBoo.com.

Watt, Fiona. *Animal Doodles (Usborne Activity Cards)*. Illustrated by Non Figg. London: Usborne, 2010.

Resources for Creating Books and Other Products from Children's Art

My Pix 2 Canvas (transfer children's artwork to canvas): www.mypix2canvas.com

Shutterfly (create a Mini Masterpieces photobook of your children's art): www.shutterfly.com

Snapfish (make calendars, coasters, cards, and other products from photos of children's art): www.snapfish.com/snapfish/kidsart

SouvenarteBooks (order custom-made books of children's art): www.souvenartebooks.com

Magazines

Action Pack (e-magazine for kids): www.action-pack.com

Alphabet Glue (e-magazine for families): www.birdandlittlebird.typepad.com/blog/alphabet-glue.html

Babybug (for children ages three and younger): www.babybugmagkids.com

Cricket (for children ages nine to twelve): www.cricketmagkids.com

FamilyFun (for parents interested in children's arts and crafts): www.familyfun.com

High Five (for children ages two to five): www.highlights.com/high-five-magazine-for-kids

Highlights (for children ages six to twelve): www.highlights.com

Ladybug (for children ages three to six): www.ladybugmagkids.com

Spider (for children ages six to nine): www.spidermagkids.com

New Moon Girls (for girls ages eight to twelve): www.newmoon.com

Index of Art Activities

By Chapter

Collage

Homemade Art

Clay and Dough

Other

By Material

Tempera Paint

Note: You can use BioColor paint and Colorations brand Activity Paint interchangeably with tempera paint. You can also use acrylic paints for most of these activities, although it is permanent and less kid-friendly.

Watercolor Paint

Acrylic Paint

Finger Paints

Printing Ink

Shaving Cream

Paper, Colored Construction Paper, and Tissue Paper

By Age

Note: Age suggestions are a guideline only. Use your own knowledge of your child's abilities and interests as you choose activities.

About the Contributors

 MAYA DONENFELD comes from a long line of early childhood educators, artists, and inventors. She lives with her husband and two children in upstate New York, where she spends her days creating and repurposing in her old farmhouse. Her biggest inspirations come from raising a family in rural surroundings and the contents of her recycling bins. Maya's work has appeared in numerous magazines, and she has contributed designs to a handful of books. Her own book, *Reinvention*, was published in 2012 by Wiley. She loves sharing ideas for creative parenting and green living, as well as celebrating all things handmade on her blog *maya*made* (http://mayamade.blogspot.com).

 RACHELLE DOORLEY is an arts educator with experience that ranges from overseeing school programs at the San Jose Museum of Art to lecturing on visual thinking at Stanford. Previously, she was a costumer with Warner Brothers and Universal Pictures. Rachelle holds a bachelor's degree in theater from the University of California–Los Angeles and a master's degree in arts education from the Harvard Graduate School of Education. She writes about creative experiments and art explorations at TinkerLab.com.

CASSI GRIFFIN founded *The Crafty Crow* (www.thecrafty crow.net), a curated online collection of children's crafts, in 2008. She started with a background in early childhood education and a love of crafts. With her website being read by thousands of people every day, she hopes to encourage people to spend time having fun and creating with their children. Cassi also has her own business designing crafts for books and magazines and shares her interests, inspirations, and many tutorials on her personal blog, *Bella Dia* (http://belladia.typepad.com). Her greatest love is homeschooling her three children and living a life surrounded by natural beauty in the mountains of central Idaho.

MARYANN F. KOHL has written more than twenty books about process art for all ages; they include *Scribble Art, Preschool Art,* and *First Art.* She is the owner of Bright Ring Publishing, Inc. (www.brightring.com), founded in 1985. MaryAnn was an elementary classroom teacher before her daughters were born, and she began writing books as a way to stay involved in education while being a stay-at-home mom. A national speaker about art, she also writes for magazines like *FamilyFun* and *Parenting* and consults for such companies as Fisher-Price and Nickelodeon. MaryAnn lives with her husband in Bellingham, Washington. Both of her daughters have careers in the arts.

JULIE LIDDLE is the founder and director of Art in Hand®, a unique parent/child art program for toddlers and preschoolers in the Washington, D.C., metro area (http://artinhand .org). She is a registered art therapist and the mother of two.

 DIANA MERCER has been a joyful and passionate teacher of children and art for more than twenty years. She is the founder of Clementine Studio, Art Space for Children in Boulder, Colorado, and Clementine Art, the first full line of all-natural art products for children (www.clementineart .com). Diana received her master's degree in elementary education from the University of Colorado–Boulder and her bachelor's degree in English from Trinity College (Connecticut). She works toward a world where all children are artists, even after they grow up.

 JUDITH A. RUBIN, PhD, ATR-BC, has written six books and created eight films about art and therapy. An honorary life member and past president of the American Art Therapy Association, she is on the faculties of the department of psychiatry at the University of Pittsburgh and the Pittsburgh Psychoanalytic Center; she is also the president of Expressive Media (www.expressivemedia.org). Judith studied art at Wellesley, education at Harvard, psychology at the University of Pittsburgh, and adult and child analysis at the Pittsburgh Psychoanalytic Institute.

 KERI SMITH is a freelance illustrator and the author of several best-selling books about creativity including *Wreck This Journal; How to Be an Explorer of the World: Portable Life Museum; Mess: The Manual of Accidents and Mistakes;* and *The Guerilla Art Kit.* Her latest book, *Finish This Book,* was released in 2011 by Penguin Books. Keri currently lives in upstate New York with her husband (the artist and musician Jefferson Pitcher), her three-year-old son, and her new baby girl. You can find out more about her at www.kerismith.com.

 SUSAN MARIE SWANSON is a poet and picture book author who is fascinated by the place where her understandings about poetry, children's writings, their lives, and their literature converge. She is the author of *The House in the Night* and *To Be Like the Sun*, among other books. Besides writing poetry and picture books *for* children, Susan Marie has been writing poetry *with* children for more than twenty-five years, teaching in the COMPAS Writers and Artists in the Schools program and in summer arts programs at St. Paul Academy and the Friends School of Minnesota. Her awards include fellowships in poetry from the Bush Foundation, the McKnight Foundation, and the Minnesota State Arts Board, as well as the McKnight Artist Fellowship in Children's Literature.

 CATHY WEISMAN TOPAL is a visual arts educator at Smith College and the Smith College Laboratory School. It was at the latter that she became fascinated by the intelligence, potential, and work of very young children. Cathy is the author of *Children, Clay and Sculpture; Children and Painting; Beautiful Stuff: Learning with Found Materials* (with Lella Gandini); *Thinking with a Line* (an interactive computer program and teacher's guide explained at www.smith.edu/twal); and two art curriculums, *Explorations in Art: Kindergarten* and *Creative Minds Out of School*. All of them are published by Davis Publications, Inc. (www.davisart.com).

Photo and Illustration Credits

Cassi Griffin: 147
Maya Donenfeld: 165–6
Cathy Weisman Topal: 191–3
Keri Smith: 221
Rachelle Doorley: 240 and 242
Julie Liddle: 266
Diana Mercer: 294